Make Your
Paintings Look
3-DIMENSIONAL

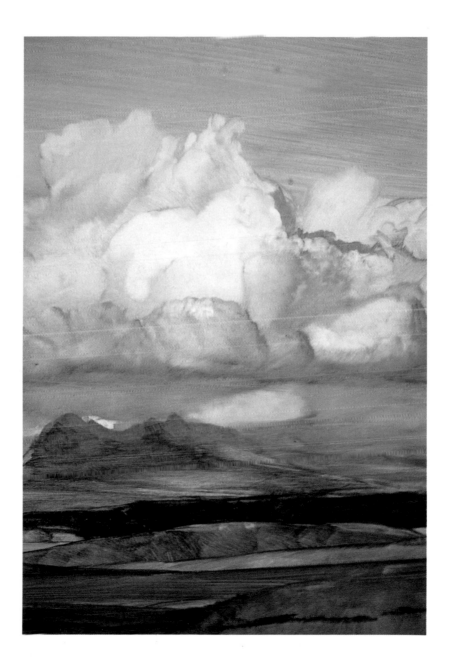

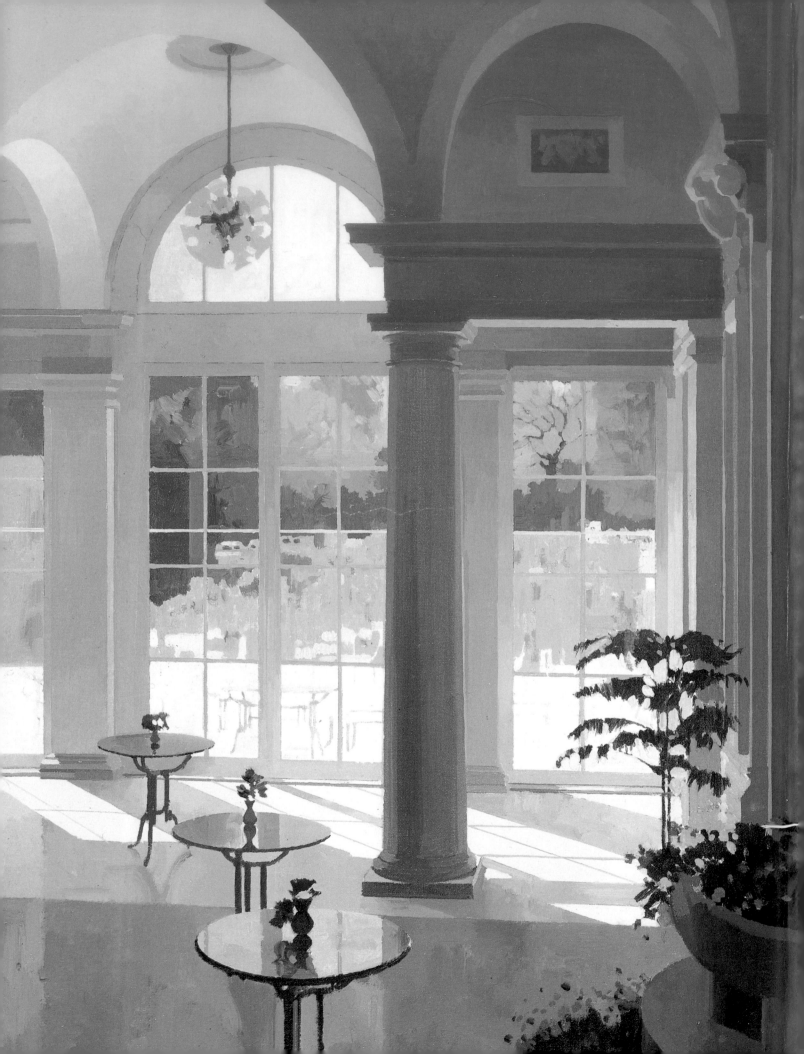

Make Your
Paintings Look
3-DIMENSIONAL

Brian Dunce

NORTH LIGHT BOOKS

Cincinnati, Ohio

A Quarto Book

First published in the U.S.A. by North Light Books,
an imprint of F. & W. Publications, Inc.,
1507 Dana Avenue, Cincinnati, Ohio 45207

First published 1994
Copyright © 1994
Quarto Inc.
The Old Brewery,
6 Blundell Street,
London N7 9BH

ISBN 0-89134-602-3

General Editor: Hazel Harrison
Senior Editor: Maria Morgan
Editor: Judy Martin
Senior Art Editor: Penny Cobb
Designer: Vicki James
Photographers: John Wyand, Paul Forrester, Chas Wilder
Picture Researcher: Laura Bangert
Picture Manager: Giulia Hetherington
Editorial Director: Sophie Collins
Art Director: Moira Clinch

Typeset by Genesis Typesetting, Kent
Manufactured by Regent Publishing Services Ltd, Hong Kong
Printed by Leefung-Asco Printers Ltd, China

Suilven

by James Morrison (p. 1)

Interior

by Peter Kelly (p. 2)

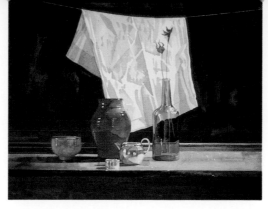

Tea Towel

by Peter Kelly

FOREWORD

When you draw or paint, one of the most significant things you are doing is creating an illusion. You are deceiving the viewer into seeing the real three-dimensional world on a two-dimensional surface. You may not always be conscious of this aspect of visual trickery when you are working, but it is as well to try to keep it in the forefront of your mind, as it is central to all representational painting. If you are painting a still life with fruit on a plate, you want to create the impression that the fruit can be touched, handled and moved, while a successful landscape painting will give viewers the feeling that they can walk into and around the scene.

Over the centuries, artists have discovered a variety of different methods for creating form and depth. One of the best known of these, of course, is perspective, whose laws were formulated during the Renaissance period, when artists were becoming increasingly concerned with three-dimensional realism. Equally important is getting the shapes and outlines right, understanding how to recognize important clues such as the shapes, contours, and relative scale of objects, and learning to analyze the tonal contrasts that describe forms.

In the end, it all comes down to the ability to observe your subject accurately and decide how you want to convey it, and this book will help you to gain these vital skills. The first section, which includes a series of exercises for you to try out, begins with the importance of line, shape, and outline, then moves onto tone, color, and surface texture, and finally discusses viewpoint – a vital factor to consider before you begin to paint. The second section of the book is subject-based, and here you will find hints on how to achieve realistic effects in each of the main subject areas – architecture; land- and seascape; still life and interiors; figures and portraits; wildlife and animals.

Throughout the book there are step-by-step demonstrations in a variety of painting and drawing media, and a wealth of finished paintings by professional artists, with helpful annotation explaining how particular effects have been achieved. Looking at the various methods shown here will help you toward developing not only your basic skills, but also your personal identity as an artist.

Hazel Harrison

What to look for
Annotated theme objects analyzing the main topics covered in each area, followed by a gallery of professional work demonstrating the points in question

Exercises
Practical guidance designed to encourage experimentation and build confidence

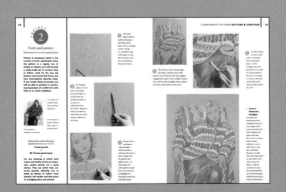

Projects
Step-by-step photographs to follow, bringing together the lessons learned

Contents

Section Two: **Form and Context** 76

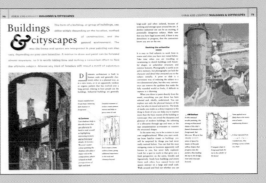

Introduction and gallery

Following the lessons of the first section, put your knowledge into context with more gallery examples to stimulate and inspire

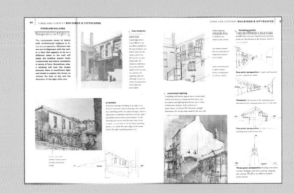

Problem solving

Advice on how to avoid errors of rendition, and practical techniques used in popular subject areas

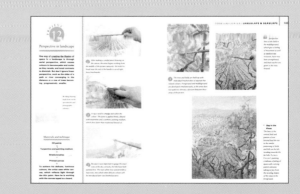

Projects

Subject-based instructional projects for you to try your hand at

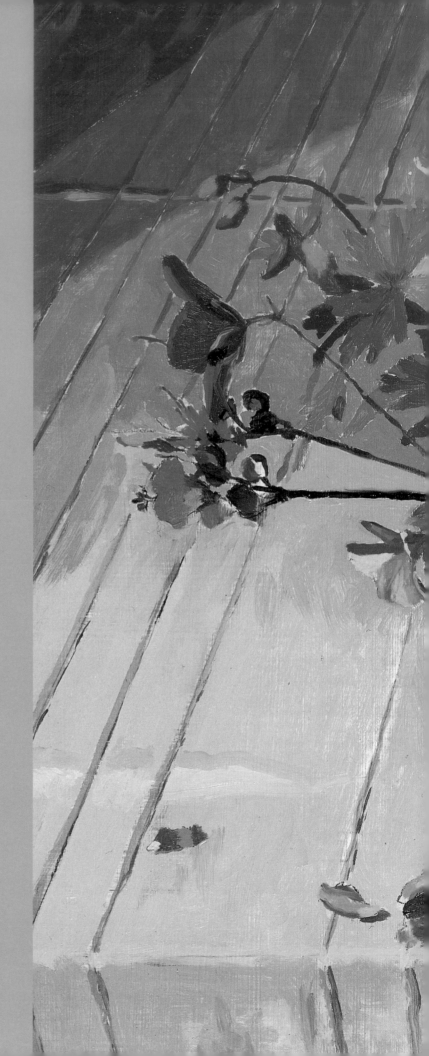

SECTION

1

The Components of Form

One of the primary tasks of the artist is to create the illusion of solidity and space on a flat surface. There are many ways of doing this, and in this section of the book we look at some of the options open to you, from using line in a descriptive manner to the conventional method of "modeling" form by the use of tone and color. You will also discover how surface detail and the choice of viewpoint affect form, while a series of exercises and projects will help you to build up your practical skills.

Geraniums in Copper Pot

by Jeremy Galton

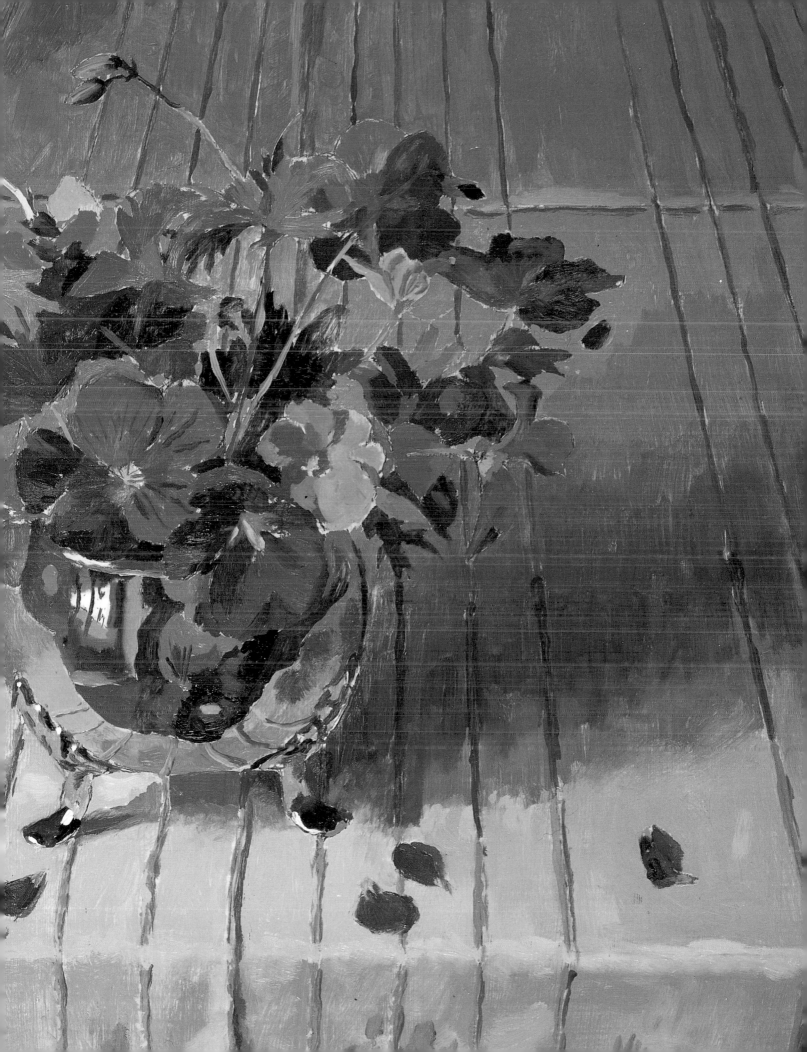

Outline & contour

Drawing in line is often treated as no more than a preliminary to creating form in a painting, a simple method of identifying objects and mapping their general location within the composition. But if drawing is considered "an idea with a line around it," then the way in which the line is drawn can be full of ideas. It can have all kinds of meanings and an implied understanding of space, solidity, and weight. It can trigger the imagination and remind us of our experience of the real world as we picked up an apple or walked through the countryside.

Strong contrasts of tone and color provide crisp edge

Contour lines provided by pattern; curves flatten out slightly toward top

Sharp line of shadow denotes flat plane at top of handle

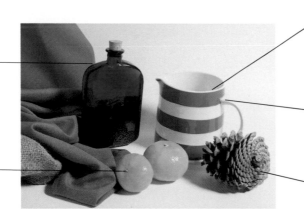

Position of "dimple" important in establishing angle of fruit on table

Crisscrossing curves follow direction of form and explain shapes of individual segments

The elements: What to look for

Start by assessing the main shapes, checking the proportions of each, and their relationship to one another. The pitcher, for example, a squat shape, is still taller than its width and measures a greater distance across than the straight-sided glass bottle. Then look for helpful contours, such as the pattern around the pitcher and spiraling lines on the cone.

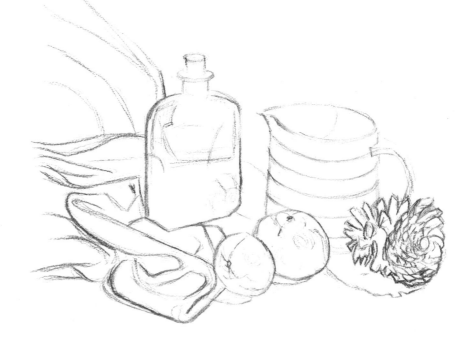

When you try to describe something visually, it is natural to make a simple line drawing initially. This can merely identify the object and set its shape or position, ignoring other descriptive information, such as color, texture, and lighting on its surface. But line is a very active medium; it has weight, motion, rhythm, and direction, which can be made to correspond to particular elements of form. Line drawing describes three-dimensionality, atmosphere, and movement through the positioning of shapes, the use of variable line thickness, and emphasis, the overlapping of areas to create depth and solidity.

The boundaries of shapes

In practical terms, it can be argued that there are no lines evident in the real world. As a convention in drawing, we put a continuous line around an object when what we actually see is the surface moving away until it turns beyond our range of vision. The change of form is the division between object and background, which gives the impression of an edge. The edge can be conveyed by a line, but is in fact the boundary of a silhouette.

When you are making a descriptive line drawing, there are two elements that need particular attention. One is to see and follow the outline accurately, so that it represents the particular subject in front of you, not something that is just generally recognizable or more or less like it. The other is to make the outline expressive both as a representation of the real thing and as a separate, newly created thing – the drawing in itself.

Even if it is easy to see the boundary of a shape as a continuous line, it may not be a consistent line. Information about the internal form of the object and its relationship to surrounding space or objects is reflected in its apparent linear boundary. Lighting conditions, for example, can clarify or disguise parts of the outline. Where an object is heavily shadowed or brilliantly illuminated, the background space or an adjacent object may be similarly affected by the direction of the light, so the effect of a firm outline

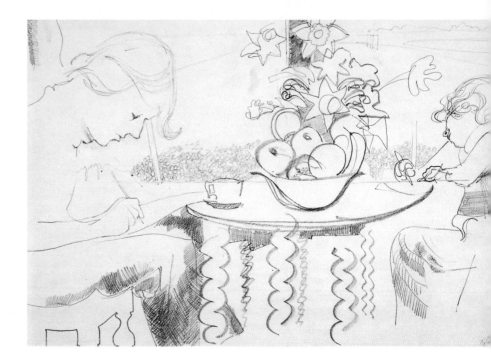

Bowl, fruit, and flowers suggested through varied lines and outlined shapes

Fine, delicate line outlines hand and arm

Thick lines express chunky, solid quality of table legs

▲ **Lucy and Veronica at Beachside**

This lovely pencil drawing by BRIAN DUNCE *demonstrates the descriptive power of silhouetted shapes in conjunction with a varied and expressive line. The figure on the right is particularly impressive, with the nostril, mouth, and waves of the hair combining with the accurately observed shape to provide an eloquent description of the turned-away head.*

between the two is dissolved. Conversely, the strength and direction of lighting may throw part of the object into sharp relief against the surrounding shapes. Here the outline appears strong and emphatic.

This principle of "lost and found" edges can be transferred to the drawing as variations in the quality of the line. Technically, an emphatic line can simply be made heavier or crisper than a dissolving edge, which could be contrastingly represented as broken, smudged, or dotted marks. The swellings and hollows of a curving form, whether it is regular like a vase or organic like a human

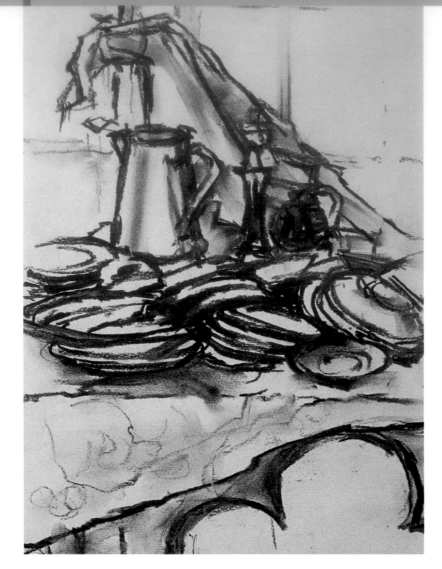

▲ Plates Still Life

Because charcoal is a soft, smudgy medium, it is harder to vary the lines, and here the forms are described less by line than by perspective, notably the ellipses (circles in perspective) formed by the pan lids and the top of the pitcher. JOAN ELLIOTT BATES *has used a little shading for reinforcement, but the emphasis is on shape and outline.*

Ellipse at top of pitcher explains form and angle of viewing

More open ellipse at bottom of pitcher; ellipses become shallower the nearer they are to your eye level

Sides of ellipses thrown into shadow as they turn away from the light

Wavy line and hint of pattern suggests softly draped fabric

figure or an animal, create a subtle shading of the outline that can be translated into the visual and tactile qualities of a particular drawing medium.

Varied line qualities are not just a technical trick, but also a response to subject and medium. You can draw on the paper almost as if you were running the drawing tool over or around the form, matching the swelling and shrinking of a shape, or its hardness or softness, with the pressure and motion of your hand. The overall rhythm of lines can indicate the character or atmosphere of a subject. Spatial depth can be implied by the strength and thickness of a line. Where one line crosses another or reappears beyond and re-establishes the impression of a continuous space, only a slight variation will create this effect.

A useful exercise is drawing very quickly without taking the pencil (or you could use a ballpoint, fiber-tip or crayon) from the paper. This helps you to capture the dynamics of your subject, even if the detail is awry. The vigor of the drawing carries conviction, and if you are trying to represent the immediacy of an event, such as a child learning to walk, an animal washing, a passing cyclist or a musician playing an instrument, it is essential to practice quick, responsive, confident mark-making.

Line qualities

You need to explore the vocabulary of drawn marks and realize the range of expression you can achieve in line alone. Try out as many different hand and arm movements as you can, from sinuous sweeps to jagged stabs. Look at the difference between a firm, confident line and a nervous, repetitive or broken line. Try twisting and turning the drawing tool to create variations of weight and emphasis. Experiment with lines of different speeds, and see how a slow, searching line differs from a swift flourish.

Line drawing can be done in pencil, charcoal, crayon or pastel, with a dip pen, a marker or a ballpoint, or with a brush. Each of these tools creates characteristic marks

and expressive qualities. A single medium can be endlessly versatile; a practiced artist will have no trouble implying vastly different qualites of form, surface texture, and atmospheric detail using the same tool in different ways. But if you try a variety of materials, you may find one naturally more comfortable or sympathetic than another.

Pencil is often preferred as a line medium, partly because it is easily erased. It suits a wide range of subjects: a fine pencil point aptly corresponds to the delicacy and intricacy of some smaller-scale subjects such as homey still lifes or little animals; but thick, dark pencils can be used with great boldness and vigor to catch the monumentality of, for example, an architectural subject or vast landscape. Pen drawing can be very fine and crisp, heavy and energetic, or fragile and hesitant; but the permanency of the ink medium means that you are stuck with your mistakes. Brush drawing is generally broader and more impressionistic than pencil or pen drawing. Charcoal, pastel, and chalk tend to impose a grainy quality, though you can apply these media with some precision by angling their tips and edges.

Try to use these qualities in your drawing without feeling restricted by them. You may be anxious about making mistakes, but you can learn from them. A pen outline that is obviously wrong, for example, gives you an idea about positioning the line correctly. Doubling up the lines, or even tracing them over and around each other several times,

Overlapping places objects in space and describes depth of shelf

Dark shading reinforces effect of overlapping, bringing shapes of decanters forward

Dishtowel and half-hidden objects in sink explain its form and structure

▼ **Kitchen**
This lovely pen drawing by BRIAN DUNCE *also owes much of its three-dimensional quality to the accurate observation of perspective effects; notice particularly how the cookie tins describe the flat receding plane of the countertop. But pattern and the overlapping of shapes also play an important part in rendering both the individual shapes and the interior space that encloses them.*

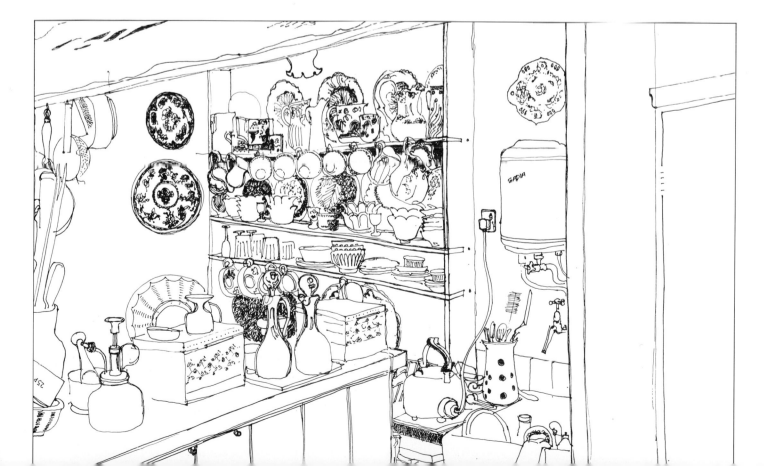

will not obscure a true sense of form. Using a brush rather than a pencil to sketch out a still life may seem a relatively crude approach, but this can help you to achieve a more direct, free rendering of fundamental shapes.

Contour

An outline is a kind of contour, since it is a line that travels around the apparent outer shape of an object. It traces specific elements of shape and form from a given viewpoint, but the true contours of the object (or a location or background, such as an interior or landscape) are traveling continuously in all directions over all surfaces. Contour drawing goes farther than outline drawing in dealing with information inside the boundaries of the shapes. In painting, such areas are typically treated as coherent masses, composed of color, texture, light, and shadow. In line drawing, the textures and shadings have to be conveyed more subtly.

Contour lines are actually visible in many natural forms, on a large and small scale and in a variety of materials. The strata of rock formations in a cliff face describe contours within the overall form; the same structure is revealed on a smaller scale in a sea-worn pebble. Some forms carry quite distinct, marked contour lines, like the spiral of a shell. In others, contour lines are implicit rather than true, but can be traced from surface detail. Human activity and industry

Brushstrokes of thin oil paint suggest grass in foreground; diminishing size of strokes in middleground area creates recession

Generalized background brings foreground trees forward in space; brushwork suggests further trees and foliage

Sweeping horizontal strokes describe flat plane of ground

Lines running around forms, flattening out where curves are less pronounced

► **Dalbrack (detail)**

Outline and contour can still play an important part in suggesting form in paintings, so look for these visual clues when painting landscapes and natural objects. In this oil painting, JAMES MORRISON has given shape and solidity to the tree through descriptive brushwork, emphasizing the contour lines provided by the pattern of the bark.

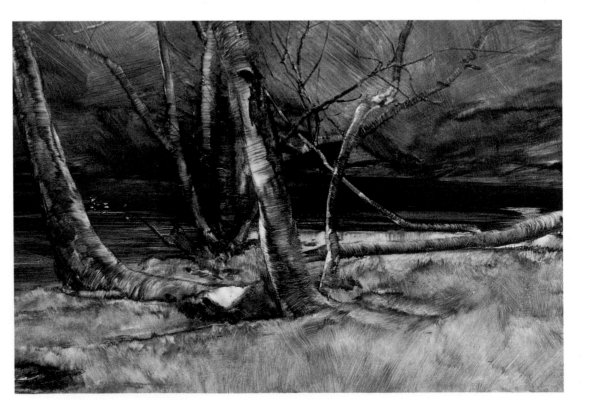

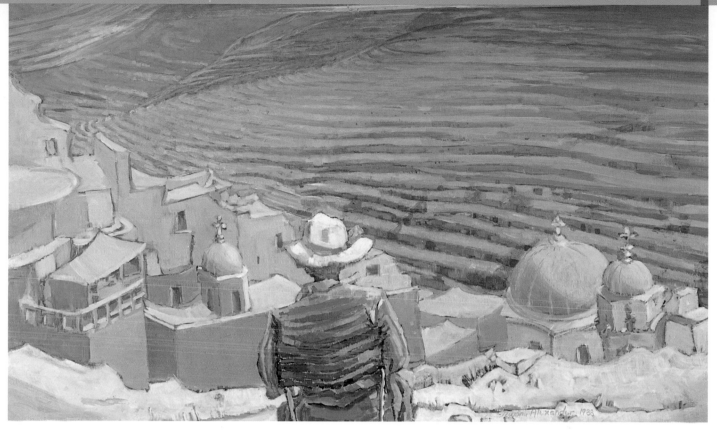

often disclose the underlying shape and form of the landscape: a plowed field reveals undulation in the ground and gives it a linear pattern; a road, pathway or fence can mark the rise and fall of otherwise featureless land and outdoor scenes.

Likewise, a band of rivets around an engine cowling, the tread of a tire, brick courses and tiling on buildings, all help to describe the forms on which they appear. The pattern on a bedspread or clothing appears compressed as it moves away from your viewpoint or wraps around a form. If you learn to pick up these cues accurately and understand what they show about the form, you have the means to create pictures with a convincing solidity about them.

A more subtle problem in line drawing is how to convey details inside the form when there are no distinct linear features or edges to qualify individual details as partly or fully outlined shapes. The human figure is an example of a highly complex form which has definite edges as in, for example, the separation of the arm from the torso, but also an infinitely variable "landscape" of the body consisting of bone, muscle, fat, and

Contour lines follow curves of hills, closing up on horizon

Contour lines shape body and echo those of hills, making a visual link

Perspective of roofs, with receding lines sloping upward, establishes position of monastery buildings downhill from seated figure

skin texture. These components are subject to continuous adjustment; for example, even when a human model is static, muscles may be tensed or relaxed differently while the pose is held. In certain poses, body parts appear as defined shapes and forms that, as they turn into each other, provide the illusion of edges and lines. Otherwise, the rhythms of the body can be very slight and subtle, but very telling if you can find the kind of mark that expresses them exactly in a drawing.

▲ **Mar Saba Monastery**

Here, too, outline and contour play an obvious part both in creating depth and in describing the landscape, as does accurate perspective. NAOMI ALEXANDER has increased the feeling of space by using the device of a prominent foreground feature, cropping the figure so that it appears to be on the picture plane itself, with the landscape stretching away beyond.

EXERCISES

Outline and contour

When you start to draw any object, you may find you are presented with a great deal of conflicting visual information. There will be variations in color and tone caused by the way the light falls, and there may also be pattern and surface texture, all of which can make it difficult to assess the overall shape of the subject, which is the first step in describing its internal forms. These exercises, which concentrate on line and outline, will help you to analyze your subject and draw it accurately without color and with the minimum of tone.

▶ Finding visual clues

When drawing a group of objects, check one against another to work out the relative sizes, and look for clues that help explain the forms. Here, the knife indicates the flat outer rim of the plate, while the fork slopes slightly up from the declivity at the center. The patterns on the china provide contour lines following the direction of the shape, while the ellipses (circles in perspective at top and bottom of the candlestick) describe the cylindrical form. If these are correctly observed, the impression of volume can be conveyed with no need for shading.

Knife indicates flat outer rim of plate; fork slopes slightly up from declivity

▼ Looking at structure

The better you understand a form – both internally and externally – the better you will be able to draw and paint it. A complex shape like this star fruit is readily comprehended from its cross-section, and cutting the orange in half shows that it is not quite the simple sphere it may initially appear. In his pen and ink drawing the artist has carefully placed the converging lines across the orange, which give the clue both to its shape and to the angle at which it rests on the plate.

Cross-section helps understanding of outer surface

Cross-section shows orange to be imperfect sphere

Correct placing of ellipses at top and bottom of cylindrical objects obviates need for shading

▶ Complex outlines

When an object is composed of many individual shapes which fit together to make one structure, it can be difficult to perceive the overall shape and outline. It is helpful to use any existing lines in the background, such as bricks or window bars, as a reference. For this pastel drawing, striped fabric has been used as a grid, enabling the artist to make an accurate drawing by checking where each line of the chair intersects the stripes.

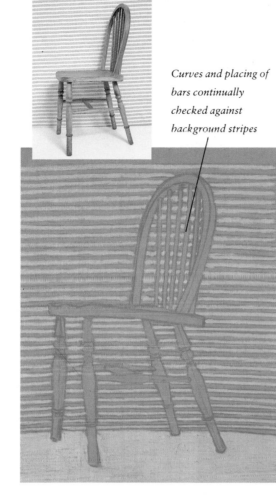

Curves and placing of bars continually checked against background stripes

▼ Contour lines

Not all objects have contour lines, that is, lines going around and over their surface, but when they do exist they make the task of describing form much easier. In this conté crayon drawing, a strong outline and the contour lines of the growth rings have provided a convincing account of the shapes and forms of the vegetables. The edge of a strong shadow will sometimes provide a contour line to follow, as will the boundaries of a highlight on a curved reflective surface.

Growth rings follow forms of vegetable

Heavier line here indicates form turning away from light into shadow

◀ Varying the line

All the lines in a drawing need not be of equal weight. With a pen or hard pencil, it is not always easy to vary the quality and weight of the line, so experiment with charcoal, conté crayon, or pastel. Draw with the points or break the sticks to make the broad, decisive strokes seen in this charcoal drawing. White paint has been used to soften some lines so that volume is expressed through linear contrasts.

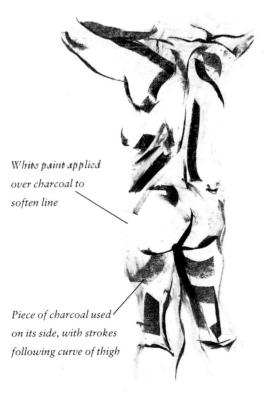

White paint applied over charcoal to soften line

Piece of charcoal used on its side, with strokes following curve of thigh

▼ Lost and found edges

The shape and texture of an object, the way the light falls, and any contrasts of tone and color will create a natural difference in edge qualities, with some outlines blurred and others crisp. The principle of lost and found edges has been used in the figure drawing (left) and in this charcoal drawing, where softness is conveyed through blurring of the outlines in places. You can make alterations with charcoal, losing an edge by smudging and finding another by drawing more heavily.

Shadow beneath leaf provides tonal contrast that clearly defines edge

1

Drawing in line

When you use line alone to draw a complex subject incorporating a number of different shapes, planes, and surfaces, you must consider how to vary the line to suggest forms and also how to recognize and utilize visual clues. The most important of these is perspective, so look for the way in which any receding parallel lines explain the planes of walls, tables, and ceilings. Look also for any overlapping shapes placing objects in space.

Perspective lines describe planes and angles at which they are seen

Table overlaps chair, thus establishing relative positions

Horizontal plane of table – lack of perspective lines creates potential problem

Materials and technique

Conté pencil

●

Sketch paper

●

Conté pencils are better suited to line drawing than short, square-sectioned conté crayons, as the pencils can be held and manipulated in the same way as an ordinary graphite pencil.

① *There are many different methods used for drawing; sometimes a series of measurements is taken and marks made at key points on the paper. This artist, however, prefers to work from the bottom up.*

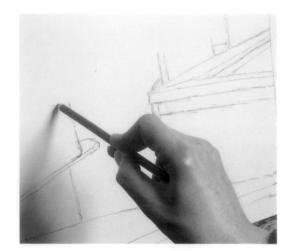

② *When drawing in line, try to avoid holding the drawing implement as you do when writing, as this gives a tight, unvaried line. Here the conté crayon is held near the end to encourage a fluid line.*

③ *The conté lines are strengthened in places to bring some objects forward in space or to suggest rounded forms, as in the case of this light fixture.*

4 *Having found that he cannot fit the top part of the subject onto the sheet of paper, the artist takes measurements and sees that he slightly elongated the forms, making the row of files taller and thinner than they are in reality.*

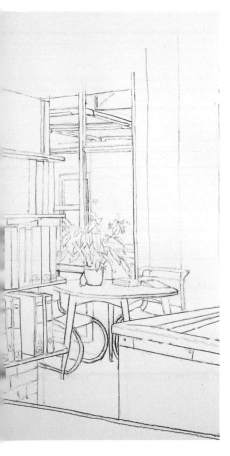

5 *The ceiling and beam could have been excluded but, because they were seen as important in explaining the structure of the room, more paper has been joined on at the top, allowing the drawing to spread upward.*

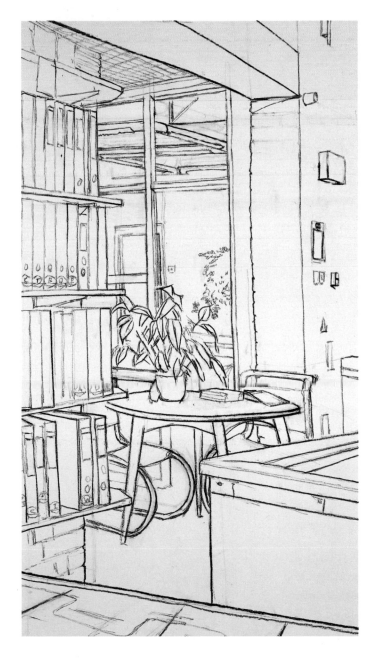

◀ **Office Interior**
In spite of the elongation of the subject, DAVID CUTHBERT'S *drawing successfully conveys spatial qualities through correct observation of perspective and thoughtful use of line. The only serious problem encountered was that of the foreground table which, lacking clear perspective lines, appeared as a vertical plane before the invention of some pattern to clarify it.*

2

Form and pattern

Pattern is extremely useful in the context of form, particularly when the pattern is a regular one of stripes or checks, as it will provide a ready-made set of contour lines to follow. Look for the way the pattern runs around the forms, and how interruptions describe folds. If you render these accurately, you will be able to produce a convincing impression of a solid form with little or no tonal modeling.

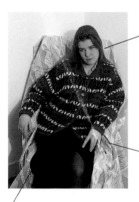

Very slight curve of pattern lines denotes sharper-edged form

Discontinuity of pattern indicates folds, softer on the thick fabric

Line of pattern undulates over breasts

Materials and technique

Pastel pencils

●

Mi-Teintes pastel paper

●

For any drawing in which both color and clarity of line are important, pastel pencils are a good choice. They are softer than colored pencils, allowing you to build up blocks of color more quickly, but harder and less prone to smudging than soft pastels.

1 *The artist begins with an outline drawing in dark blue pastel pencil. She is working on the "wrong" (i.e. smoother) side of the paper, as this has less texture and does not break up the pastel strokes.*

2 *In a human subject, errors such as wrongly assessed shapes or proportions are quickly spotted, so accuracy is important from the outset. Measurements are taken to check the size of the head in relation to the body.*

3 *Because she is working on colored paper, which provides a medium tone, the artist is able to begin with the darkest and lightest areas. On white paper the white pattern would have to be reserved as highlights by drawing around each individual shape.*

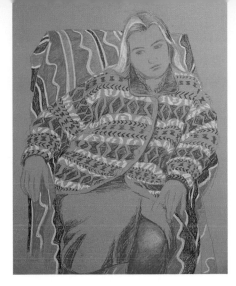

4 The forms are now convincingly described, with the curve of the pattern over the back of the chair slightly exaggerated to give it more solidity. Notice how well the dark and light stripes explain the forms and positions of the arms.

5 Foreshortening is hard to deal with in a drawing that is essentially linear. On the sweater and chair back, there is no need for tonal gradation, but here it is needed to reinforce the lines of the folds which only partially explain the form.

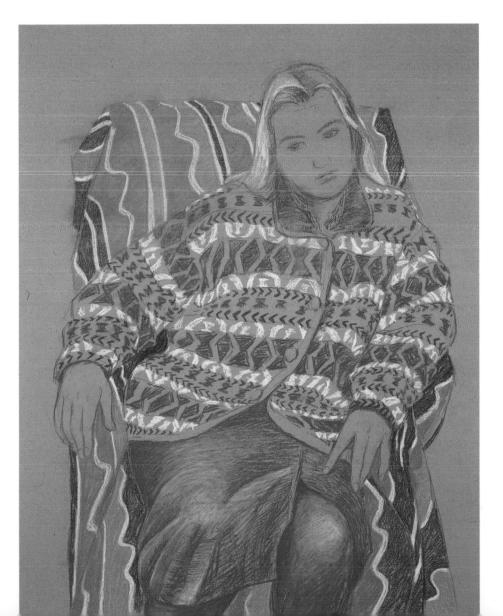

◀ **Anna in Patterned Sweater**
Drawing and painting involves making decisions at every stage of the work, and when she had completed the figure and chair, ROSALIND CUTHBERT had to decide whether or not to add color to the face and hands. Because it would have been impossible to treat them in the same way as the fabrics, without variations in tone, she wisely left them as uncolored paper, with the forms described by outline alone.

Tone, volume, & mass

Tone describes the qualities and range of lightness and darkness in image-making. Where line can suggest form and indicate aspects of volume and depth, tonal modeling gives a more solid, illusionistic sense of three-dimensional form and space. In a literal sense, light reveals the contour, volume, and mass of an object, and its relationship to the space it occupies, by shading its surface levels descriptively. You achieve an impression of form by recreating that pattern of light and shadow on a two-dimensional plane, from the subtlest tonal gradations to dramatically contrasted effects of highlighting and deep shadow.

Shadow makes definite shape, curving around side of fruit

The exact placing of highlights is vital, as they are shaped according to the form

Bottom of jug merges into strong cast shadow on left; on right side curve is clearly visible

Undulations in shadow thrown by pine cone describe uneven surface of sacking

The elements: What to look for

The overall shapes you see in the subject are always important, so sketch these in first and then look for the way the shadows describe the forms. If there is not enough light and shade, rearrange the lighting if possible so that it comes from one side, as in this group. Avoid using too linear an approach; instead build up the forms so that they look solid before adding details such as pattern and highlights.

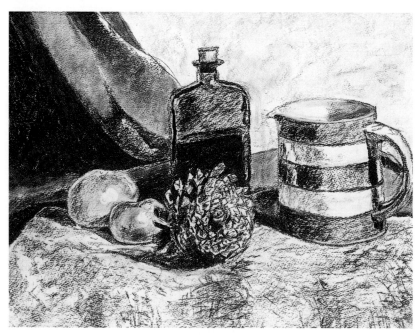

Tonal variations relate to the strength and direction of the light falling on a surface. As the surface turns away from the light, it becomes more shadowed, and this occurs both across a whole shape and in relation to any surface irregularities, so that the contours of the form are mapped by gradations from light to dark. To this extent, there is a logical pattern that can be seen, understood, and translated to a drawing or painting.

This sounds simple, so why is it often difficult to construct form convincingly or accurately? The problem is that you may find yourself grappling with a variety of visual information, some of which is contradictory. Outdoors, for example, the light is often diffuse and apparently even; contrasts are not pronounced, and there seems to be no particular direction governing the gradations of light and shadow. If you set up a still life or portrait setting at home, you can control the pattern of light by using a single, angled light source, which gives a strong effect of modeling; but you may still see reflected light from an unexpected direction, and you have to deal with relatively complex surface variations of color and texture that interfere with a simple tonal pattern.

Concentrating on tonal values alone means you must be highly selective, but also thoughtful and accurate in your selection process. Eliminating color from your materials – working in pencil or charcoal, for example – does not in itself provide any clues as to how to eliminate detail in the subject that is colorful rather than tonal. A black vase, or gate, or animal, is described by tonal variations in the same way as a red or white one; but the gradations may be harder to see because black is such a dark, dense color. Learning to ignore deceptive features and simplify and sort the visual pattern is an important aspect of understanding form.

A range of values

Look at a black-and-white photograph from a newspaper or magazine. Imagine the subject in the "flesh" and consider how the

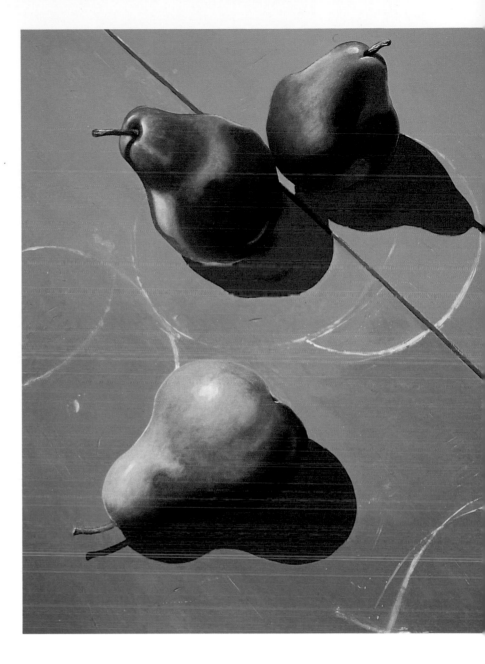

▲ **Pearanoia**
In this acrylic painting, EARL GRENVILLE KILLEEN *has used tonal modeling in a deliberately exaggerated way to create both a three-dimensional effect and a strong pattern of light and dark, reinforced by the white-paint circles on the table.*

Blue of table lighter in background than foreground, suggesting receding plane

Patch of reflected light separates fruit from cast shadow

Lower edge of pear shades into black of shadow

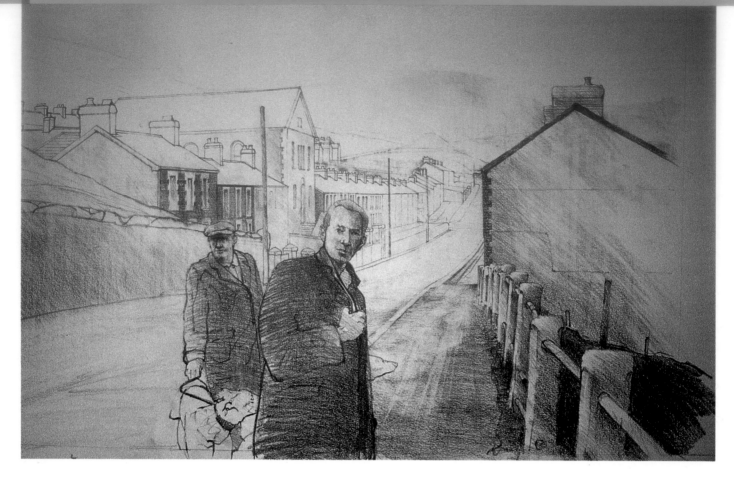

▲ Pencil Study

In this pencil drawing, made as a study for a painting, DAVID CARPANINI *was concerned with establishing the main shapes of the figures and their relationship to their surroundings.*

Shading in uniform tone used for flat plane of building

Careful pencil shading models forms and indicates direction of the light

Figures treated primarily as broad shapes, but with enough outline to explain forms

photograph is representing it. Has reduction to monochrome emphasized space and form, or has it flattened and merged them in places? Is there anything incongruous in the picture, such as a heavy, dark shadow with no apparent source? Cameras are selective in the sense that they record certain types of information relative to the amount of light available to reach the film. They do not choose the same things from a scene or situation that you might if you were drawing it. Yet a monochrome photo is "readable"; it has reduced the three-dimensional reality to a tonal pattern that remains recognizable.

Drawing and painting are additive as well as selective processes; every practiced artist is familiar with the sense of having overworked a piece, and knowing what to leave out, as well as what to put in, is part of the skill. If you start with only the most basic components of the subject, you can build gradually. Tone is one such basic element of image-making; it can be isolated from line and color, or you can use it as an underlying framework for the composition.

▼ Amazing Gracie

This pastel painting by DOUG DAWSON *relies almost entirely on tonal modeling to create the forms. But although there is no actual line, the boundary where the shadow of the hat meets the lighter color of the lower face provides a descriptive contour, as do the suspenders curving over the shoulders.*

Light colors shading gently into darker pinks and greenish-browns to convey roundness of cheeks

Dark, almost flat color for sharp plane of upper lip; curving pastel marks for highlights on rounded lower lip

A strong tonal plan can carry the organization of a picture and give it a solid sense of form and space. To see the fundamental pattern of shapes in your subject, simply half-close your eyes; this reduces the tonal range and sorts out the relative values. Make drawings in only three, four or five tones; this forces you to make continuous decisions about light, dark, and middle values so you can fit them to a restricted plan. If you see something that confuses form rather than clarifies it, such as an unusual cast shadow, you can simply leave it out.

Techniques of tonal rendering

Despite what you have learned in line and contour exercises, when it comes to working tonally, you need to abandon your impressions of outlined forms and avoid the temptation to begin by mapping in a linear way. Tonal gradations certainly do not have lines around them, any more than the whole shapes that they occupy have real outlines. The illusionistic "edge quality" created by a surface turning away is more realistically rendered by tonal contrasts. Work with whole blocks of tone, putting down the values as quickly and roughly as you like. Make distinct shapes, not necessarily hard-edged, but with a definite presence.

Occasionally it appears that part of an object, say, has much the same tone as its background, the same degree of illumination or shadow. In a drawing with a reduced tonal plan, the shapes will simply merge. As you come to handle tonal values in a more complex range, or to start work in color, you may find some subtle nuance in one or other component that "separates" them again on the paper. But as with outlines, the lost-and-found quality can help to imply three-dimensional form and space, as long as your decisions are made in an informed way.

To begin with, you may find it helpful to work strictly monochromatically. Again, it is often tempting to use pencil because you are not irrevocably committed to the marks you make; and pencil shading can produce very

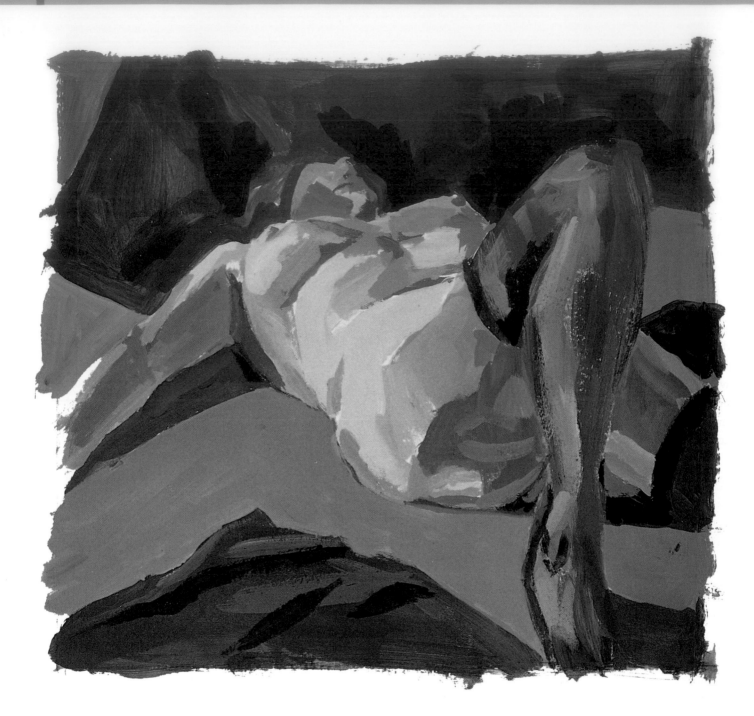

Lighter area of tone separates leg from torso and suggests relative flat plane of thigh

Dark shadow provides a contour curving around side of upper rib cage

▲ Life Study

It is often possible to simplify the forms of a body. In this oil sketch by MICHAEL WUJKIW *it is seen as a series of planes differentiated by distinct tonal boundaries. Brush strokes on the leg follow the direction of the forms.*

beautiful, subtle tonal values and textural qualities in a drawing. Similarly, you can work with charcoal or conté crayon, a pastel or a graphite stick. But try to work fluently and boldly; don't always rush to erase things that seem like mistakes. Trying to retrieve a drawing positively can be more instructive than simply getting rid of it.

Another thing to consider when you are working tonally is whether it is necessarily appropriate to use a method that builds from light to dark. Shading with a pencil point can be laborious and may even distract you from

really looking hard at your subject, by constantly pulling your eye back to the marks you are making on the paper. Try using a toned paper to establish a middle tone – it can be gray but you might prefer to use something more colorful. Then work on it with black and white crayons or pastels, making your tonal decisions to either side of the middle base. Or try working "white out of black"; cover a whole sheet of paper with charcoal and then use an eraser to bring back middle and light tones.

If you are using a pointed drawing tool on white or toned paper, you don't have to build tone with solid or gradated shading. You can use hatched and crosshatched lines, stippled dots, crosses, hooks, ticks, and other freely formed marks to provide graded black-and-white contrasts that "read" as grays. Dip pens, ballpoints, and markers can be used in this way. Because they are not easily corrected, these materials encourage you to

▼ **All But Over**

Strong contrasts of tone have been used to dramatic effect in this charcoal drawing by DAVID CARPANINI, *in which space is created by the lines of the road, rail fence, and wall sweeping in toward the horizon.*

Downhill sweep of road and slightly curving surface suggested by tonal variations

Uniform dark tone of house throws highlights on rail fence into relief

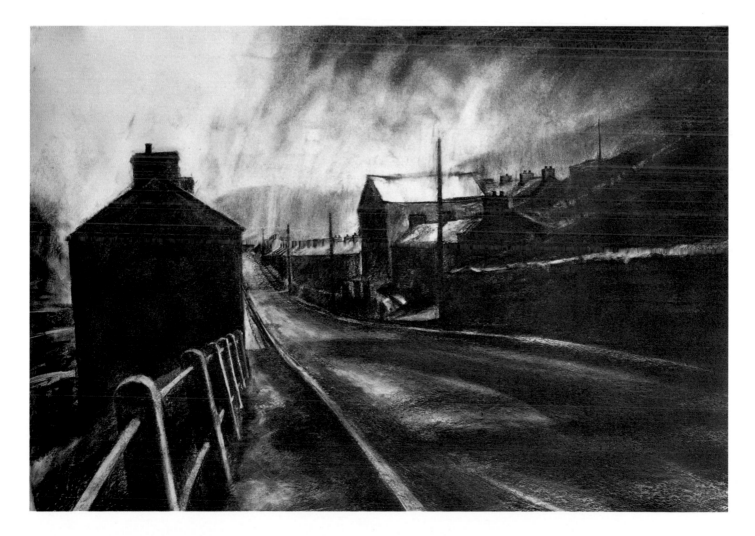

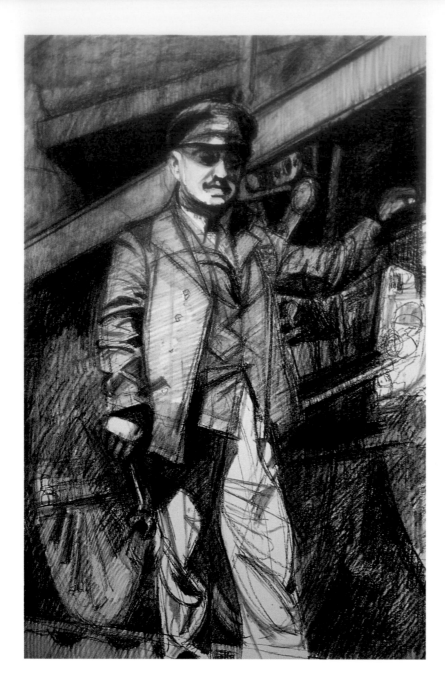

make bold, direct statements that can help to focus your observation.

Tonal renderings are often associated with drawing materials, but you can use paint in the same ways, either as a form of shaded brush drawing or to block in solid masses of tone. Try working with a large brush and a thick, manipulable paint such as acrylic or gouache, in black and white only, or black and white with one to three premixed grays. Use thinned washes or glazes of ink or watercolor to build up tonal patches from light to dark; or work in black paint and correct with white chalk. You can also introduce color as tone, in a limited way. For example, applying red as a middle tone, or using yellow, red, and blue to represent basic tonal values.

Developing your range

Once you have practiced and gained confidence in working to restricted tonal patterns, start to increase the variety of tone in your drawings by extending both your observation and technique. Use the more complex effects of light, such as reflected light and cast shadows, to increase the dynamic qualities of the image. Cast shadow is a naturally dramatic element – think of theatre and film lighting cast sideways or upward to give a mood to the narrative, or heavy spotlighting that isolates an individual subject. Reflected light is subtle; you may see glimmerings of pale tone on the shaded side of, for example, a curving bowl or the forearm of a human model, or on an isolated hillside in a darkly lit landscape.

Learn to use your materials freely, without waste but without inhibition. If you keep coming upon similar problems, try changing your method or your medium – work in paint rather than pencil, on large sheets of inexpensive paper rather than purpose-made drawing papers (try brown wrapping paper or newspaper as a middle-toned ground). Use the texture and weight of your materials to help you define the nature of form in your choice of subject.

▲ **Father the Driver**

In this powerful charcoal drawing, BRIAN DUNCE *combines tense linear qualities with solid areas of tone to provide an expressive portrait.*

Strong sidelighting and shape of cast shadow describe forms of face

Flat plane of jacket suggested with diagonal hatching; contour lines follow folds of sleeve

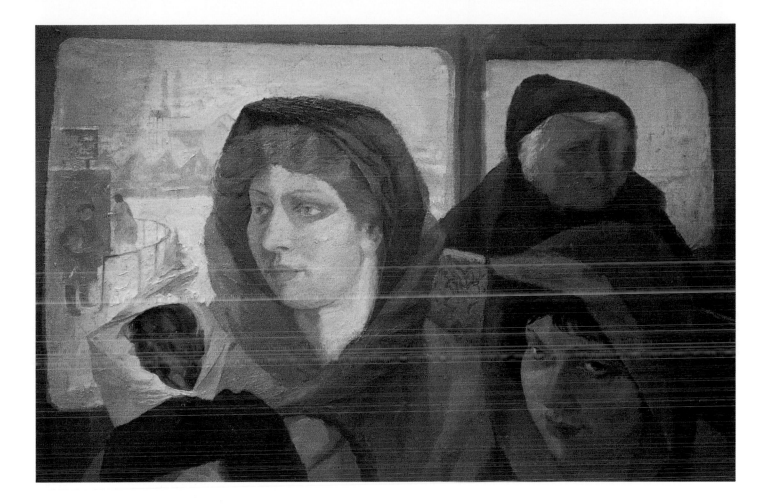

Tone and color

All paintings have a distinct tonality; sometimes this is the anchor of the composition, sometimes it is apparently more incidental to the color sensations. But don't feel you have to eliminate color from your drawings and studies until you have completely mastered tonal values. Introduce naturalistic colors in a limited range. Begin with key colors and basic shapes and ignore surface detail.

Apply thin layers of watercolor or acrylic paint, so you can model form easily with a sweep and turn of the brush, gradually building up layers of integrated tones and colors chosen from a restricted palette. Experiment with applying color over your tonal drawings; for example, using watercolors or inks to wash over pencil shading or ink lines, or soft pastels to put soft hues and color accents into charcoal drawing. Use simple exercises of this kind to start to look at relationships of tone and color.

▲ Women in a Bus

Tone has been used both to model the forms and as a compositional element in DUDLEY HOLLAND'S *striking painting, based on the interaction of light and dark shapes. The snow-clad landscape beyond the window emphasizes the space in which the figures are enclosed.*

Blending of tones light to dark models rounded forms; hood creates strong shape

Features of shadowed face lightly suggested with minimal tonal contrast

EXERCISES

Tone, volume, and mass

A form is modeled by the light that falls on it, creating dark areas of shadow, bright highlights, and a range of middle tones. This sounds simple, but when we are presented with colored objects, it can be difficult to assess relative tones – our eyes register colors immediately, but have to be trained to perceive tonal variations. The exercises here are designed to assist you in this basic learning process. If you find it hard to recognize tones, look at your subject with your eyes half closed; this cuts out detail, reducing the impact of colors.

▶ **From dark to light**

A useful way of identifying those highlight areas which play a vital role in modeling form is to work up from dark gray to white. Cover the paper with charcoal and rub it lightly to produce an all-over gray. Then make an outline drawing, again in charcoal, and start picking out the brightest highlights with a putty eraser. You can now work into the drawing to strengthen the tones in places.

Fine, precisely shaped highlights achieved by pulling eraser into a point

Further applications of charcoal have strengthened darker tones and defined forms

Clay model captures distribution of weight and angle of body

Pose and forms both well understood, as student has studied model from different angles

◀ **Working in three dimensions**

It is not possible to draw something convincingly unless you fully understand it. The great Edgar Degas, a supreme draftsman, would study and draw a figure from all angles before he felt he really knew it, and there is no better way to learn about form than making three-dimensional models. This clay model and the drawing were both made by the same student, and you can see how the hands-on experience has helped with the two-dimensional pencil rendering. Many ready-prepared modeling substances can now also be bought from art supply outlets.

▶ **Tone with line**

With pastel, charcoal, or conté crayon, the pressure can be varied to create lights and darks, and they can be smudged to create areas of soft tone. Describing form with a line medium such as pen and ink is a different matter, as you can only darken tones by laying a series of lines close together (called hatching) or crisscrossing over each other (cross-hatching).

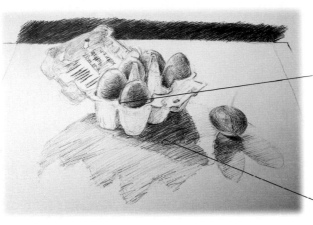

Curving hatching lines follow forms of eggs, closer together in dark areas

Straight hatching lines placed close together describe dark shadow on flat plane

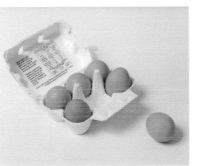

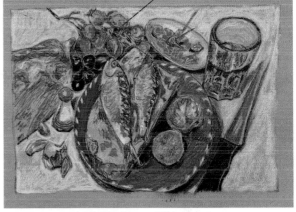

Color of paper stands as second to lightest tone

White of paper used as fourth tone for highlight areas

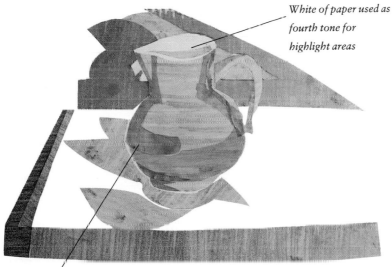

Mid-toned paper carefully cut and placed to provide contoured shadow

White conté crayon used for highlights; black crayon applied heavily for darkest tones

▲ **Using three tones**

This exercise, using tracing paper and different grades of pencils, will help you to establish how the form of an object is modeled by light and shade. Prepare three different tones by scribbling on pieces of tracing paper, using a soft pencil for the darkest tone, a hard one for the lightest, and so on. For clear highlights use the white of the paper as a fourth tone. Make an outline drawing as a guide, look for the darkest tone first, cut or tear a piece of paper to fit, and glue it on. Continue, working up to the lighter tones, until the object looks solid.

▲ **Using five tones**

In most subjects which contain several different elements, such as a landscape or this still life, there may be at least ten different tones, but it is possible to create an accurate rendering with as few as five. Either use paints, premixed into one dark, one light and two middle-tones, or draw with pastels, as here. The artist has used black, white, and gray, with mixtures producing a second dark tone and the color of the paper providing a further light one.

Light and space

Light greatly affects how interior or exterior space is perceived. A landscape may look more extensive under a gray sky than on a sunny day, when shadows break up the land, and a room's proportions appear to change according to the light. In the evening it will look more enclosed than in the daytime, when open curtains provide an extra dimension of outdoor space.

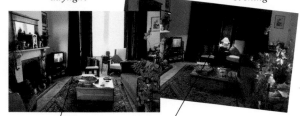

daylight *evening*

Strong tonal contrasts and predominance of whites give light, airy feel

Tonal contrasts diminished and colors warmer, creating cozier atmosphere

Materials and technique

Graphite sticks or pencils

●

Watercolors

●

Bristle and soft brushes

●

Sketch & watercolor paper

●

In the drawings, areas of solid tone have been built up with a soft graphite stick, while watercolor is used for the painting, with small touches of pastel. The artist works standing, holding the board vertically, and using bristle brushes.

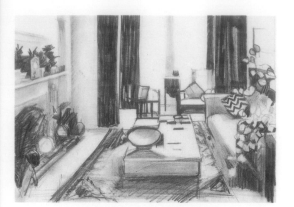

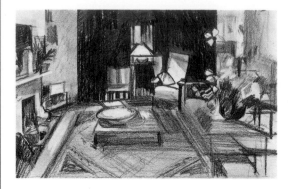

◄ Before painting, the artist makes two tonal drawings to explore the effect first of natural daylight and then artificial light. She finds that the latter has more compositional potential, with the table lamp providing a focal point and the dark curtains enclosing and defining the room.

1 *Rather than applying the conventional flat washes of watercolor, the artist uses long-handled bristle brushes to make sweeping vertical and horizontal strokes.*

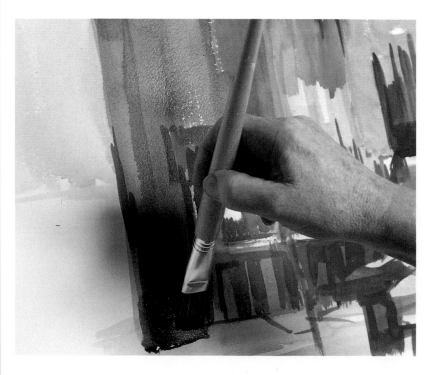

2 With the first colors used for the curtains now dry, she begins to darken selected areas to suggest the folds in the heavy fabric. The square-ended brush is held on its side to take the wet paint around the edges of the chair.

3 The television is a potential problem. A blank screen would give a dark, ugly shape, while too much detail could detract from the picture's focal point. The artist decides to treat it simply in terms of color, giving a broad suggestion of the moving image.

4 The foreground flowers are again treated broadly in keeping with the overall effect. Touches of pastel together with watercolor, now applied with a soft brush, begin to define the leaves and shapes between them.

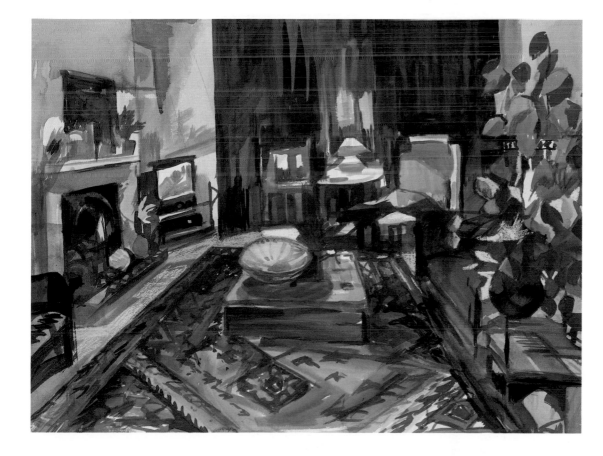

◄ **Lamplit Interior**
Although there is the minimum of detail in PIP CARPENTER'S watercolor, it successfully conveys both the impression of interior space and the individual character of the room. The colors are carefully controlled, and the strong brushwork adds a lively quality to the composition.

PROJECT 4

Distance and light

Distance reduces detail, allowing you to see the overall shapes and forms more clearly than in close-up, where the wealth of detail is often confusing. Changes in light also help you to understand structures and forms.

Working drawing made from on-the-spot sketches and photographic reference

Close crosshatching lines in pen and ink on shadowed sides of buildings

Paper left white in sun-struck areas

Looser, more varied crosshatching describes forms of trees

Materials and technique

Gouache paint

●

Sable brushes

●

Smooth watercolor paper, stretched

●

It can be a rewarding exercise to use a drawing in one medium as a basis for a drawing or painting in another, and here brush and wash, with well-thinned gouache paint, has allowed the artist to build up the forms more rapidly than the pen and ink medium.

1 Neither watercolor nor gouache can be altered to any great extent, so the artist has begun with a pencil drawing to make sure that the first washes of water-diluted paint are placed correctly.

2 Brush drawing is a very direct method and allows broad shapes and areas of tone to be blocked in rapidly. Here the middle tones have been established, and the paper left bare in the highlight areas.

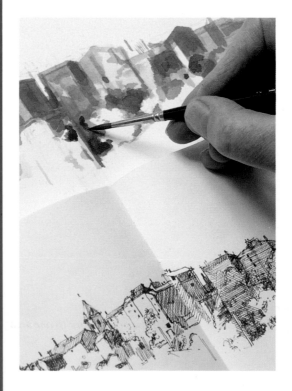

3 With the pen and ink sketch placed on the paper for ease of reference, the artist begins to work into the first washes with darker paint. The trees and buildings are beginning to acquire form and solidity.

4 *Paintbrushes are not usually thought of as drawing implements, but in fact they can yield sensitive and varied lines as well as achieving fine detail. Here broken lines and small rounded dots are made with a fine sable brush.*

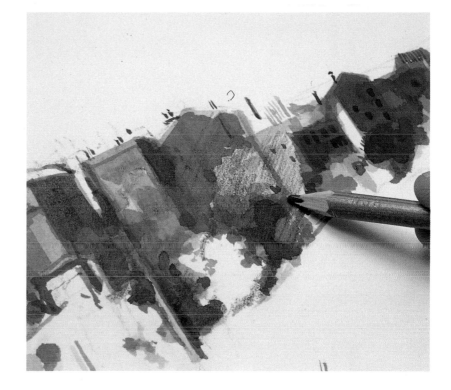

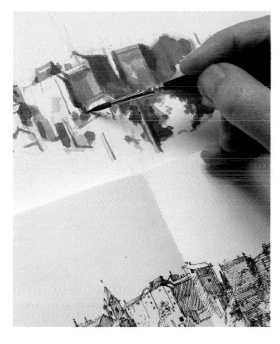

5 *In order to give more prominence to the foreground tree and thus increase the three-dimensional feel, the artist has decided to "knock back" the other tree and now lightly hatches over this area with a soft pencil.*

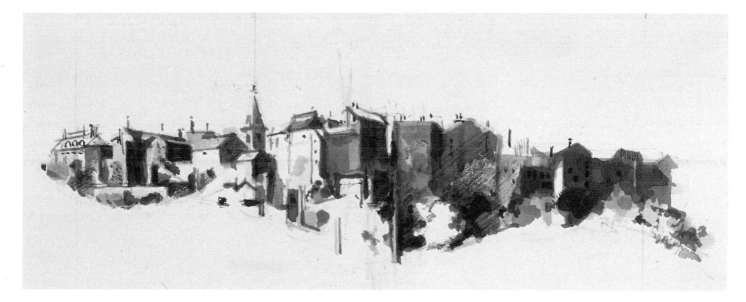

▲ **Italian Hilltop Town**

In the final stages BRIAN DUNCE used the pencil again to strengthen certain areas of shadow. In any work in which two media are used – in this case, pencil, and gouache – it is important that they work together; restricting the pencil work to one area could have drawn too much attention to it, thus creating a disjointed effect.

Color & form

Color is one element that artists use to construct form, and in painting it has a variety of functions. It can be descriptive, associative, and symbolic, invariably expressive, and indicates time and mood. Choice of colors can affect both the emotional context of an image and its formal, purely visual impact. You can use color to help you convey weight, mass, space, depth, and atmosphere, and to do these things you must also consider the texture and handling properties of your medium. When you work in color you are juggling a complicated set of painterly considerations.

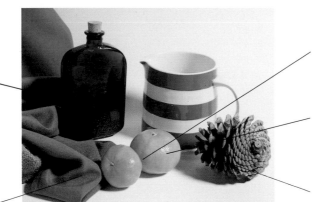

Light shining through bottle throws brilliant patch of color on drapery

Gradations of tone, from medium blue to very dark, describe softly rounded fold

Middle-toned red shadow, darker than lit side of fruit; lighter than any part of bottle

Highlight almost pure white, but broken up by texture of fruit

Very dark shadows where segments slope in sharply away from light

The elements: What to look for

Identify the local – that is, actual – color of each object first and then see how this is affected by the fall of light. Try to work out how much tonal variation there is between shadow and highlight areas, and avoid making shadows too dark or your rendering will lack sparkle. Look for any reflected colors in cast shadow; for example, the oranges here throw a distinctly red shadow, while that beneath the pine cone is greenish-brown, shading almost to mauve.

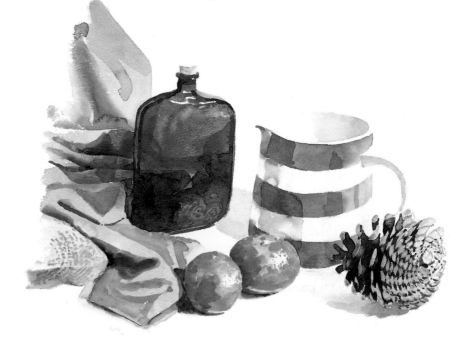

The properties of color are defined in three ways: hue, the type of color, such as red, blue or yellow; tone, the lightness or darkness of a color; and intensity, which refers to the brightness and strength of a hue. The variety of colors in your palette and the mixtures you can make with them provide the means to form a variety of harmonies and contrasts. You can employ similar or opposite hues and tones; contrast intense, pure hues with subtle, muted colors; or play off warm colors (red, orange, yellow) against cool ones (green, blue, violet).

It is important to be aware of the visual sensations and effects of color relationships, but you can discover these gradually in practice; though if you want to find out more about the general principles and background of color theory, it is extensively described in a number of specialized publications.

Aspects of color

When you study a subject in order to paint it, you are seeing various levels of color information. One is the colors of the physical materials of which objects are made; the true color of a thing is known as its local color. Another is the action of light modifying colors through tonal modeling of forms; this can greatly alter the impression of local color over part or all of a form. There is also the impression of mood created by color and light, dependent on the strength and color bias of the light source as well as the local colors of objects and their surroundings.

All these things are reflected in surface qualities that you can identify and represent with paint. If you have acquired a confident sense of shape and volume through your work with line and tone, you can move on easily to extending the color values in your work. Approach it in the same way as the tonal exercises, initially by simplifying the overall plan – again half-close your eyes as you look at your subject, to knock out distracting incidental colors and shadings.

It is a good discipline to try mixing all the colors you need from a very basic palette.

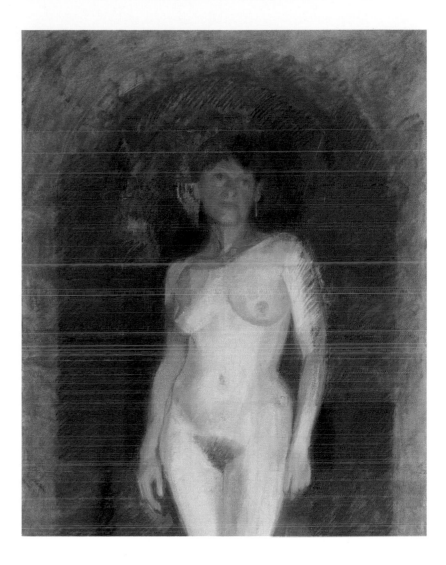

▲ ▼
Color has been used in an inventive and unusual way in this pastel study. While conventional flesh colors have been used for the torso, there is a dramatic change from the neck up. BRIAN DUNCE has exaggerated a natural effect of light; the model was standing in a red-painted arch, with parts of the body reflecting the background color.

Meeting of dark and light tones helps to describe angle of arm and shoulder

Cool blue shadows model receding plane of upper chest

Touches of red reflected from background give warmth to the shadows

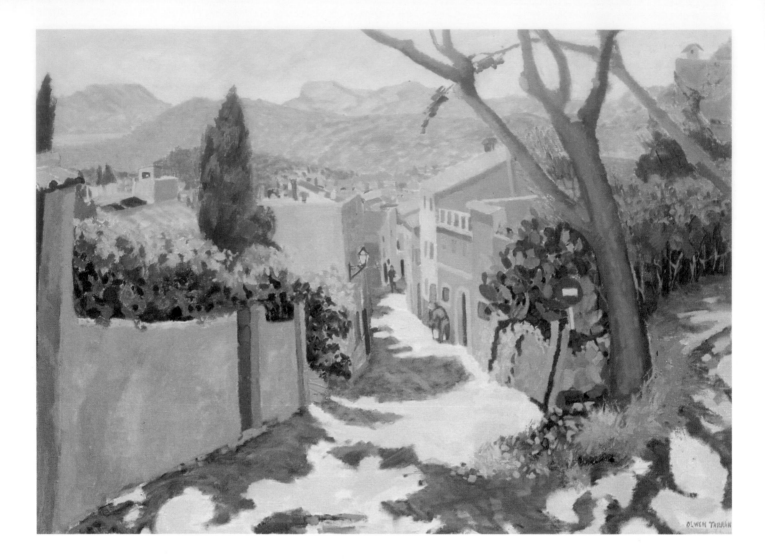

*Tall tree makes link
with middleground and
far distance; dark color
accentuates paleness of
hills*

*Perspective lines of wall
lead eye into picture
and describe downward
slope of path*

*Colors become paler in
the distance, with
contrasts of tone much
smaller than in
foreground*

▲ En la Colina

OLWEN TARRANT *has
created a sense of
space in a number of
ways in this lovely oil
painting, the most
striking being the use
of yellow and mauve
for the patches of sun
and shadow on the
path. Complementary
colors (see page 44)
create exciting
contrasts drawing
the eye to the
foreground and into
the distance.*

This way, you get to know a progressive scale of color relationships, and you can select and control colors more effectively as you open up your palette. Working with, say, eight colors can be like trying to control eight monochrome drawings at once, attempting to balance and adapt each color to the particular value you have identified for it. If you can become confident about achieving a well-orchestrated image using only a few selected hues, your ability to exploit a broader palette will be all the more effective.

Color in form and space

Look at broad areas of local color, and the basic pattern of tones. Then break down these basic shapes into subtler nuances of tonal shading and color variations. You will find that you can model form and space quite expressively with a limited set of color

values. Reflected color, like reflected light, appears in unexpected places, such as a flash of bright color on the shaded underside of a form; you might see this on the curve of an apple or orange sitting on a colored plate, or in the flesh tones of a figure or portrait study, where colors reflect onto the skin from clothing or draperies.

Contrasts of strong colors and subtle shades contribute a sense of space. Atmospheric perspective, the "blueing" and paling of colors over distance, is often used in landscape painting to suggest far horizons, but the simple principle of colors appearing less intense and highly contrasted as they get farther away can be used in pictures with less extensive pictorial spaces.

Oppositions between warm and cool colors can be as effective as tonal contrasts in developing form against background, or internal modeling of forms and structures. Once you begin exploring color, it is wise to get away from direct tonal analysis and

Dark color throws figure into prominence; washes applied slightly unevenly to create interest in this area

Flat gray wash used for shadowed side of body, but form suggested by crisp definition of folds

Dark washes applied over lighter ones to suggest play of light and shade

▼ **Early Morning**
Watercolor is a fluid and expressive medium, ideal for conveying the effects of light, the main theme of this lovely painting by PETER KELLY. *The clear, sparkling highlights that model the form of the face and body have been created by the classic method of reserving white paper, that is, painting washes around the areas to remain white.*

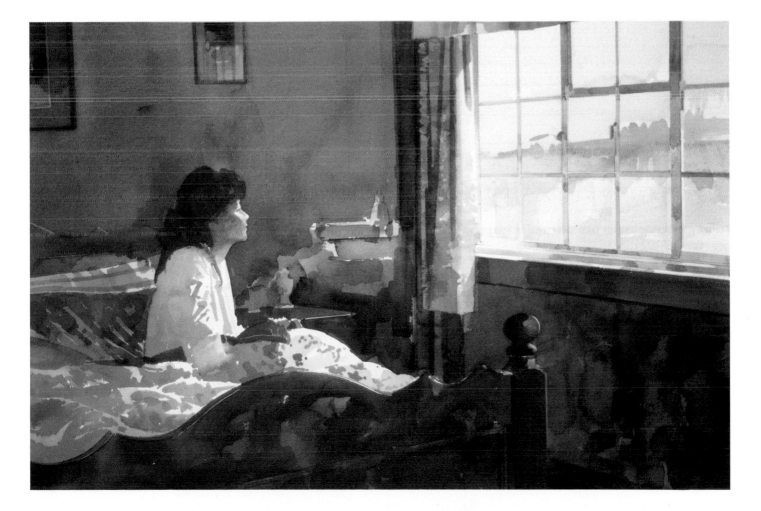

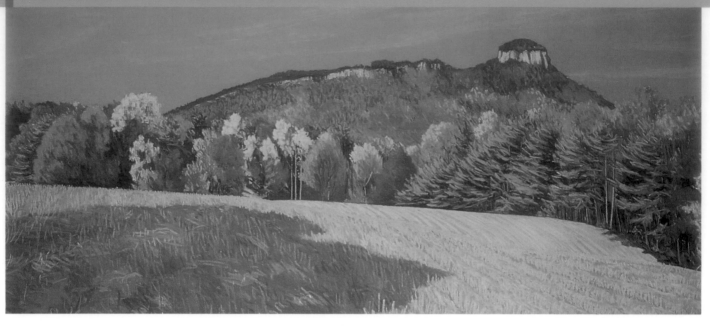

Strong contrasts of tone take eye from bright trees to rocky crag, thus leading around the picture

Lines curving over undulations describe forms of land and lead eye to middle distance

Diagonals lead eye to dark tree on left, which forms a "block"

Linear pastel marks suggest grasses; size of strokes varied

Patch of vivid shrub creates triangular shape, pointing in toward middle distance

From the tree, the eye is led toward white building that echoes mountain crag

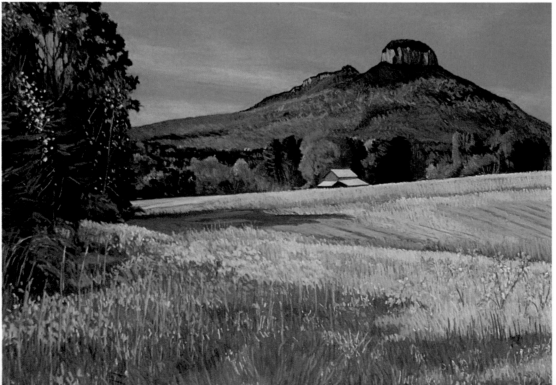

Pilot Mountain

In both of these pastel paintings – different views of the same subject painted in different lighting conditions – ELSIE DINSMORE POPKIN *has used the lines of the fields in foreground and middleground to lead the eye toward the distant trees and mountain. In the top picture, the fall colors of the trees claim our attention, while to the left the bold shape of the hill swelling up to the dramatic crag dominates the composition.*

experiment with color variations that suggest form. Brilliant light falling on the side of a house or face in strong sunshine may be intensely colorful, and even the heaviest shadows are not a uniform black.

Look at the way other artists have tackled similar subjects; specifically, how they have responded to the colors and light and how the form and depth are enhanced by the color relationships.

Using your medium

The actual use and control of pigments – the coloring agents in paint – are affected by the binding material used. This gives the medium particular handling properties that are part of your repertoire for creating form.

Watercolor is a very pure, transparent paint, made with a fluid gum binder that preserves the clarity of the colors wet and dry. It is most expressive when applied in thin washes, adjusting the strength of tones and colors gradually and delicately. The brightness of a white support showing through exploits the translucency of colors; if you use a toned or colored paper, this will modify the paint colors that you apply.

Watercolor has great immediacy as a sketching medium and for finished works, capable of capturing the slightest color changes and a great sense of atmosphere and luminosity. By controlling the direction and pressure of the brush, you can give individual strokes and basic shapes an evocative sense of form, and build up the complexity by overlaying layers of color as the washes dry. Because it is so accurate and responsive, watercolor is still often used for recording natural forms in scientific and botanical illustration, in preference to photography; but it can also be used in a very free, broadly descriptive manner on a large or small scale.

Gouache is opaque watercolor; the pigments are coarsely ground, and white pigment is added to all colors, which makes them dry, clean and flat, but with a slightly chalky bloom. Gouache is best used thickly, rather than washed in like watercolor. It dries quickly and the surface is robust; you

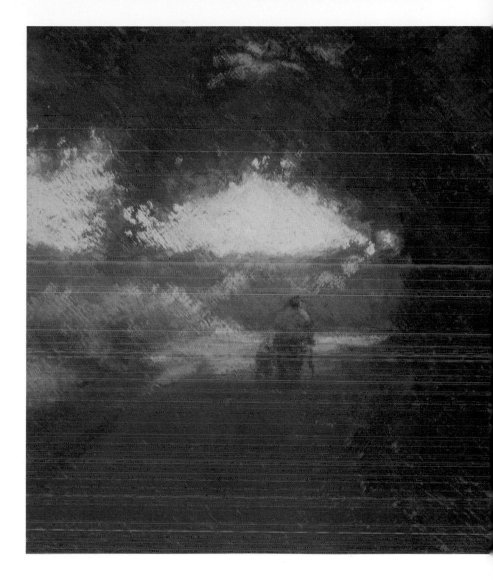

Curve of path and area of almost flat color leads eye toward figures and patch of sunlight

Dark trees merging into path at bottom create a frame within a frame, leading eye to focal point

Our eye follows walking figures into landscape toward trees and hills

▲ **Evening Hike**
Here pastel is used thickly, with one color laid over another to produce a highly painterly effect. Although there is a strong feeling of depth, DOUG DAWSON has used vivid and relatively warm colors in the background. As the strongest concentration of color is in the middle, the background is pushed back.

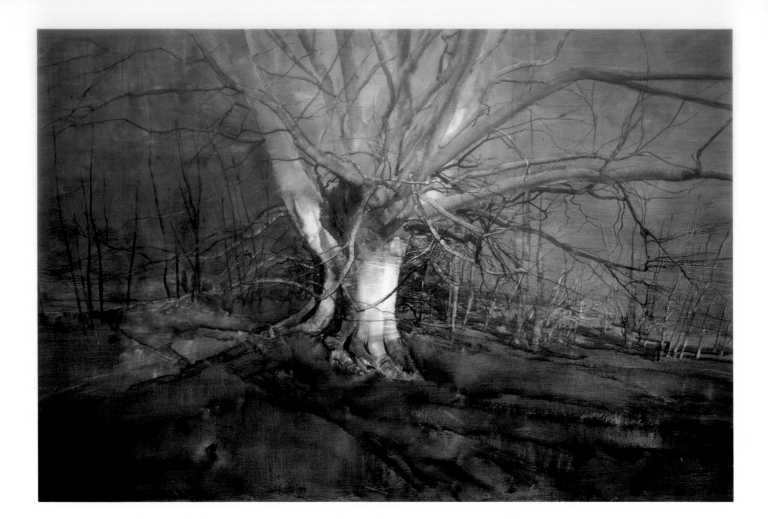

can rework color areas continuously, flatly or with vigorous techniques such as dry-brushing or impasto, to develop modeling, surface texture, and reflected color.

Pastels are the most direct of color media. Soft pastels are pure pigment, and the colors can be very brilliant and emphatic; but pastel sticks are dry and crumbly, and you may have difficulty gaining control of the medium. Use a toothed paper that grips the fragile pigment particles; pastel papers range from pure white through a widely varied selection of muted or strong color tints. Oil pastels are a more malleable medium; the oil binder keeps the colors moist on the paper, and you can blend and scrape them, build up impasto marks, or brush them out thinly with a spirit diluent. It is an advantage that when you use pastels you cannot premix colors; you are forced to handle a limited color range and make confident decisions about color values and relationships.

▲ **Beech Tree**

JAMES MORRISON *has an unusual oil-painting technique. Although oil is an opaque medium capable of thick impasto effects, it can also be diluted and used thinly, as it has been here, in a series of washes over a smooth board surface. This method gives a delicacy and luminosity of color reminiscent of watercolor.*

Detail suggested with brush lines, but tonal contrasts kept to a minimum to focus attention on central tree

Paint so thin in places that white of board shows through; darker lines suggest shadows and undulations

Linear effect of contour lines produced with light touches of a splayed bristle brush

Binders for acrylic paints are synthetic resins; the colors dry very quickly and do not fade or change, but you have limited scope for blending and mixing on the support. Dried acrylic is plastic and flexible but completely insoluble; you cannot scrape back acrylic paint once it has begun to dry. Acrylic techniques typically depend on layering the surface. You can use them very thinly, diluted with water and acrylic medium into glossy, translucent glazes, or apply them direct from the tube in thick strokes, or mixed with gel to form a heavy impasto.

Oil paint is more forgiving than the water-based paints. You can handle it roughly, unlike watercolor, which can suddenly "die" and look overworked. The buttery, slow-drying consistency of oil-based paints gives you plenty of time to blend, lift, scrape, and rework on the surface. Diluted with spirit and/or oil, the paint forms thin, transparent glazes; applied direct from the tube with a brush or palette knife, it retains weight and texture on the support.

There is plenty of room for experiment; you can also try markers, water-soluble colored pencils and crayons, or large, juicy oil sticks, and explore resist techniques, combining waxy and oily materials with water-based media or dry pastels with wet paint. The shape of the brush you choose can be influential in capturing form – try using a crisp, flat-tipped bristle brush or a smooth roundhair sable.

While there are standard working methods for each medium, it is important to develop a personal vocabulary of techniques. Look at the characteristics of your subject and match them to the qualities of your tools and materials – smooth or textured surface finishes; hard edges and soft, dissolving planes; curved forms and flattened or angular shapes; bright colors and tones against muted colors and deep shadows. You can combine many techniques within a single painting, or concentrate on integrating the shapes, volumes, and textures.

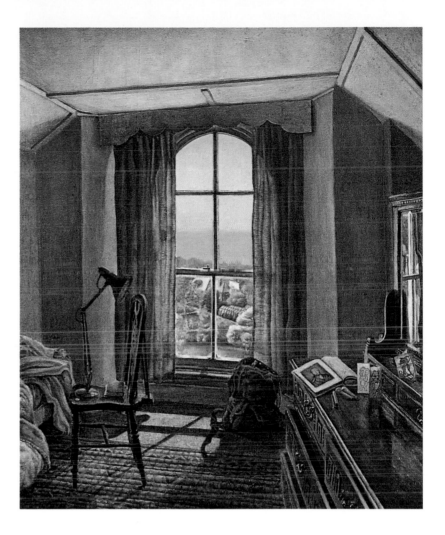

Warm colors of curtains and walls separate interior from landscape

Stippling technique with point of brush suggests surface texture

Brushstrokes of thinned paint following direction of plane describe flat, polished surface

▲ **Room 15, Kathmor House**

Oil paint is extraordinarily versatile, suitable both for broad, impressionistic effects and for the kind of fine detail seen in this painting. PAUL BARTLETT *has employed the common device of a view through a window to help define and emphasize the interior space and has also made use of warm/cool color contrasts.*

EXERCISES

Color and form

Form and depth can be conveyed in drawing by line, tone, or both, while in most paintings, three-dimensional effects are obtained by color and tonal modeling. But controlling tones is not always simply placing a dark color next to a light one; colors have properties of their own which can help you create the spatial illusions which are the essence of realistic painting. Some are "warm" and inclined to advance to the front of the picture, while others are "cool" and tend to recede. The exercises here will help you understand how color can be used in the context of form and recession.

▶ Complementary colors

These three pairs of colors – red and green, yellow and mauve, orange and blue – are opposite one another on a color wheel, with one color in each pair being warm and the other cool. Since cool colors recede, it is possible to build up forms with little tonal modeling, using the cool color for the shadows and the warm one for the highlights; here the artist has used the mauve/yellow pair for the face. See if you can obtain a similar effect in shades of red with green shadows.

▶ Local color

The local color of an object is its actual color: grass is green. You cannot convey local color – nor can you describe the form – unless you recognize how little of this color is actually visible. A good example is a white object. Because everything is affected by the light that falls on it, you will only see pure white in tiny areas, if at all, and the same is true of any other color. Try painting an orange first in its local color, which makes it appear quite flat, and then in the colors you actually see.

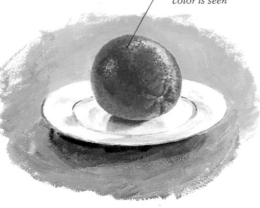

Painted entirely in its local color, orange is flat and formless

Because of the fall of light, less of the local color is seen

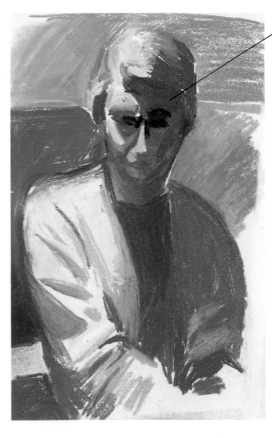

Mauve shadow contrasts with yellow highlight area, making shadowed side of face recede

▶ Neutralizing with complementaries

Complementary colors can set up exciting contrasts, but they can also be mixed together to form a neutral color that has a bias toward one or the other depending on the proportions used. These mixtures are ideal for making the darker-toned shadows on a brightly colored object such as this red pepper, rendered in acrylic in only two colors. Try this for yourself, using a yellow, red, or orange object, and neutralizing with mauve, green, or blue respectively.

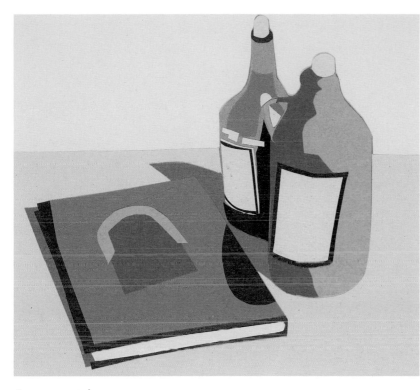

*Forms suggested
through shapes and
tonal relationships*

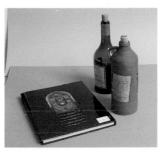

◀ Color equivalents

*It is seldom possible to reproduce faithfully every
color you see, as you are limited by pigment
applied to a two-dimensional surface. The artist
thus looks for equivalents – colors that will
convey the impression of a subject without
necessarily matching it in every detail. Work with
a selection of precolored papers, as shown here.
Because you cannot mix colors, you will need to
find ways of "translating" the subject while still
creating the illusion of three dimensions. If you
give thought to the tonal relationships and
balance of warm and cool, bright and muted
colors, you can create a surprisingly realistic
impression.*

*Red mixed with green
to make neutral shadow*

*Shape of highlights vital
in describing form*

▶ Tone and color

*To increase the
feeling of space in a
landscape, try
introducing a "frame
within a frame" to
establish the picture
plane – the
theoretical beginning
of the picture from
which the landscape
stretches away. This
could be tall trees
going out of the
picture at the top, or
you could work from
the inside of a room,
using the window
bars, as in this
painting. The white
grid suggests
the interior.*

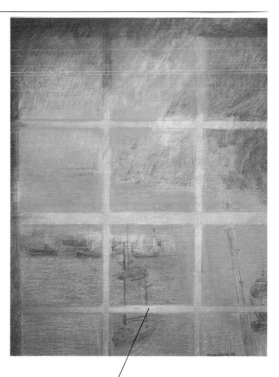

*White grid establishes
picture plane and
pushes landscape
back in space*

PROJECT 5

Lighting and background

In a floral still life painting, it is important to arrange the lighting so that it shows up the forms and colors of the flowers. Here the light, coming from above and to one side, creates shadows and highlights that define the rose petals very well. The background has been chosen for harmony rather than contrast.

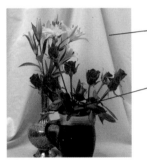

Shadows in folds give added depth

Strong tones and colors position this vase of flowers in foreground

Materials and technique

Heavy watercolor paper
●
Acrylic paints
●
Acrylic medium and water
●
Bristle brush, Chinese brush
●

The medium is acrylic, which is highly versatile and adaptable to numerous painting methods. The artist has begun with a mono-chrome underpainting, enabling her to build up the shapes and forms in tone before putting on transparent glazes of color.

1 *Acrylic diluted with water to the consistency of watercolor has been used to make a light brush drawing, and the paint is now used slightly more thickly for this area of darker tone.*

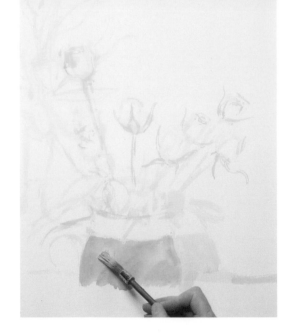

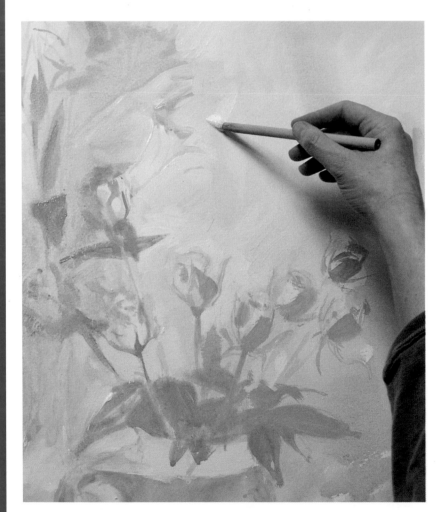

2 *Acrylic can be laid in thin transparent washes, or used undiluted straight from the tube. If the consistency is to be varied in the painting, it is best to reserve the more solid applications for highlights, as the contrast between thick and thin paint helps to describe the forms. Here juicy white paint is applied with a Chinese brush.*

3 The tonal underpainting is now complete and is left to dry before the next stages. Glazing techniques rely on the effect of one color showing through another, so it is important to make the right choice of color for the underpainting. This warm yellow-brown provides a foundation for the yellows and reds to be laid on top.

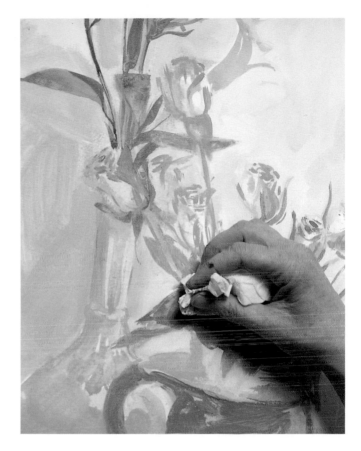

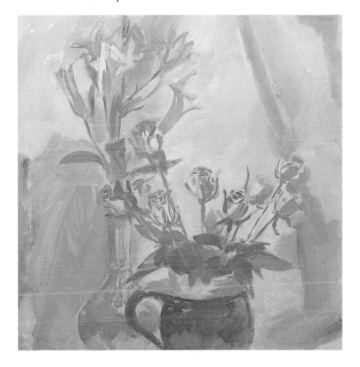

4 For the leaves, the artist uses dark green paint thinned with a mixture of water and acrylic medium, which makes the paint more transparent. For a soft effect, she dabs into the wet color with a rag so that it only partially covers the underpainting.

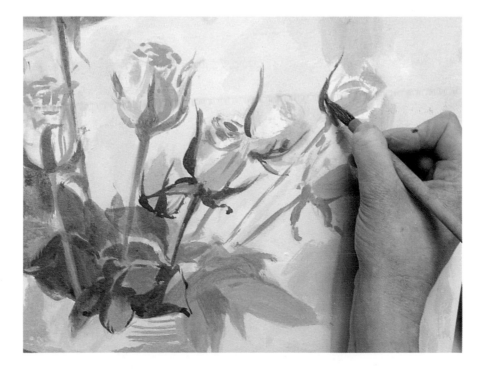

5 The process of building up the colors is methodical, with the darker tones of the leaves established first to help the artist assess the strength of color needed for the roses. These small leaves, which are also important in defining the forms of the flower heads, are painted carefully with a Chinese brush.

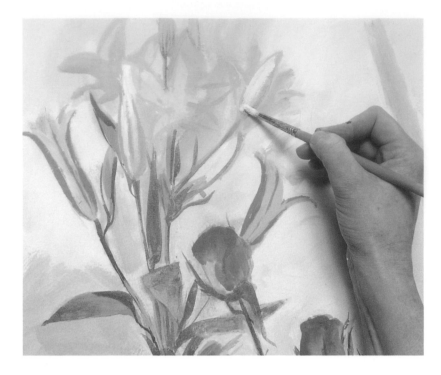

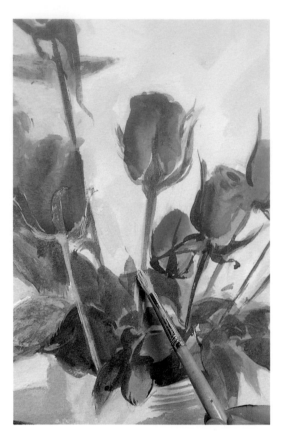

6 *Watercolor-like washes have been laid over the underpainting on the red flower heads, and highlights are again built up with thicker paint. The bristle brush follows the direction of the form, and the more solid application of paint provides a hint of texture.*

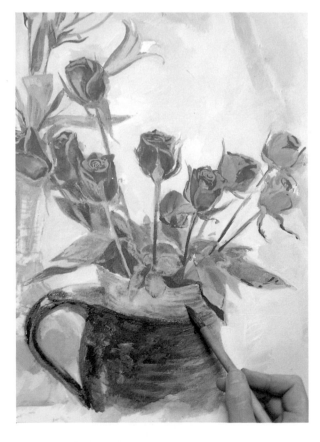

7 *White, or colors containing a high proportion of white, are always opaque, so must be handled with care in transparent techniques. White mixed with a little blue is applied very lightly over the dark greens and golden yellows; notice how these gentle highlights on the left-hand leaf define the structure.*

8 *Because she wants an overall effect of lightness and bright but delicate color, the artist avoids heavy tonal modeling on the pitcher. Instead, she builds up the form by using contour lines – the ridges created by the potter's hands.*

9 It might have been tempting to deal with the metal vase in detail, making much of its intricate pattern and vivid highlights, but this could have destroyed the sense of space. It is thus treated more lightly and sketchily than the pitcher, which makes a solid presence in the foreground.

▼ Roses and Lilies

The effect of the glazing method, which is particularly well suited to floral and other delicate subjects, can be seen clearly on the roses and leaves, where ROSALIND CUTHBERT has left the original underpainting still visible in places.

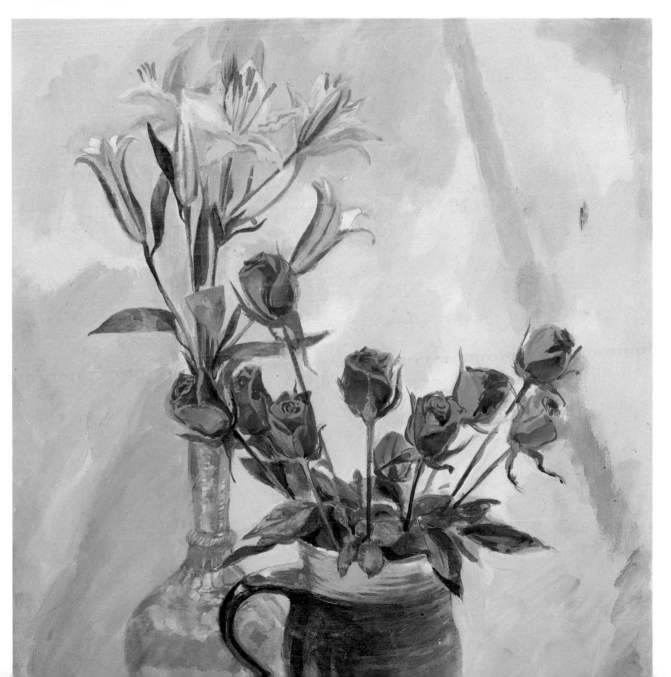

PROJECT 6

Light and form

A bright midday sun produces very distinct light and dark areas on clouds, with the tops often appearing white and the undersides deep blue or purple-gray. The more subdued light of dusk creates a semisilhouette effect, reducing the tonal modeling and allowing the drama of the shapes to emerge.

Clouds merging into solid mass near horizon

Enough light from above to produce slight tonal modeling

Fence in front of sky establishes foreground plane

Materials and technique

Oil bars

●

Stretched and primed canvas

●

The aim is a bold effect, and oil bars, which are well suited to such an approach, are used. A relatively new invention, they are oil paint in solid form, somewhat similar to oil pastels in handling properties. Colors can be moved around on the working surface, and any errors removed with mineral spirits.

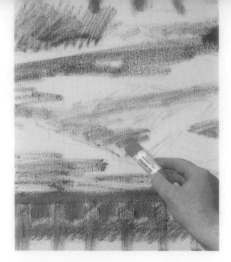

1 *As with oil paints, one color can be laid over another, but this may sacrifice their purity, so the bright and middle-value colors are initially established as separate areas.*

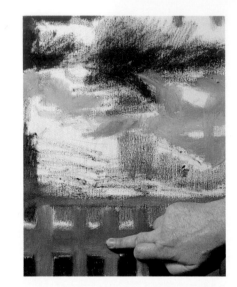

2 *Having begun to build up the dark colors and shapes of the clouds at the top, the artist now has a key against which to judge the strength of tone needed for the fence. To produce flat color, he blends the oil bar with his fingers.*

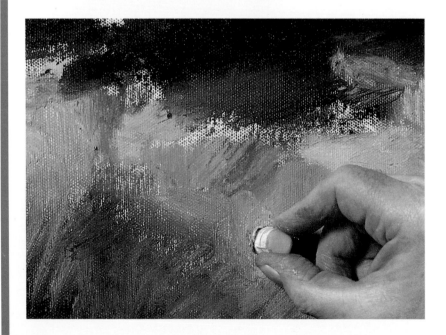

3 *A major difference between oil paints and oil bars is that the latter cannot be premixed on a palette, so color mixing must take place on the picture surface, as with pastels. Here, a transparent bar made for the purpose is used to blend one color into another.*

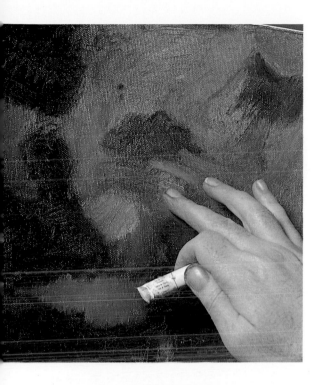

4 *Light blue is laid over darker color and gently rubbed with a finger. Notice that the artist has varied both the directions of the marks and the thickness of the paint in this area of clear blue sky, giving a feeling of movement and energy which echoes the progress of the clouds across the sky.*

5 *At this stage the sky was stronger and more defined than the fence, which thus receded instead of advancing to the front of the picture. The forms are now built up more positively, with suggestions of highlight and darker shadows below the horizontal bar imparting strength and solidity.*

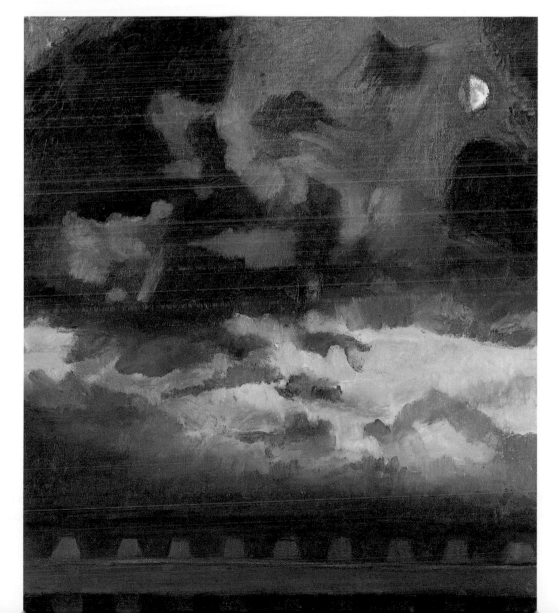

◀ **Clouds at Sunset**
Paintings based on a fleeting moment or transitory effect of light can seldom be completed direct from the subject, so BRIAN DUNCE *has worked from the photograph opposite in conjunction with quick sketches, observation, and memory. By deliberately increasing the tonal contrasts he has produced a powerful composition which combines semi-abstract qualities with a feeling of space.*

Form & surface

Form usually gives clues to its character by the way that light falling on it models the surface, by colors and patterns traveling over the form, and by surface textures. Seashells, fruit, and vegetables may have repeated structures which are displayed at the outer layers. Transient conditions such as cloud shadows moving slowly across the landscape, a receding tide leaving wet pebbles and ripples in sand, or even the cracking on a rock face can indicate, however briefly, the nature of the land.

Dark shape where fabric is seen through glass helps to stress semi-transparency of bottle

On reflective surfaces such as glass, highlights are crisp and often pure white in spite of the underlying color

Sharp tonal contrasts on smoother surface of background fabric

Highlight broken into small points of white by lightly pitted surface

Very small gradations of tone indicate undulations in matte-surfaced fabric

The elements: What to look for

Shadows and highlights play a major role in describing the surface qualities of objects, so it is important to pay attention to lighting – direct frontal illumination should be avoided, as this casts shadows only behind the objects. Try to identify the way in which highlights are affected by the surface; on the oranges they are broken into individual dots, while on the glass bottle the white line is clear and incisive.

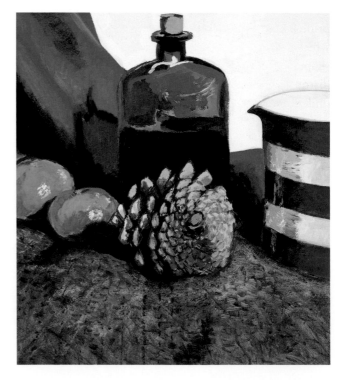

To a certain extent, it is possible to find similar structural patterns occurring at very different scales. The contour and texture of flint can demonstrate the form of an area of landscape, a rock pool, or a section of coastline. When these characteristics are recognized, it means it is possible to use close observation of relatively small objects to help you to understand forms that cannot be handled or observed so intimately, such as cloud formations and forests. There is a geometry to the structure of flowers, trees, fruit, and most natural objects that, when you can decode the surface pattern, gives an insight into the underlying form.

Surface and structural patterns

The surface of a subject will reveal its underlying form and structure if the surface material is soft; such as skin, which reveals the forms of skeleton and muscle at points of articulation or stress on the body and face. Fabrics act similarly, as with clothing draped over figures or coverings on furniture that are modeled to underlying shapes. The surface texture or pattern of the fabric can help you to identify basic shapes and volumes. Shiny fabrics reflect light brilliantly on curves and folds; woven textures and printed patterns consist of repeated units which, because you know the unit's size and shape, show how the fabric is molded or disrupted by the changing levels of the form underneath it.

As with contour drawing, you can pick up surface details that help to indicate how the overall form is shaped: a necklace running around the neck and across the chest; a wristwatch or belt circling the form, the strap of a shoulder bag. Similar elements occur in objects as well as figures; the painted pattern on a china bowl wrapping around the form; wood grain lines on a tabletop turning around edges and corners; or writing and livery on ships and aircraft.

In some forms, the pattern of construction is the essence of the thing itself. Girders and latticework on bridges, for example,

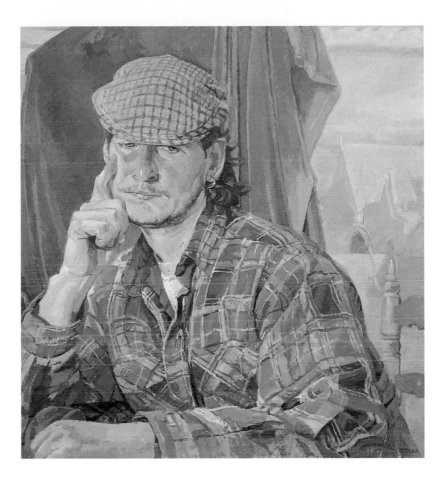

▲ Portrait of a Young Man

In a portrait, the sitter's clothing can play an important part in reinforcing the likeness by providing clues about personality and lifestyle, as it does in this oil painting. The patterns have also helped DAPHNE TODD to describe the forms and given her an opportunity to exploit differences of surface texture.

Paint dragged lightly over surface, creating slightly broken lines that suggest coarse texture

Crisply defined areas of tone and color define ridge of nose

Small downward brushstrokes used for facial hair, following direction of forms of chin and upper lip

Texture still present but less obvious, flattening out distant planes and suggesting recession

Textures and forms of rocks built up by complex layering techniques and ridges of impasto (thick paint)

▲ Rocks and the Bay

The contrast between different surfaces is often a theme in still lifes, but in a landscape too much of this contrast can destroy the unity. In this acrylic and mixed-media painting, JILL CONFAVREUX has dwelt on the theme of rough texture throughout.

show the volume, weight, and depth of the overall structure; the fences and trellises in a backyard create a three-dimensional framework for the view. All kinds of repetitive, linear patterns or regular shapes can give you the key to creating space and depth. Brickwork, steps, paving stones and fences trace the basic planes and volumes of a city street, and the scale of things near and far can be judged by looking at how these patterns change and converge over distance. In an interior, a similar role is served by tiles, floor coverings, and wallpaper patterns.

► **Fred's Island**
*The surface of water
is fascinating – it has
no light or color of
its own but produces
them through
reflection; a flat
plane which swells
and breaks up with
movement to
produce a myriad of
shapes and colors.
Try to observe the
general directions of
waves or ripples, as
BRIAN DUNCE has
done in this oil
pastel, and
remember that
because the surface is
basically flat, they
will become smaller
with distance.*

*Long sweeping strokes
follow direction of
gentler ripples*

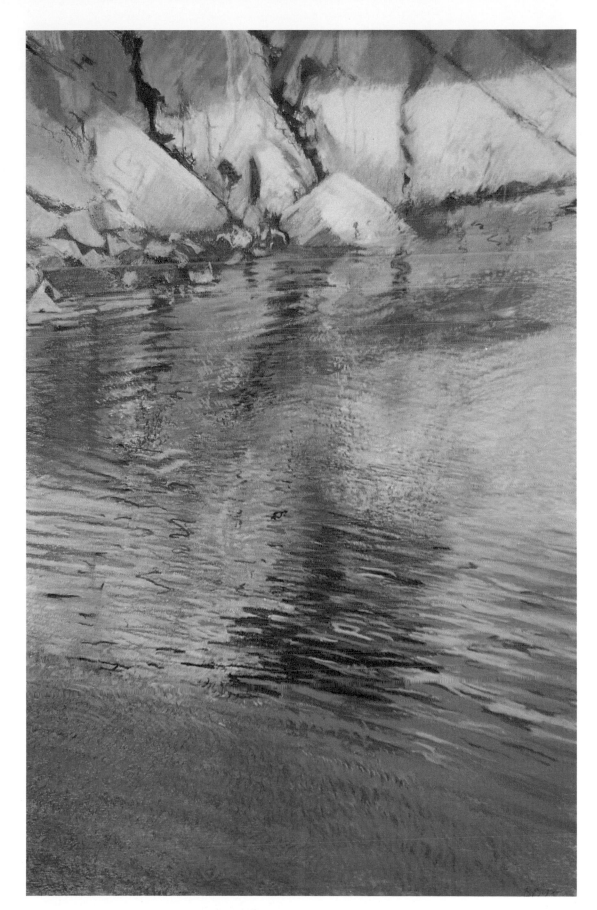

*Dark squiggles suggest
reflection broken by
movement of water*

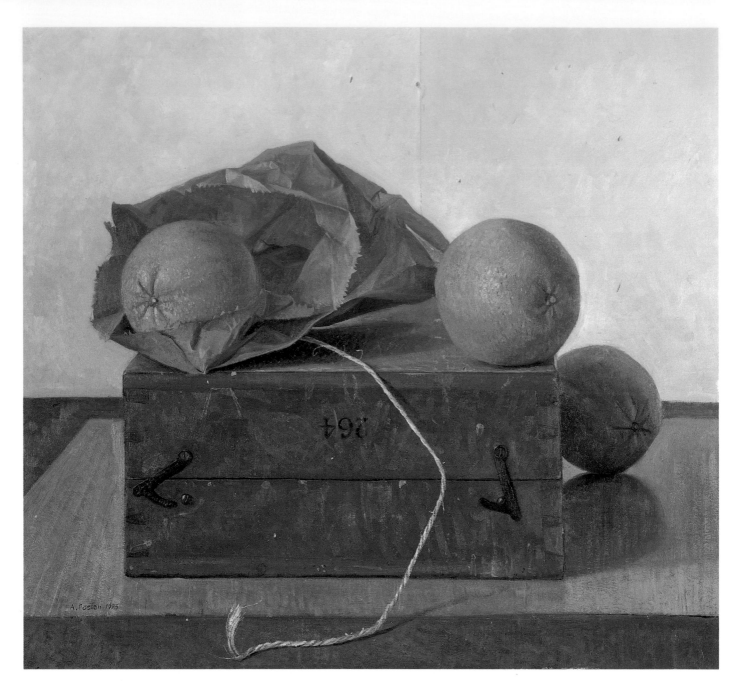

Dry brush technique (picking up the minimum of paint on the brush) covers surface incompletely to suggest rough texture

Small dabs made with the point of the brush, following contours of rounded surface

Light-colored paint scumbled lightly over dry, darker color

▲ Oranges With Brown Paper Bag

Texture is also an important element in ARTHUR EASTON'S *still-life paintings, a genre in which he specializes. He works in oil, in this case on board, building up his effects by means of careful brushwork that is at the same time varied and coherent. In general, it is easier to convey texture with an opaque medium such as oil or acrylic – or even pastel – than it is with the more fluid and less controllable watercolor.*

Surface detail

Generally, in order to establish the scale and detail of your painting, it is useful to lay out the larger shapes first and construct a basic impression of space. Then you can deal with variations of form and texture on the surface that relate your rendering more precisely to given features of the subject. Look at the texture of pebbles as a beach recedes from you toward the horizon. If you match the size of the marks you make to the relative sizes of stones, you can mold the ground plane and give depth to the space at the same time.

When you have an identifiable progression of shapes within shapes, as on the beach or in a display window, the clues to form and depth are relatively easy to pick up. You have a lot of information in front of you to select from related to individual forms. Some surface effects are less easy to see because they are broken up more randomly, such as manufactured forms made from highly reflective materials such as metal and glass, or a very rough, irregular texture like tree bark or lichen-crusted rocks.

These relatively complex surface appearances are composed of elements that you are used to dealing with in simpler subjects. Take an intricately detailed motif, such as a glass vase containing flowers: you can see solid and translucent forms, different layers of information in the outer surface of the vase, the flower stems inside it, and background colors and shapes showing through. But you can focus all of these elements as a set of interlocking shapes, a two-dimensional pattern. Likewise in tree bark, there are color variations relating to the true colors of the bark and its rugged or flaky texture, as well as a tonal pattern where the light molds the ridges and crevices in the wood.

In principle, you can apply this to any object and its surface texture — try to visualize it as a formalized arrangement of shapes and simplify the range of colors and tones, as in your earliest exercises on expressing form. You can handle it quite selectively and still come up with a convincing image, either by working in detail piece

Successive layers of thick, opaque watercolor; top layer sanded to reveal colors underneath

Solid black background highlights forms and textures

▼ **Untitled**

EARL GRENVILLE KILLEEN *works sometimes in acrylic and sometimes in watercolor, as in this case, achieving his texture effects by means of a layering and sanding technique. When dealing with a small segment of the seen world, in what is virtually a still-life painting, textures and surfaces assume more importance than they might in a landscape, where they often play no more than a subsidiary role.*

by piece, or by using brush techniques that broadly texture your paint surface, producing an effect optically similar to that of the original material.

Selecting the detail

Don't be afraid to leave out, or decide to paint out, things that make your rendering seem ambiguous or too fussy. The tonal pattern of a heavy surface texture reduced to a two-dimensional plan can interfere with, rather than enhance, the sense of underlying form; likewise, a printed or painted pattern that is too dominant a feature of the painting can flatten out the surface it is supposed to shape. Use shadows and highlights selectively, picking on those that emphasize dips and hollows or changes of plane. Cast shadows that fall across several forms can create interesting traces of the individual contours; but a cast shadow cutting across, say, a portrait or figure study can simply make the form seem wrongly modeled.

Consider, too, how this detailed work

Sunlight coming from side acts as spotlight, producing strong contrasts of tone that model forms

Individual forms become smaller and less distinct as they turn away from light around main curve

More generalized treatment of background tree places it further back in space

▼ **Ficus Walk**

The surface of these trees is the essence of the form, with a number of root-like structures combining to make the shape of the trunks, just as bricks or stones combine to make a wall. Side lighting has helped JOHN HOUSER *to make the most of the intricate twisting and curving shapes in his oil painting, while to convey the grand scale of the trees, he has included a figure as comparison.*

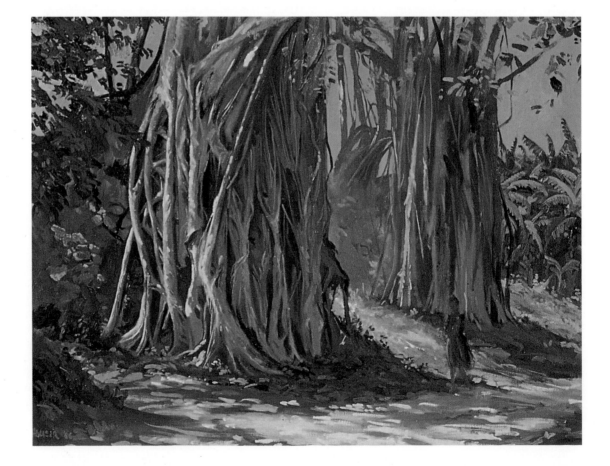

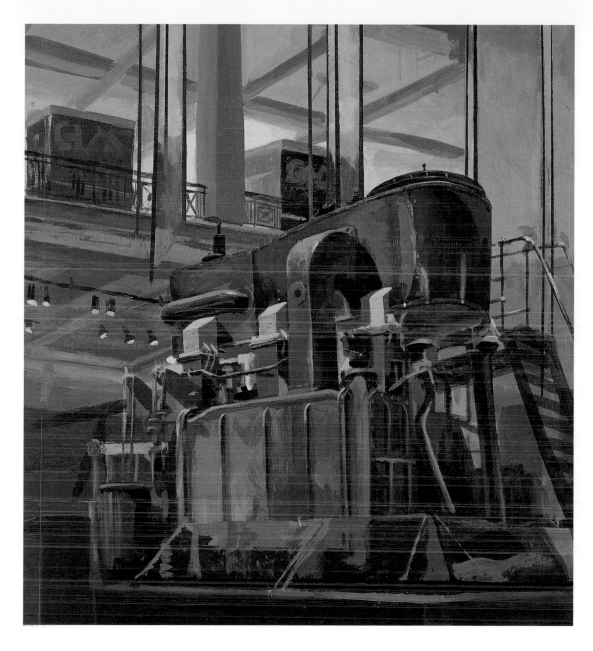

◄ **Ship's Engine**
An artist is always free to select or reject any element in the subject that interferes with an interpretation, and surface qualities can sometimes do this. Here, however, they are vitally important, as they both reinforce and explain the shapes and structures. MICHAEL WUJKIW *has used his oil paints with assurance to suggest the surface textures, while still subjugating them to the forms.*

affects the overall plan of your composition and the impression of space and form within it. A still life or interior composed of several forms with different patterns and textures, or a subject with masses of color and intricate detail, such as a flower garden, makes a very lively, bright, and appealing picture with a great deal of surface interest. But this may make a picture with a strong graphic sense, which emphasizes two-dimensionality. Try to find ways of varying the space and depth: look for how patterns lock into or contrast with solid shapes; give the painting patches of color, shadow or clean highlighting.

Rough surface suggested by lightly scraping paint with knife

Smooth application of paint plus gentle highlight emulates painted-metal surface

Strong contrasts of tone, with hard, dark shadows describe thin, sharp-edged shapes

EXERCISES

Form and surface

The surface of objects can be revealing or confusing – highly reflective surfaces are confusing, but always fascinating. In most paintings and drawings it is important to give some indication of surface qualities, but there is a danger of becoming so interested in them that you "lose the wood for the trees," so always look for the relationship between outer surface and inner structure. Take care with scale. If you are painting a brick wall, for example, note how many individual units make up the overall structure – your rendering will lack realism if these are too large or small.

▼ Surface and space

When dealing with an expanse of landscape, you may have to find a way of suggesting surface texture in a generalized manner; too much detail could destroy the impression of space. If you have a photograph of a grassy landscape or pebbled beach, try making a drawing or painting from it. Don't try to draw or paint individual pebbles or blades of grass; instead, express the texture through pencil marks or brushstrokes, varying the size so that the marks become smaller in the distance, as in this oil pastel painting.

Individual marks of pastel clearly visible in foreground; smoother treatment in background

▲ Nature in microcosm

The 19th-century British artist, critic, and teacher John Ruskin would often set his students the task of drawing small objects such as stones in order to gain understanding of larger ones such as cliffs and mountains. This was sound advice; if you can produce an accurate rendering of something like this piece of slate, you will be able to draw the formation of a cliff made of similar material. Alternatives include tree bark or small twigs.

▶ Repeated structures

Some objects are made up from a series of small components, each fitting together to form a whole which is a structural repetition of the parts. This Italian cauliflower rendered in watercolor is an extreme example, with each floweret following the same spiral structure.

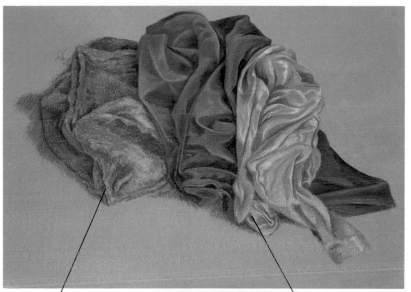

◀ **Fabric textures**

If you are painting portraits or figures, you must learn how different fabrics behave and how any folds and creases may model or disguise forms. There is no better way of training your eye and hand than by setting up a group of different fabrics such as the sacking, satin, and velvet shown here, all of which have different characteristics. The satin has a shiny reflective surface, giving sharper contrasts of tone and color than the velvet or the heavily textured burlap. The drawing has been worked in pastel, using a combination of blending methods and linear marks.

Scribbled marks, with no blending, suggesting rough texture

Reflective surface, giving sharp contrast of tone and color

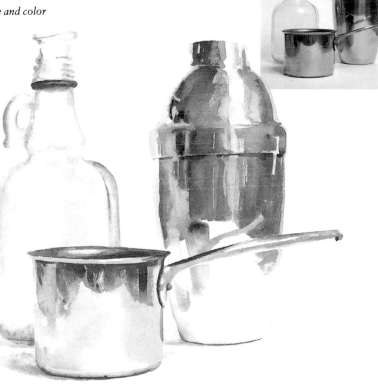

Main form built up with darker color on shadowed side

Watercolor used quite loosely, with brush-marks suggesting individual forms

▲ **Reflective and transparent surfaces**

Highly reflective surfaces are a challenge, as reflections not only confuse but contradict the form — you look into rather that at the object, as you do when you look at your reflection in a mirror. On curved surfaces, reflections often have to be simplified, as they are in this watercolor. Transparency is in general easier to cope with, but you must observe very closely. The highlights and dark areas are not always predictable, but they must be placed correctly, as it is they that explain the forms.

7

Form and texture

In natural objects like trees, rocks, and seashells, surface pattern and texture are inextricably linked. Particularly heavy textures can obscure forms, but more often they provide important clues, as in the case of growth rings on a tree. Try to see how the texture relates to and describes the basic forms.

Clear division between dark and light denotes smooth surface

Spiral formation clearly shown by growth rings

Prominent curving ridges circling around form

Materials and technique

Watercolors
●
Graphite pencils
●
Colored pencils
●
Watercolor paper
●

The combination of drawing and painting media has helped the artist both to build up the forms and exploit contrasts of texture.

1 *Preliminary drawings for watercolors are usually kept light so that pencil marks do not show through the paint, but in this case pencil and watercolor are to be used hand in hand, with the drawing forming an integral part of the image.*

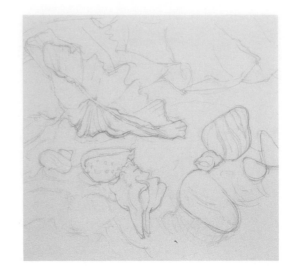

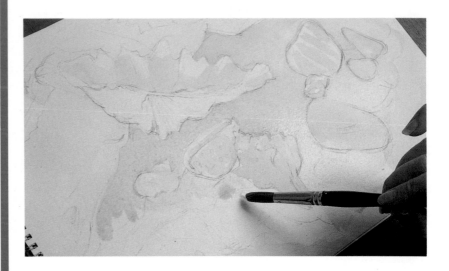

2 *A light watercolor wash is taken carefully around the outlines, with the shells and stones initially reserved as white paper.*

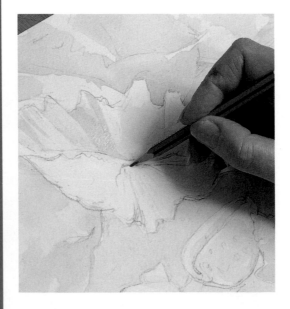

3 *With light gray washes beginning to establish the forms of the shell, and the background area of sand slightly darkened so that the white ridges stand out clearly, the artist reinforces her original pencil drawing.*

4 *In order to maintain the careful balance of tones and colors, she moves from one area of the picture to another, working alternately in pencil and watercolor.*

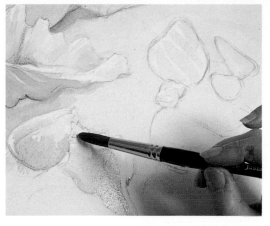

5 *In the final stages the forms are built up more strongly with colored pencil shading over dry washes. This is kept light so that it marries well with the delicacy of the watercolor.*

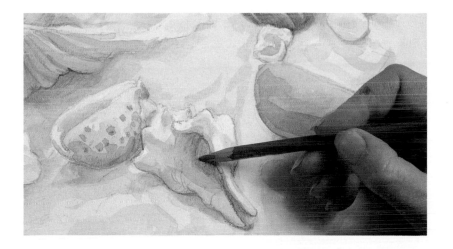

▼ Seashore Still Life
The forms and textures are convincingly rendered, though Elizabeth Moore *has avoided too much detail, as this could have spoiled the fresh quality of the painting. The graininess of the pencil drawing and bold lines of hatching on the large shell suggest the roughness of the surface rather than describing it literally.*

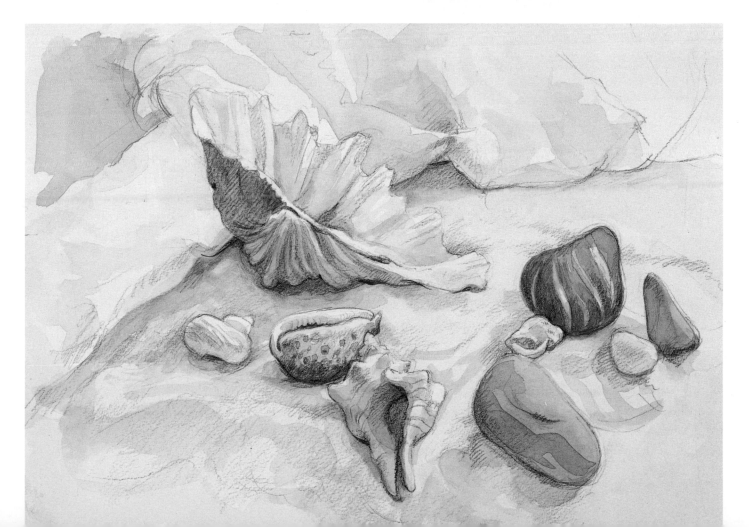

Viewpoint & perspective

Selecting your viewpoint carefully, preferably by moving all around your subject, gives you the opportunity to find the image with most impact. Exploring the subject as thoroughly as possible beforehand enables you to understand its drama or dynamic, perhaps even identify a narrative to be explained. A single form can appear more interesting from an alternative angle. Grouped objects, figures, or buildings construct all kinds of descriptive relationships from differing views.

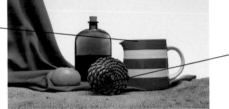
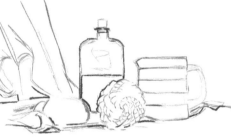

Straight-on, eye-level view flattens pitcher, as there are no ellipses or contours to describe form

Overall shape of pine cone hard to understand from this angle

Seen from slightly above, square shoulders of bottle are visible, but overall shape becomes shorter and squatter

Pine cone slightly difficult to assess; this could be overcome by moving the object itself

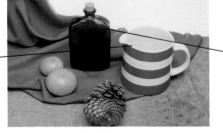

High viewpoint provides wide ellipses that describe shape of pitcher well

Good viewpoint for showing shape and form of bottle

The elements: What to look for

The viewpoint you choose will not only affect the composition of your drawing or painting, but also the way you perceive the forms – as soon as you move, you will see the objects in a different perspective and relationship to one another. Make sketches before you embark on a finished work, and if you find the forms difficult or ambiguous from your original viewpoint, move your position (or the objects) until they begin to make pictorial sense.

Your viewpoint constructs the sense of form and space in your picture more influentially than any other single factor. A very small change can radically alter the potential; try looking at things with one eye closed; then close the other eye and see how the scale of objects and their spatial relationships seem to shift, even with such a small variation of focus.

Selecting a viewpoint

When you set up a still life, move the objects around and group them in several arrangements. When you find a satisfactory grouping, try looking at them from a higher or lower eye level — sit on the floor, or on a tabletop rather than a chair. A high viewpoint helps you to organize things spatially; you can arrange a still life on the floor so you are looking down on it from a normal working position. In interiors or townscapes, look for a high vantage point such as a balcony or a wall that gives you an unusual view.

Similarly, when you work on a figure painting or portrait, check all the angles. Can you explain a foreshortened or partially hidden form from the position you first chose? Does moving slightly to one side clarify the shape? If you cannot move to another spot to make your drawing or painting, as when you are working in a crowded life class, walking around the model at least gives you an opportunity to absorb all the shapes and forms and draw on your memory of them. If you are sketching figures in a public place, you can make many quick sketches from alternative viewpoints to find the most pleasing composition of a group.

In landscape or townscape, try walking through what would be your picture area, exploring the space itself and the relative proportions of its component forms. You can gain a clear sense of the overall structure and the way individual features contribute; you may even find an extra element that you did not know was there from your original view. If you are in a car, use the window to "frame" your picture. Working inside a building looking out, use features such as

▲ **Chocolate Brunch**

A high viewpoint, has allowed WILLIAM C. WRIGHT *to exploit the pattern element of the subject in his watercolor while still allowing the forms to be "read" clearly. The lighting has also been chosen with care, as the strong shadow cast by the flowers is integral to the composition.*

Central shadow forms focus for eye and links objects together to form coherent group

Shadows strengthen and help to explain forms of objects, also introducing contrasts of tone to composition

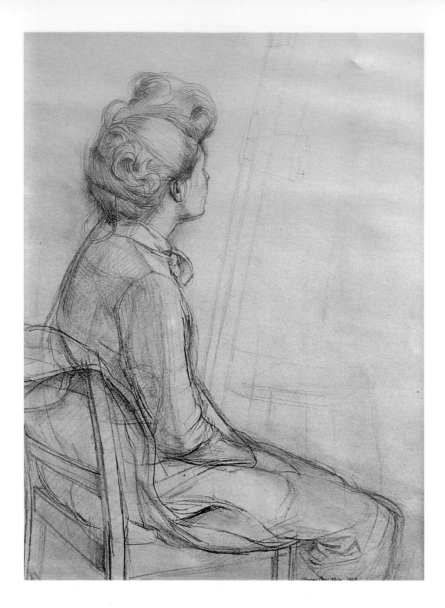

Pulled-back hair follows shape of head; fine pencil lines follow contours

Forms of body built up with light pencil shading and suggestion of contour lines

▲ Costume Study

This pencil drawing was made during STEPHEN CROWTHER'S *student days as a study of hairstyles, and it was therefore essential to choose the viewpoint that best allowed him to analyze the complex twisting shapes and relate them to the head beneath.*

window frames as a grid to help you organize the picture space.

Changing your viewpoint after you have started may save you struggling to resolve a basically flawed concept; but don't give up just because the composition is difficult – that's a different problem. Figure out what it is that you are trying to express; what was it that attracted you to the subject? Make a viewing frame by holding up your fingers and masking out parts of the view; move your hands around until you have what seems to be the most eloquent solution. Or cut a rectangle in a piece of cardboard or paper and use it as a mask. As you assess the different possibilities, look for the overall balance of shapes, the contrasts of scale, tone, color, and texture, and try to use them to advantage.

Always carry a sketchbook so you can make use of any interesting viewpoint that you come across by chance. It is possible to draw without attracting attention on a train or bus, at the theater, or in a café.

Perspective drawing

A change of viewpoint almost always causes a substantial change to the perspective of the picture. It is useful to know the basic principles of linear perspective systems, though a true perspective can be achieved by eye with practice. The systems, however, give you substantial clues as to how particular parts of a scene should be working, or the way shapes of figures and objects should relate to your viewpoint. You don't have to construct complicated grids, but the basic structure that a perspective grid would give you establishes a broadly correct framework for composing the picture.

The basis of perspective is a horizon line that corresponds to your eye level. It may not be visible as an actual horizon; if, for example, you are painting an interior scene, you must set a notional horizon line, but in landscape painting you may be able to see a real boundary line marking the limit of your viewpoint.

In one-point perspective, parallel horizon-

tal lines appear to converge on a vanishing point at the horizon. The classic figurative example of this is a road stretching away from you into the distance, which is drawn not as two parallel lines but as a cone with its point on the horizon. In two-point perspective, there are two vanishing points, which can be illustrated by the idea of looking at a building from one corner; the horizontal lines of the walls on both sides extend toward the vanishing points, seeming to converge as they recede. In both these types of perspective, vertical lines remain vertical.

In three-point perspective, however, the convergence also applies to vertical lines. If there is a vanishing point above the horizon line, the effect is equivalent to looking up from ground level. If the vertical convergence is downward, toward a vanishing point below the horizon line, your viewpoint is technically above the scene.

If you were drawing, say, a street of

▼ Weeds

In a landscape it is always wise to explore different viewpoints before starting to best emphasize the features that interest you. In this pencil drawing, the plants form the main subject, and MICHAEL BERNARD *has chosen a low viewpoint so that the upward-thrusting shapes occupy a large area, with the horizontal lines of the roof providing a balance.*

Tall plants overlapping roof establish relative positions in space and link foreground and background

Ridge of meadow highlighted and thrown forward by dark shadow tones inside barn, giving dimension to drawing

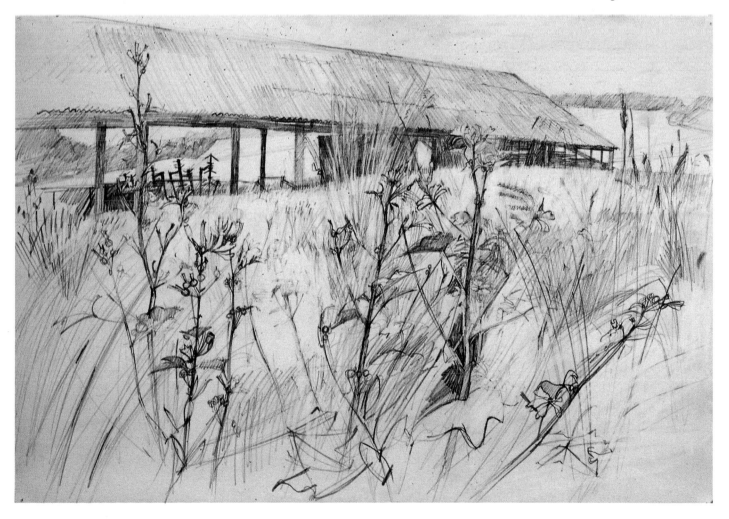

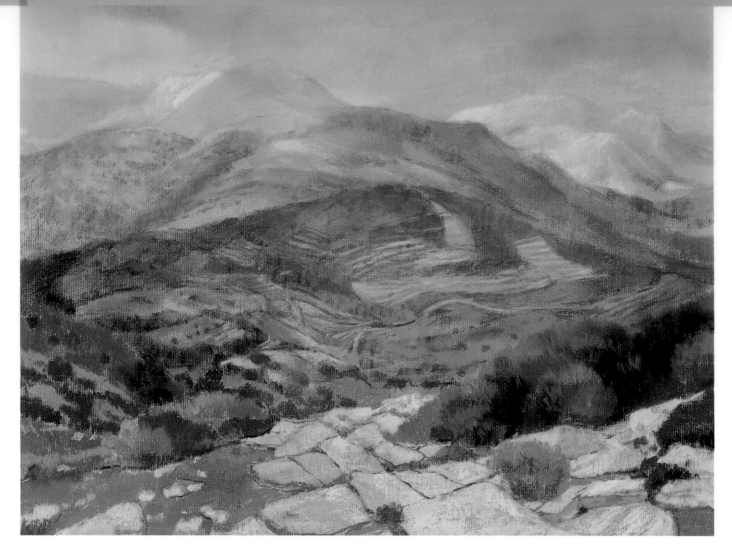

Pale colors repeating
those used for sky
create impression of
distance

Patterning of fields
describes forms of hill
and leads eye toward
mountains

▲ The Mountains of Naxos

The viewpoint for this pastel and charcoal painting was relatively high, with HAZEL HARRISON *standing at an easel at the top of the foreground hill. This vantage point has prevented the foreground from dominating the composition and allows her to make the most of the distant mountains and foothills in the middleground.*

houses from a normal eye level, one- or two-point perspective states that the horizontals representing the bases of the houses are traveling up toward the horizon in your picture, the lines of the rooftops are slanting down. The same basic principle applies to the floor and ceiling of an interior. As lines converge, the space between them appears to diminish, so objects within the room, or features such as windows and doors on the houses, seem to get smaller over distance. Diminishing scale is an important principle of perspective. It can help you to understand how things are positioned in relation to each other in many cases.

However, if you use a system too rigidly, the result is a dull, even unrealistic drawing. When you observe your subject, think about where your eye level is and how the basic lines within the view relate to it. Try making a tiny thumbnail drawing to check the

position of horizon line and vanishing points. You get only the most basic impression of the perspective in this way, but a simple grid can also help you to arrange the composition and discover the dynamics of the image. When you come to make a full-scale drawing or painting, use the simple plan to organize the image, but keep checking with the subject in front of you — trust the evidence of your own eyes rather than a system.

Foreshortening

Foreshortening is a perspective effect directly relating to how figures and objects appear from the given viewpoint. It means that the depth or extent of a form may appear shallow or distorted compared to what you know to be its actual size and shape. Think of a plant with similar-sized leaves; as you see the leaves in different positions, some square on, some curving away, the shapes and sizes seem to vary.

The same thing happens with a figure; if a person is sitting in front of you with their legs stretched out toward you, the legs appear foreshortened because you are looking along the axis. They form a truncated, relatively broad shape, which you may misjudge because you know the legs are longer and thinner than they seem. Similarly, if you are looking down on someone from a high viewpoint, the proportions of the figure are telescoped inward. The relative scale of things is rearranged; for example, the facial features are compressed into a small area within the overall shape of the head.

The organization of a picture can be complex at the best of times. If you try to do everything at once, it is extremely difficult. But if you choose the best possible viewpoint and try to group the shapes representing space and form methodically, one aspect will usually take priority over another, and you can progress in stages with the development of the picture.

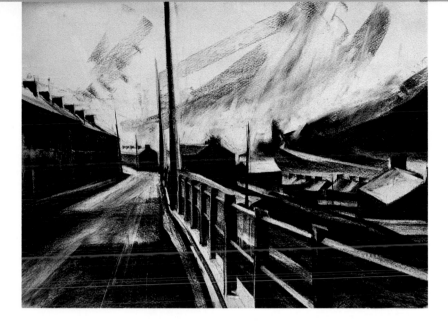

Receding parallels of road, rail and houses converge on horizon

Upward-sloping curve leads eye toward echoing curves of hills

Nant-y-Moel ▲
and The Winder ▼

These two charcoal drawings by DAVID CARPANINI *show how the choice of viewpoint affects the composition as well as helping to create distance and depth. In the top drawing, an eye-level view gives strong perspective lines leading straight into the picture from the foreground, while (below) a high view causes the receding parallel lines of the roofs to slope upward.*

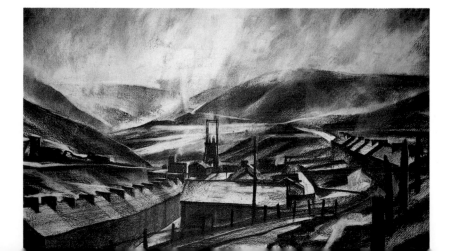

EXERCISES

Viewpoint and perspective

If you draw a cube-shaped object from directly in front and at eye level, the form will barely be discernible because you will be seeing only one plane. A slight shift to either side will bring a further plane into view, and if you then move again so that you are looking slightly down at the object, you will see the top plane as well, and thus fully comprehend the shape and depth. The fact that viewpoint affects your ability to render form sounds obvious, but is often overlooked, as is the vital role it plays in the way you organize your picture. These exercises will help you to understand the importance of viewpoint in both contexts.

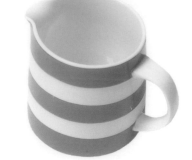

◀ **Drawing ellipses**

An ellipse is a circle seen in perspective, and it changes according to your angle of viewing. If you look at a cylindrical object directly from above, you will see a perfect circle, but as soon as you lower your viewpoint the circle becomes an oval. It is important to get ellipses right, as they describe the form of the object, so practice drawing a mug or pitcher at different heights, as in these pencil drawings.

High viewpoint: ellipse is a near-circle. Stripes around pitcher become closer together as they curve away

Slightly above eye-level: ellipse at top of pitcher closes to become oval

Exactly at eye-level: ellipse at top becomes straight line, but ellipse at bottom (below eye level), visible as slight curve, is more open

Two planes of book visible, explaining form; ends of paper rolls describe thickness

▲ Foreshortening

This perspective effect, which makes that part of an object nearest to you seem disproportionately large, can make forms appear distorted and thus difficult to "read." With a figure, it is likely that some part of it will be foreshortened; but with a still life, you can arrange the objects so that the effects are not extreme enough to obscure the forms. In the first photograph, the book and roll of white paper make very little sense, but in the second one they do. Practice drawing objects from a variety of viewpoints.

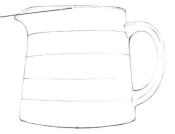

▶ Viewpoint in landscape

You can learn a lot about viewpoint by drawing individual objects, but to discover how much it affects both perspective and composition, you will need a larger subject, such as a building or cityscape. Try drawing a house or street of houses, first from a low viewpoint so that the perspective lines slope sharply downward to the horizon (your eye-level), and then from above. A very low viewpoint can emphasize the height of a building, while a very high one creates a slight "fish-eye" distortion of perspective, which has been deliberately exaggerated in this pen drawing.

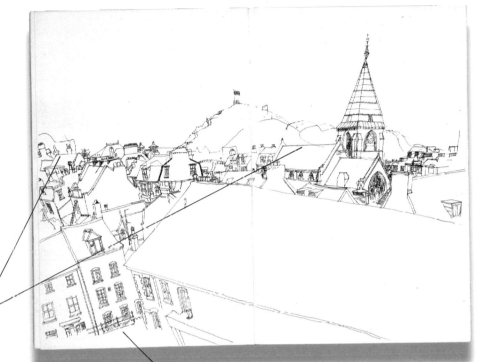

Artist's eye on level with top of roof, thus line is horizontal

"Fish-eye" view causes verticals to slope inward, an effect seen in photographs

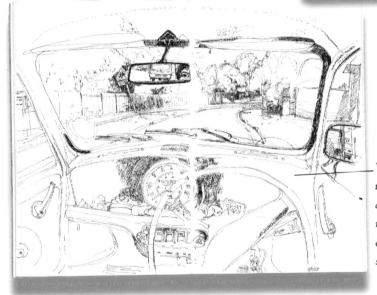

View through windshield: close-up of dashboard and reflection in mirror emphasizes outside space

View through side windows: dark pen shading on seat belt establishes foreground

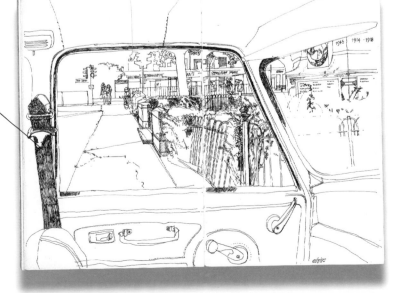

◀ Framing the view

If you have trouble deciding on the best viewpoint for a subject, try using a viewfinder made by cutting an oblong hole in a piece of cardboard. Move it around, holding it at different angles and distances from you so that you can isolate the subject from its surroundings. Or use a car window as a viewfinder, as in these pen drawings, in which the interior of the car forms unusual foregrounds as well as framing the views outside.

8

Spatial relationships

A still life is ideal for exploring the forms of individual objects and the way they relate to each other in their unit of space. Try different viewpoints before you begin, as even a small shift can change a horizontal line into a diagonal or cause objects to overlap in a more interesting way.

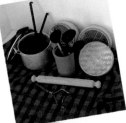

Medium viewpoint: forms well defined; spoons and handles make strong shapes

Higher viewpoint: shapes of ladles become lost against background object

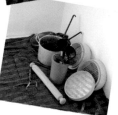

Seen from side: close overlapping of objects; rolling pin, and potato masher create triangular shape

Materials and technique

Gouache paint
●
Bristle brushes
●
Sketch & watercolor paper
●
Gouache can be used thinly to give effects similar to watercolor and thickly as an opaque medium.

▼ *This series of brush drawings has helped the artist to decide which of the various viewpoint options to use for the painting. He chose the frontal view with the low viewpoint because this gave a strong, triangular-based composition, with the ladles and handles outlined against the light background.*

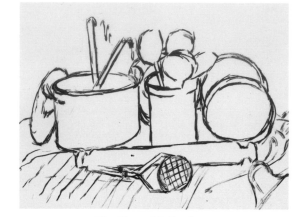

Medium high view

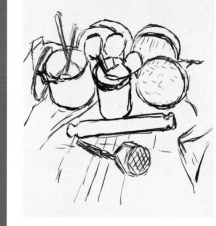

High viewpoint

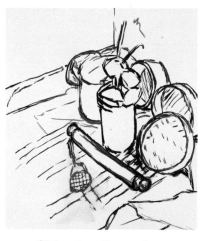

Side view from above

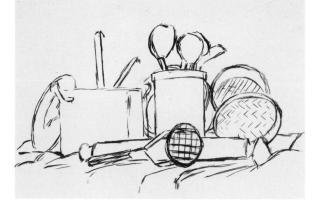

Eye-level viewpoint

1 As a general rule, gouache paint should not be used too thickly in the early stages. On the rounded forms, thin paint serves as a foundation for further layers of paint, while dark, solid color is used for the outlines of the ladles.

2 Using a bristle brush, the artist paints in the slats of the vegetable steamer. This color will be modified by later applications, worked light over dark, the procedure also followed for the diffused highlight on the flowerpot.

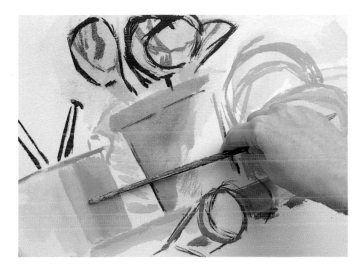

3 Concave forms like these ladles can be difficult to convey satisfactorily, and the artist takes care with both the forms and the shapes, observing the nuances of tone, and reserving areas of white paper to describe the outlines.

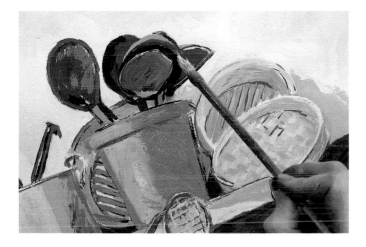

◀ **Kitchen Still Life**

Gouache is an attractive medium, but needs to be practiced. Because the paint remains water-soluble even fully dry, each layer tends to mix with those below, creating muddy effects. DAVID CUTHBERT has avoided this by combining tonal modeling – involving layering methods – with linear brush drawing.

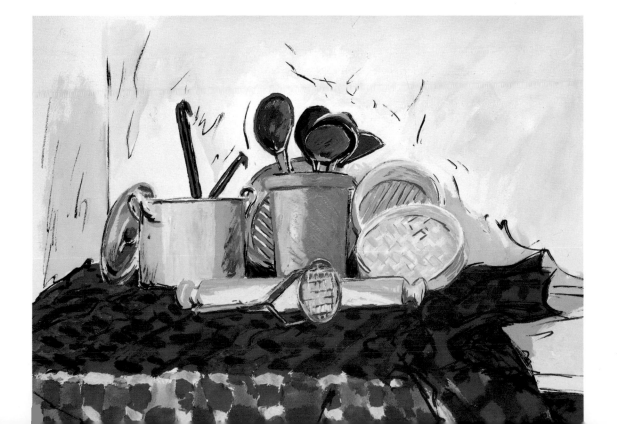

9

Life drawing

Because the forms of the human body are so complex, it is vital to choose a viewpoint that allows you to analyze them and render them convincingly in your drawing or painting. Severe foreshortening, for example, can be difficult to cope with, and a profile view can give a silhouette effect, making it hard to convey the solidity of the body. If the life class is not too crowded, walk around the model to find a position that allows you to express both the forms and the rhythm of the pose.

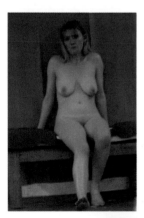

Foreshortening of legs makes the pose more difficult to understand, but creates an attractive compact shape

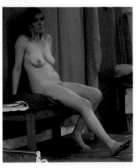

Three-quarter view accentuates long sweep of body and leg, and provides descriptive outline of breast and stomach

▶ *The same view has been chosen for each of these three drawings. In this pastel, the student has modeled the forms of the body well and shown a good understanding of the pose, but the head is a little small.*

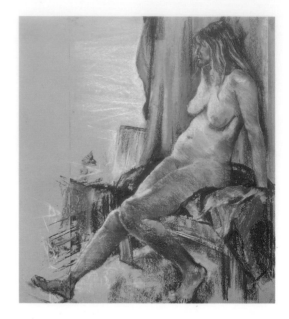

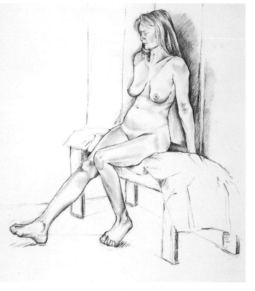

◀ *Charcoal has been used with confidence to describe the interior forms, but the uniformly hard outlines have slightly weakened the effect.*

▶ *In this drawing, also in charcoal, the student has concentrated on building up the forms of the body, giving a good account of the skeletal and muscular structure below.*

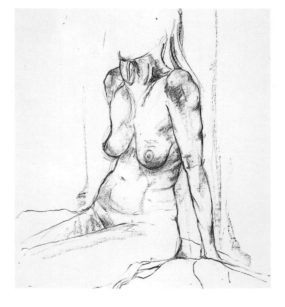

1 For this mixed-media drawing, the student has chosen the difficult foreshortened view in order to emphasize the main shapes. He makes an accurate pencil drawing, varying the lines to suggest the forms.

2 The whole area of the body is now covered with acrylic paint, used thinly so that the pencil lines are still visible.

3 He then begins to build up separate areas of strong color, applied flatly to give an effect similar to that of paper collage. Although the colors are not naturalistic, forms are successfully described through accurate observation of shapes, outlines, and tonal contrasts.

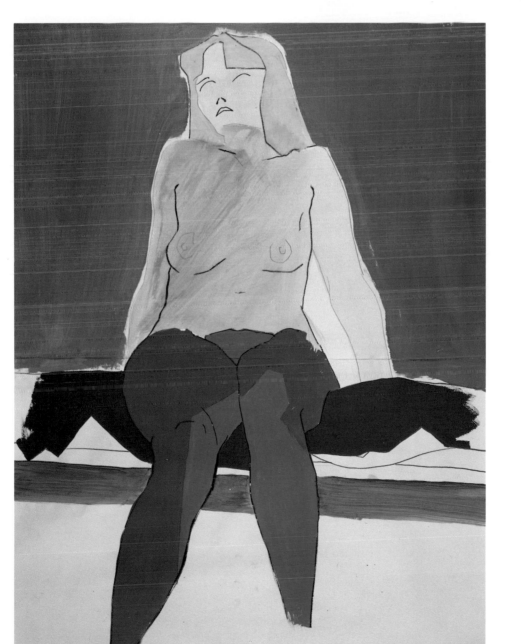

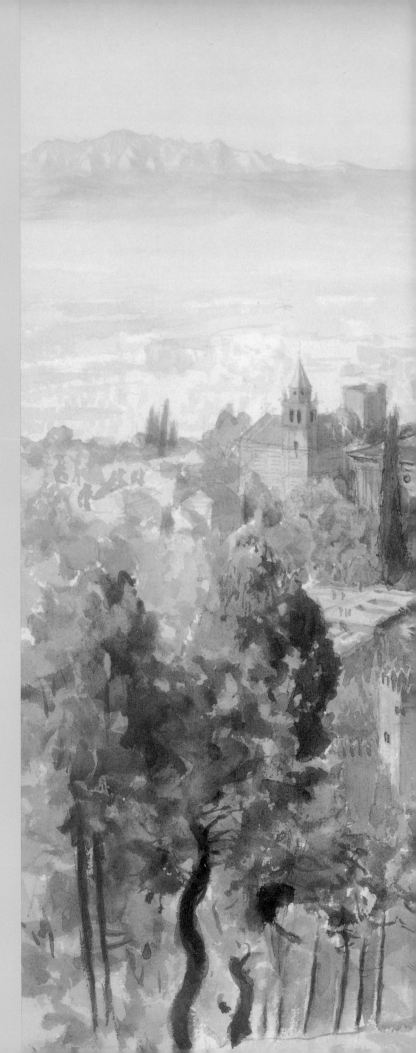

In the second part of the book, we look at form and depth in the context of specific subject areas. If your interest is landscape, you will discover how to recognize visual clues that help you to describe the contours of landscape or the flat planes of water. You will learn how to manipulate lighting to reveal the forms in a portrait or figure painting; how to organize a still life; and how to convey the shapes and forms of animals. Each chapter includes at least one project and one special feature highlighting particular problems you may encounter.

Alhambra Granada

by Paul Osborne

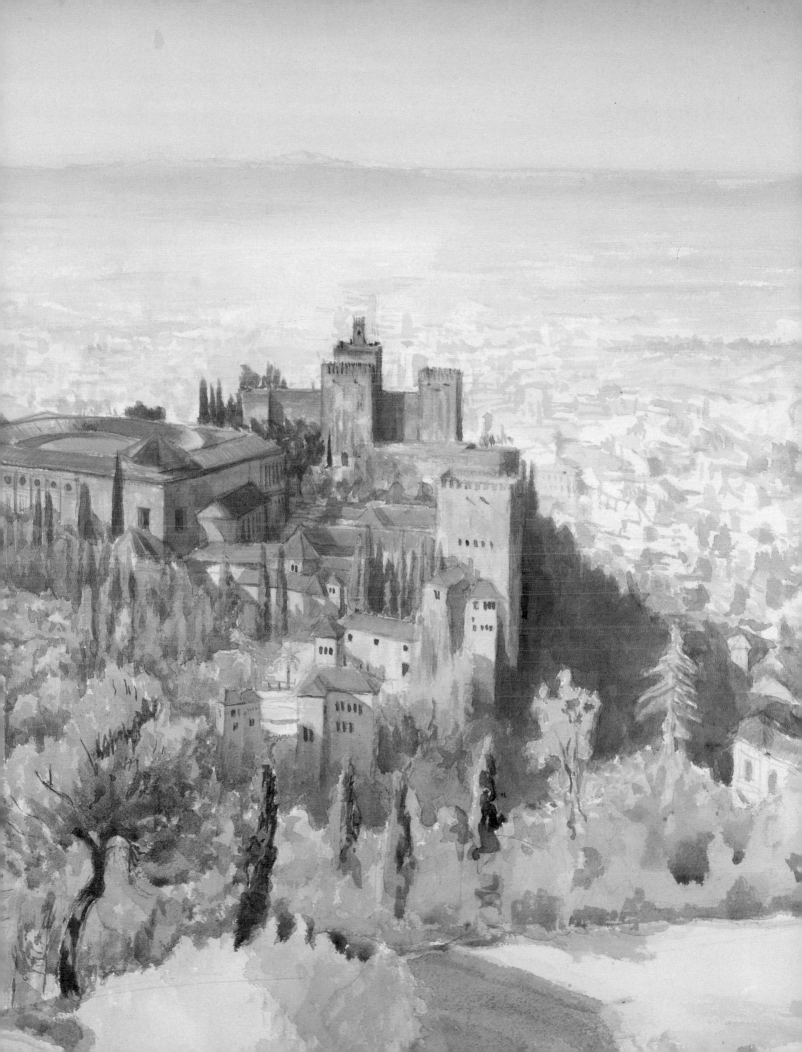

Buildings & cityscapes

The form of a building, or group of buildings, can differ widely depending on the location, method of construction, and the general environment. The way the forms and spaces are interpreted in your painting can also vary, depending on your own intention. A motive to draw and paint can be focused almost anywhere, so it is worth taking time and making a concerted effort to find the ultimate subject. Almost any kind of location will reveal a motif of substance.

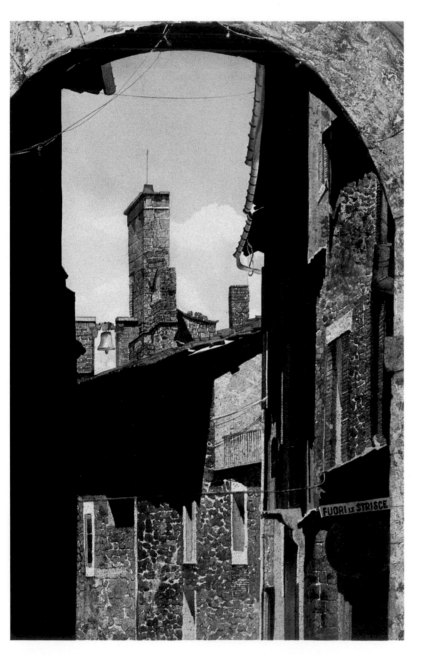

D omestic architecture is built to human scale and generally clustered, either in a planned way, as in a new subdivision, or in an apparently random or organic pattern that has evolved over a long period, relating to how people use the buildings. Industrial buildings are

Details simplified into broad shape, balancing dark shadows in foreground

Detailed treatment of surface creates pattern interest and helps to give sense of scale

◀ **Cortona**
Cast shadows help to describe forms that can otherwise be hard to read, as well as highlighting interesting textures and architectural details. In SANDRA WALKER'S *water-color painting, the shadows also play a major role in the composition, which is based on bold juxtapositions of light and dark.*

Arch creates a frame within a frame, giving additional importance to roofs and chimneys beyond

generally large-scale and often isolated, because of working and storage space around the site. An abondoned industrial site can be an exciting, if potentially dangerous, subject. Make sure that you have legal access and, if there is any demolition in progress, that the contractors know you are on the site.

Seeking the unfamiliar

It is easy to find subjects to work from in towns and cities you have not visited before. Take time when you are traveling or vacationing to sketch buildings with beautiful shapes or unfamiliar structures and exterior features. Photography is useful as an aid to memory, but photographs can lack the character and detail that attracted you to the subject initially. A print or slide is a convenient way of reducing the subject to a two-dimensional plan, but this very convenience can remove the qualities that make the fully rounded world so lively, if difficult to capture in a drawing.

When you draw or paint directly from the motif, everything you put down has been selected and, ideally, understood. You can explore not only the physical features of the site, but also its mood and activity. The kinds of marks you make as a direct response to the thing in front of you can help you to express more than the basic masses of the building or townscape; they can reveal the sharpness and glamour of modern buildings; the softening of a silhouette through age and wear; or the way ornamentation accentuates or counters the structural shapes.

In the same way, try to be a visitor in your own neighborhood. When you start working from familiar streets or buildings, you will be surprised by things you had never really noticed before. You can find the most intriguing vistas in locations apparently well known to you, but never fully explored. Look for a spot to work in that gives you a fresh perspective on the scene, literally and figuratively. Study how buildings and streets frame each other, how massed forms and spaces interact on a large and small scale. Walk around and find out whether you can

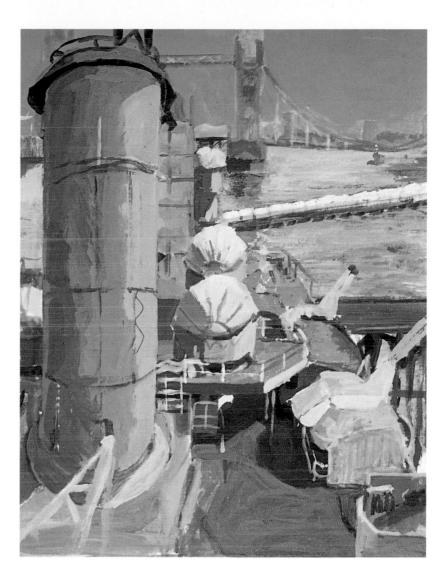

▲ **HMS Belfast**
In this unusual acrylic painting, the strong architectural shape of the ship's funnel dominates the foreground, but MICHAEL WUJKIW *has cleverly created a sense of space by means of the pale yellow shapes that progress into the picture, thus leading the eye to the bridge, river, and cityscape beyond.*

Paint applied more flatly than in nearer area of water, emphasizing distance

Color repeated from rectangular shapes to rounded ones, thus forming a series of links in a chain

Triangular shape in foreground leads eye to cylinder of funnel

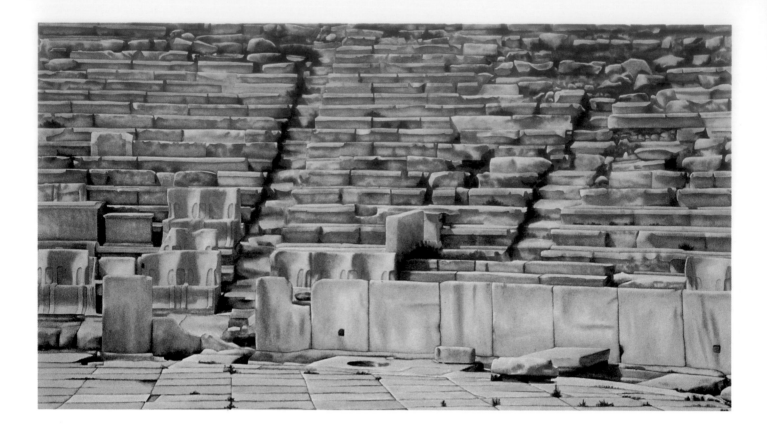

▲ Cavea and Orchestra

NICK HARRIS *has a particular interest in the textures of buildings and often focuses in close, as in this acrylic painting, which owes its impact to the tactile quality of the stones and the pattern formed by light and shadow. The forms have been built up gradually, with the acrylic used thinly in a series of overlaid washes.*

Placing of shadows and gradations of tone important in suggesting concave forms

Careful observation of perspective describing flat plane in foreground

Smoothly blended paint, with no obvious boundaries between tones, creates impression of smooth-surfaced but weathered stone

occupy a higher or lower vantage point.

In a tree-lined street, use the opportunity to choose a viewpoint from which a building is partly obscured by the foliage, and make part of the picture to do with this discontinuity of the buildings's basic form. If you can draw from inside a café, or some other place where there is a particular activity in progress, this helps to focus the surroundings. If you can glimpse through a window the street activity by day or night, it gives an intriguing sense of narrative to the general view.

Very complex architectural subjects require a heavy commitment of time, even if elaboration such as regular window and door patterns can be completed later. Try to tailor your drawing to the time and effort you can allow; select the essential features, make quick visual notes of attractive and enlivening detail. If you cannot work in color in front of the subject, make written notes, including indications of local color and effects of light and shadow. If you are going to work up a drawing or painting from sketches, find time to do it while the observations are still fresh in your memory.

▶ **Sunlight in the Mosque**

Perspective is all-important in an ambitious subject like this, as incorrect placing of receding lines will destroy overall structure and individual forms. In this lovely oil painting, PETER KELLY has also made good use of light and shade both to provide a compositional framework and to give the feeling of an enclosed space.

Raised bands make series of ellipses, becoming more open (i.e. sharper curve) at top of column

Diagonal formed by shadow and sunlight leads eye into picture; shadow also delineates shallow step

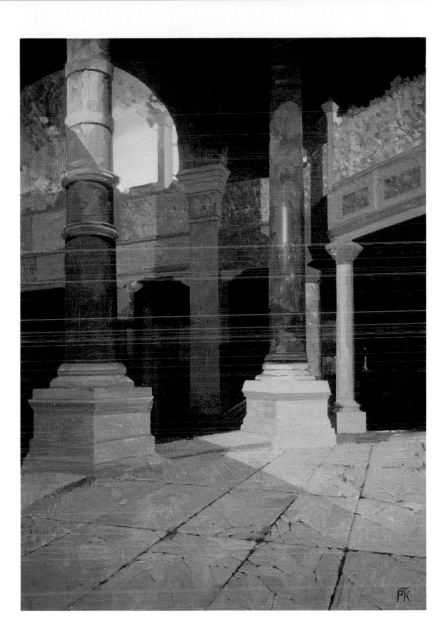

Space and structure

When you first observe an architectural subject, consider what you know about the form and space. Does your viewpoint reveal the structure logically? Do external features and surface details emphasize or counteract the basic shapes? A confused image is often the result of confused intentions. Decide what your priorities are and work at them methodically. If you are observing a single building, then the underlying form may be relatively simplistic, the surface details what gives it interest as a subject for close study. Brickwork, fences, window frames, and unusual colors created by weathering of the building materials all contribute character and give individuality to the overall form.

In a broad cityscape, you can actually see less detail of individual buildings; the interplay of basic shapes and forms is typically more important. In this case, you can choose to deal mainly with the relative height, width and depth of buildings and the impressions of surface color, forming a pattern of shapes that illustrates the evolution of the city as a complex, interactive structure. Smaller features that you can see clearly defined provide accents of color, pattern, and texture that enliven the broad view.

Sketching buildings that are in a derelict state or in process of demolition enables you to see and study the construction and possibly explore both the inner and outer

▶ **Feeding the Pigeons**

Weather, and hence the quality of the light, has a direct effect on the mood of your painting; a building or townscape first seen under a lowering sky is immediately transformed by the emergence of sun. In this watercolor, PETER KELLY has exploited the physical effects of weather – a recent rainfall driving most of the populace indoors – to create an atmosphere of quiet and calm.

Emerging sun creates spotlight effect, creating light/dark contrasts between this and right-hand building

Vertical bands of reflection in wet pavement lead eye up to central white building

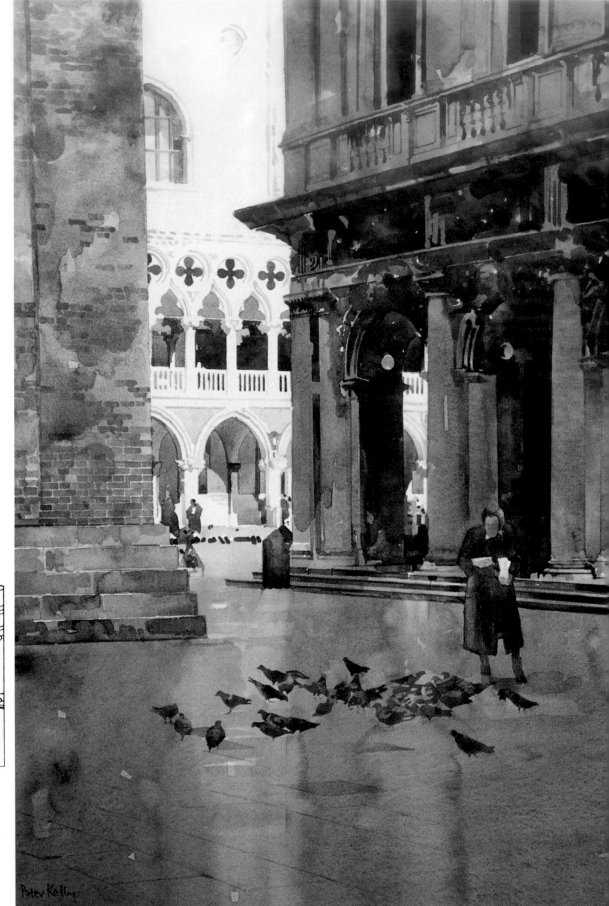

▼ **Beaufort, N.C.**
*In this acrylic
painting on canvas
by* NEIL WATSON, *drama has been
created in several
different ways,
among them the
strong contrasts of
tone. The red flowers
also play their part in
the composition,
providing vivid color
accents in an
otherwise muted
color scheme.*

*Sweeping brushstrokes
of thinned paint give
feeling of movement
and excitement*

*Raking light throws
strong diagonal
shadows crossing the
vertical brushstrokes to
create lively foreground*

*Right-hand building
deliberately left
incomplete in order to
focus attention on
central house*

volumes at the same time. This is invaluable information for working out the space which a large building inhabits. Being able to see the interior space from outside, due to broken walls or a missing roof, gives insights into the structure that you could otherwise only guess at. You can draw on this knowledge when you are studying complete, enclosed forms.

Character and mood

Some buildings look as if they have always occupied their place; others seem awkward in their surroundings. The kind of contrasts created where new buildings have been erected among the old architecture offer many fascinating juxtapositions of form,

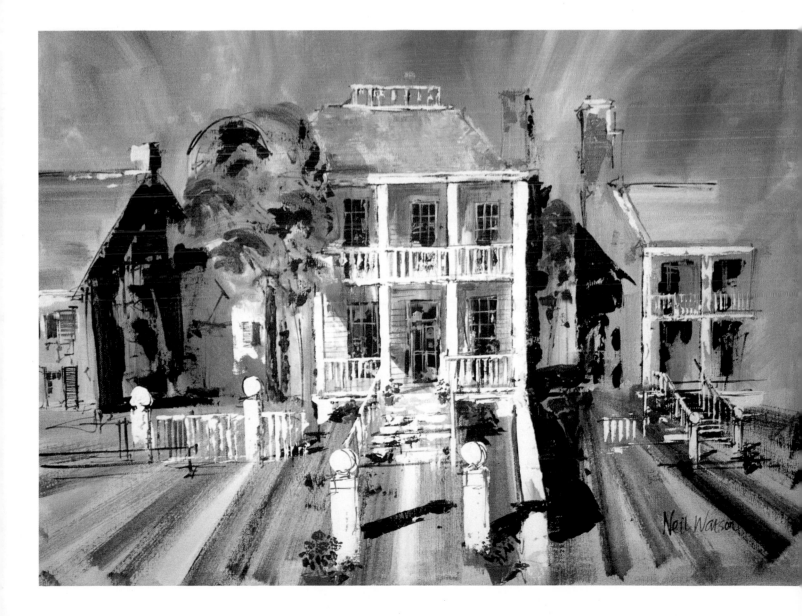

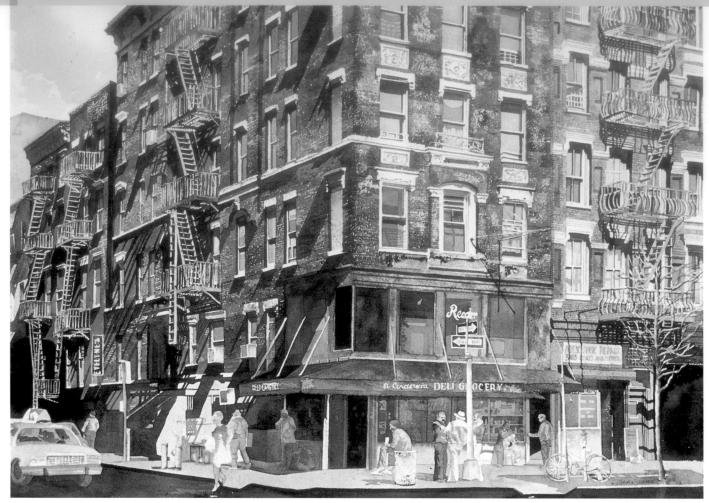

space, and surface detail. Buildings standing alone in great expanses of landscape are either built into the landscape sympathetic- ally or appear harshly contrasted; you can exploit such extremes. Compare the shapes, colors and decoration of rail stations, markets, cafés, harbors; these comparisons sharpen the eye and also provide a good source of reference for future work.

Light and shade give character and mood to an image. Try making a composition by framing a brightly lit building between others in shadow. If the sun falls at an angle, extraordinary cast shadows may occur that give drama to your picture. Look for colorful and irregular detail on an otherwise regular frontage: awnings and shutters, window boxes and curtains, signwriting on windows and doors. Include the patterns of reflected color and tone in glass-clad office buildings, apartment-building windows, and shop or bar frontages.

The particular age and function of a

▲ Bowery

It is sometimes possible to convey the character of buildings through color or shape alone, but in this impressive watercolor it is expressed through meticulous attention to detail and texture. Notice how Sandra Walker *has chosen the light that best emphasizes these qualities, as well as allowing her to use the slanting shadows as a compositional device.*

Detailed treatment of brick textures and patterns on stonework provide accurate "portrait" of building

Slanting shadows both explain shapes and forms and create an exciting light/ dark pattern

Careful observation of people helps to express feeling of place

▼ Near the Spring

This atmospheric pastel painting by Doug Dawson *is also an accurate portrait of a building, though here the mood is quiet and gentle. The impression of the house seeming to grow out of the landscape is emphasized by setting it in the middle distance and treating it as the trees and grass.*

Red of roofs echoed in trees, thus making color links that unite building and landscape

Thickly applied pastel imitates texture of whitewashed walls

Shape and proportion of windows of more importance than detail

building can provide interesting visual features. Tenement buildings may be stained and scarred and uncared for. Restored buildings and streets can be full of characterful detail – rail fences, cobblestones, lights. Make a feature out of lines of washing, ornamental brackets and cast-iron balconies, flights of steps. Look at stores, stands, arcades, and beach huts trying to outdo each other with brightness. Search the façades of old buildings for signs of advertising or working features – lettering, pipes, lifts, cables – anything that suggests a clue to their previous use. Each type of building will have a story and an atmosphere that can be deduced with empathy and understanding.

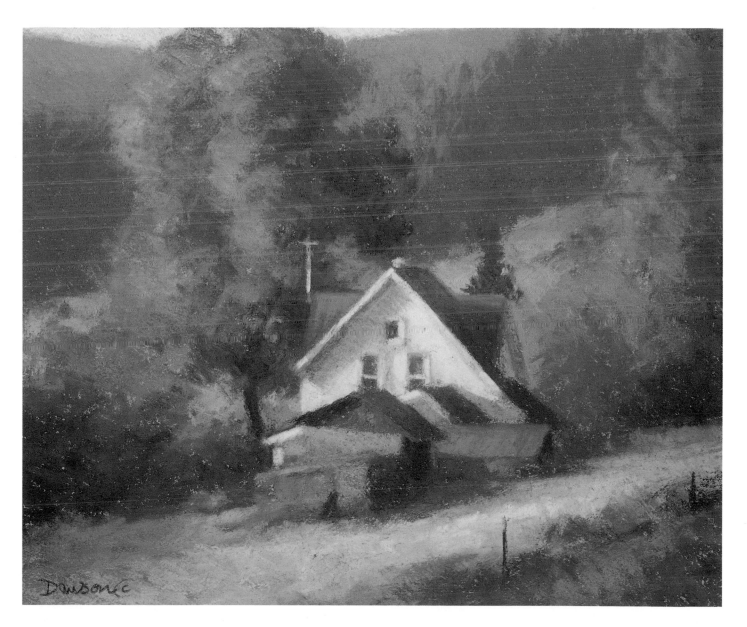

Dawson

PROBLEM SOLVING

Perspective and lighting

The most common cause of failure with architectural subjects is incorrect perspective. Windows that are out of alignment with the roof, or a door that appears to be on a different plane to the wall will make the building appear badly constructed and hence unrealistic in terms of form. Sometimes, also, a building will look flat simply because there is not enough light and shade to explain the forms, so choose the time of day and the direction of the light with care.

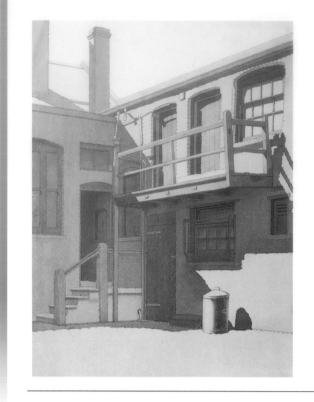

◀ Cast shadows
HENRY BARTLETT'S *watercolor,* Cambridge Street Canal Wharf *is an excellent example of the way shadows can help to describe the shapes and forms. Behind the wooden balustrade, the shadows emphasize the arches and the depth of the recesses. In contrast, the painting opposite, although correct in terms of perspective, looks dull and lacks depth.*

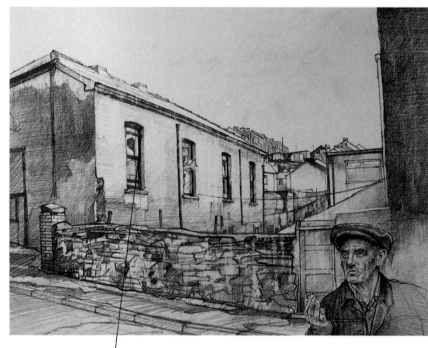

Depth of door and window recesses convey thickness and solidity of wall

◀ Solidity
If you are viewing a building at an angle, as in DAVID CARPANINI'S *pencil drawing, there will be two vanishing points (see opposite page), and it is important to remember that these will also affect any details such as doors and windows. In the drawing you can see that the inner lines of the window recesses lead to the left-hand vanishing point (LVP), while the outer edges of the frame lead to the right vanishing point (RVP).*

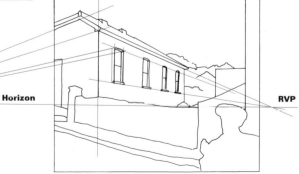

LVP · Horizon · RVP

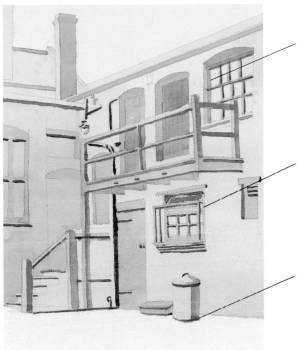

Diffused lighting (overcast day) throws no shadows and reduces tonal contrast

Cast shadow beneath balcony would improve composition and give sense of depth

Light from behind and to right of subject throws receding plane of wall into shadow

▼ Directional lighting

A building will always appear more convincingly solid if you choose a viewpoint that shows you two planes and lighting that throws one or other of them into shadow. *In* Kay Ohsten's *watercolor,* La Rouen PH, *sunlight illuminates the strong shape made by the near side.*

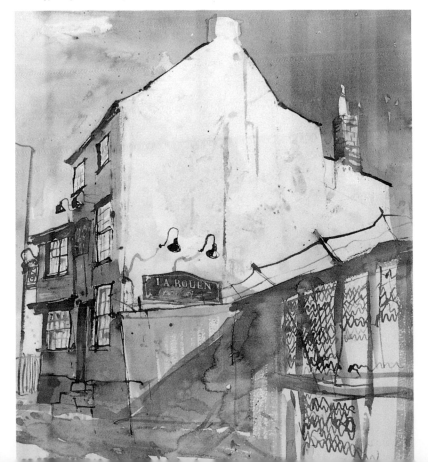

▼ Vanishing points

A basic rule of perspective is that all receding parallel lines meet at a hypothetical vanishing point on a line known as the horizon, which is your eye level.

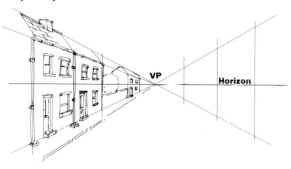

One-point perspective *A single vanishing point in center, opposite the viewer.*

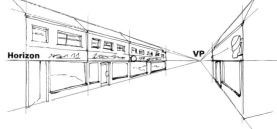

Viewpoint *The position of the vanishing point is determined by the viewing position; here it is off-center.*

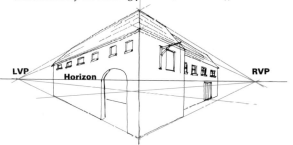

Two-point perspective *Each plane has its own vanishing point on the horizon line.*

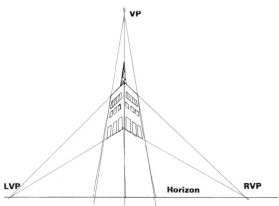

Three-point perspective *Receding vertical lines, as when a building is seen from a very low viewpoint, also converge. The effects are seldom as dramatic as this, however.*

10

The character of buildings

The way you go about a "portrait" of a building depends on what you see as its most important feature. This may be its overall shape, as in the case of a castle or cathedral, which you might paint silhouetted against the sky, but sometimes it is the details of buildings more than anything else that make them memorable, and you can do most justice to these by taking a close-up view. Look for anything that will help you convey the building's character, such as texture.

Balcony omitted in painting, as it weakens effect of tall window and flowers

Photograph taken on dull day; shadows invented in painting

Materials and technique

Watercolor

●

Sable brushes

●

Masking fluid, putty eraser

●

Watercolor paper

Watercolor, traditionally used for architectural renderings, is ideal when crisp detail is important.

① *Having made a careful pencil drawing and laid light washes over the wall area, the artist works on the details surrounding the window. The washes have not been taken over the windows, as small areas are to be reserved as pure white highlights.*

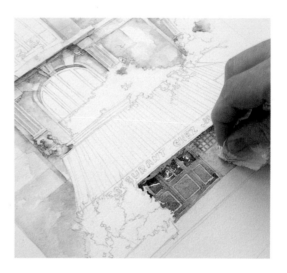

② *A hint of texture is introduced by dabbing lightly into the paint with a piece of paper towel. This separates the area from the woodwork of the door by giving it a different quality.*

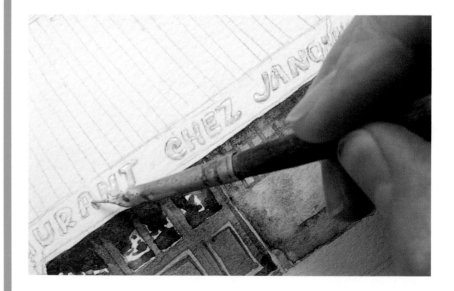

③ *The lettering is an important element and must be placed correctly and defined clearly. Masking fluid is used to block the next application of paint so that the letters remain white. It is left to dry.*

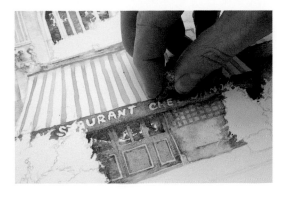

4 A dark green wash laid over the fluid has in turn been left to dry, and the rubbery substance is removed with a putty eraser. Notice that the window above has now been painted, with small areas of reflection reserved as white.

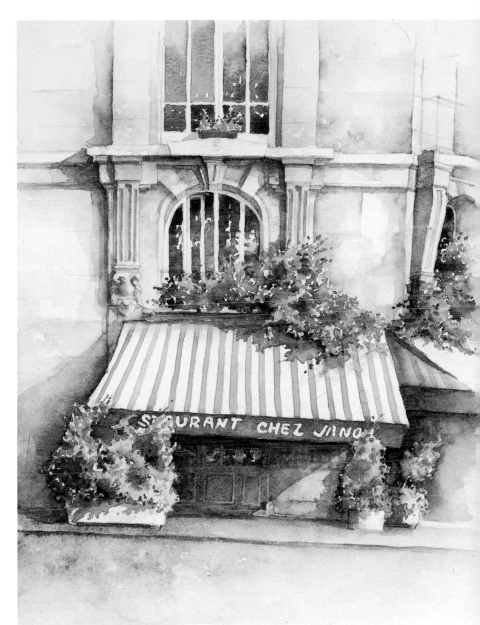

5 The foliage below the window has been begun with a succession of small dabs made with the point of the brush. Darker colors are now applied in wet pools to create softer effects in certain areas.

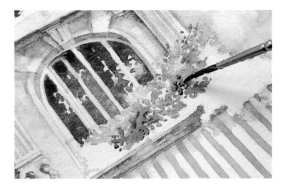

6 Having strengthened the shadow beneath the flower container, he uses very wet paint to suggest texture on the road.

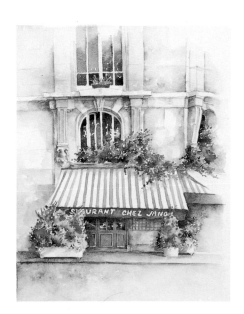

▲ **Paris Restaurant**

Painting the façade of a building can present a problem, as it is difficult to give a three-dimensional feeling when you are dealing with only one plane. When RICHARD TAYLOR'S *painting was almost complete (left), he saw that it needed lifting in some way, so he added shadows, which immediately gave depth and definition. Never be afraid to use invention in the interests of the picture.*

Editing your view

When faced with a complex subject such as a cityscape, whether you are working from a photograph, as here, or from reality, look at it critically in terms of your painting and decide what you might emphasize, simplify or omit so that your painting has a strong compositional structure as well as feeling of solidity and space.

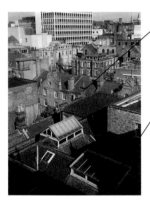

Detail necessary as perspective of windows establishes plane of wall

Shadows strengthened and treated as large, bold shapes to bring area forward

Materials and technique

Oil bars, oil pastels, pencils

●

Pointed painting knife

●

Heavy watercolor paper

●

The technique is both unusual and individual. By laying successive layers of oil bar, pencil, and oil pastel, the artist makes a kind of paste which she can move around on the picture surface and scratch into with the point of a knife to produce almost etched effects.

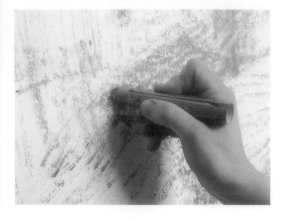

1 *To watch the forms and details emerge gradually, the artist makes no under-drawing. After scribbling lightly all over the paper with a colorless oil bar, she lays in broad areas of color.*

2 *The painting knife is used to draw into the picture, the action pushing the top layer of color into the colorless waxy substance below so that it fills the grain of the paper.*

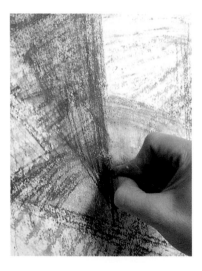

3 *As the picture proceeds, the artist works alternately with the knife, pencils, and oil pastels. Here she begins to build up the foreground shadow with strong lines of oil pastel.*

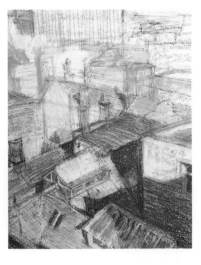

4 *At this stage, the artist takes a critical look at the work. The area of bright green on the left takes the eye out of the picture, so she decides to knock this back, and to strengthen the zigzag pattern which leads into and around the picture by increasing the tonal contrasts.*

5 *Yellow oil bar, which picks up the colors of the wall beyond, is used for the window bars. Although her technique creates an impression of bold spontaneity, she works carefully to establish the correct perspective.*

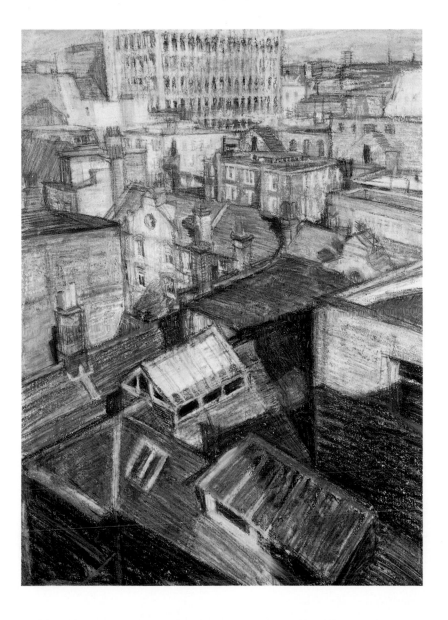

6 *The foreground shadow, which plays a vital role in the strong structure of the composition, has been progressively deepened with successive applications of color. The point of the knife is now used as a drawing implement, to sharpen the lines of the gutter and wall.*

◀ **Cityscape**

The painting is full of movement, with the zigzag rhythm running through the picture and taking the eye in from foreground to background. A high viewpoint will always help to convey a sense of space, and KAREN RANEY *has increased the bird's-eye view effect by deliberately distorting the perspective so that the sides of the background building lean in toward the center of the picture.*

Landscape & seascape

These are probably the largest subjects that you will attempt from direct observation. However, despite the scale involved, there are smaller elements to look for that will help you to understand the whole more easily. A landscape often holds clues to the geology causing swellings and breaks in the surface. Trees, rivers, and other natural features show the contours of the land. The flatter the landscape, the more sky you will see – a feature more dominant in seascape. Always changeable, the sea's surface is a most challenging subject.

Low sun creates exciting contrasts of color and models forms of clouds

Sweeping curve, balanced by line of clouds, leads eye around to dark mountains

Since its earliest inclusion in paintings, landscape has appeared as both a formal subject, for example as arranged gardens and sculpted vistas, and informal, as in vast areas of uncultivated land. Evidence of industrial landscape is much more recent, producing different kinds of massing and organization of the land influenced by human activity such as farming. The elements in a landscape will vary

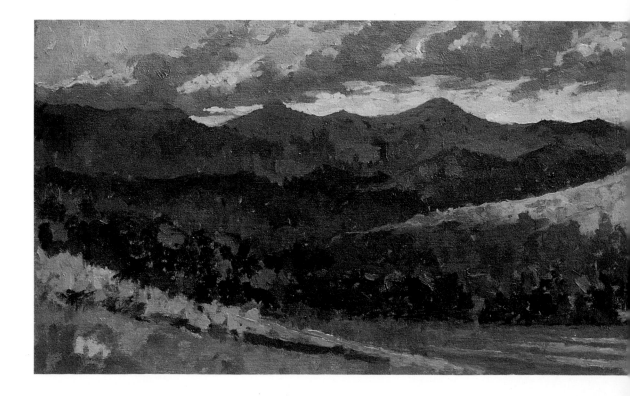

▶ **Untitled**
In this small oil painting done direct from the subject, JAMES HORTON has concentrated on bold shapes and juxtapositions of light and dark. The opposing diagonals of the light fields give a lovely sense of movement to the picture.

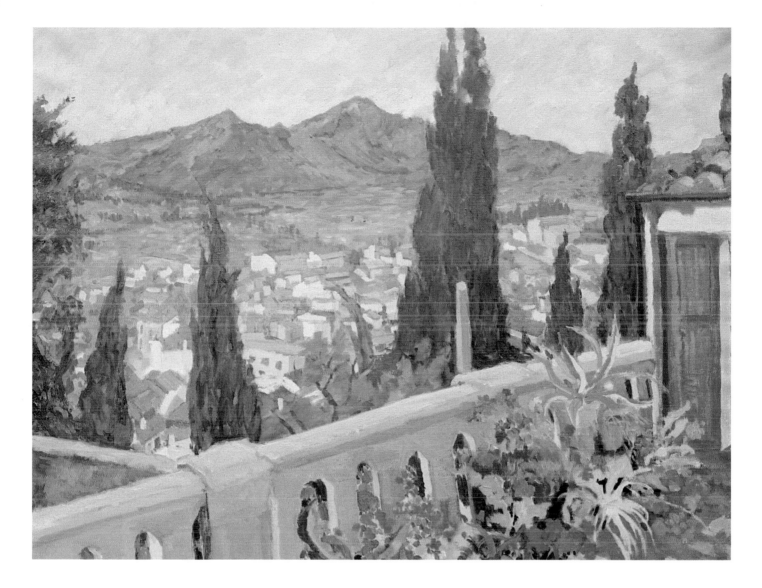

widely according to the particular location and the way in which you choose, perhaps, to catch at a mood that you feel in the landscape.

The form of landscape

If you are working on small, intimate areas, such as a glade in woods or an area of garden, it is possible to exercise a lot of control over the composition. Traditional ways of organizing landscape include "framing" the view between trees, or leading the eye into the picture along a footpath or track. Such devices give an immediate depth and scale to the image, within which you can develop different aspects of the subject. In small-scale views, a small variation of viewpoint can change the composition signi-

▲ **C'An Joana**

In this oil painting, a strong foreground pushes the middleground and distance away through obvious contrasts of scale. Notice that OLWEN TARRANT *has chosen a viewpoint that gives a diagonal line in the foreground (the wall), which the eye follows to the verticals of the door and trees.*

Tall, dark tree links foreground and distance; contrasts of tone smaller than in immediate foreground

Colors similar to those in background to unite composition, but used stronger, emphasizing foreground plane

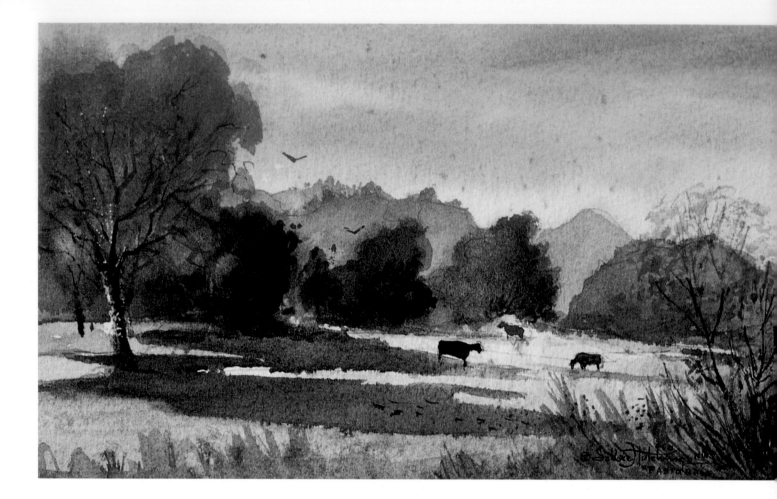

Dark shapes of cows
create focal point and
increase sense of space
by setting scale

Crisp drawing and
brushwork defines
foreground and places
it on picture plane

▲ Pastorale

*In this lovely
watercolor by
LAVERE HUTCHINGS,
painted in a
controlled wet into
wet technique,
shadows are used to
advantage both as a
compositional
element and to
emphasize the
flatness of the land.
The cows give a
sense of scale, while
the pale, cool color
used for the
mountains
establishes their
position in the
far distance.*

ficantly. If something appears obstructive or awkward in the view, try to see beyond it or find an angle that gives it compositional value. If you cannot, simply leave it out, imagining the flow of detail that passes under and behind it by reference to surrounding features.

A large expanse of land can be more difficult to control. It may be contrasts of land levels and wooded or open areas that draw your attention to the subject, but flat and gently undulating land under a huge sky can also make a dramatic composition. If you look hard, you will find the clues that indicate how the landscape has been formed. Footpaths are a good indication of terrain, as they usually evolve through people or animals walking repeatedly across the same access to water or cover. Such traces are seen particularly in reference to grassland, pasture, and hillsides.

Rivers and streams also find the easiest route, so in flat land a river may slowly

◀ **Plaited Landscape**

JILL CONFAVREUX'S *main interest in this mixed-media painting (acrylic, collage and print) lies in the patterns made by the landscape formations, and to emphasize these she has omitted the sky althogether. Although space is not an important element, the painting is by no means flat; the forms of the hills and foliage are conveyed through contour lines and variations in color and texture.*

Dark shadow contrasts with light tones of land on left to describe sharp declivity

Touches of linear drawing on leaves explain forms and provide foreground focus

meander in a series of bends that you can use to create depth in the picture. Because of the vastness and, often, the subtlety of contours in open landscape, you can describe both surface form and depth at the same time. Where you are close enough to see clearly defined forms, try to capture them exactly. Foliage and bushes soften the contours of the land, but sometimes form unexpected shapes and contribute interesting contrasts of tone

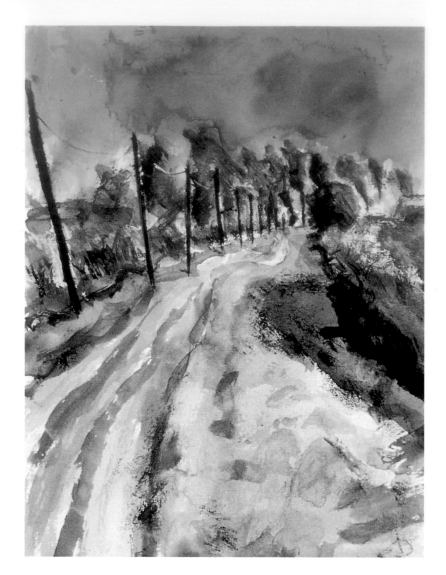

and color. Water rushing over a ledge or plunging into a canyon shows the forms of rocks and stones underneath. Water smooths surfaces as it wears a route through rockfalls, stones, and earth, so look for rounded, eroded forms against the sharp edges of new rockfall or uneroded slabs of rock.

As with all subjects, it will help you to see the landscape and its constituent parts if you can walk around and spend time getting to know the lie of the land. Use this tangible sense of landscape in association with what you observe from different viewpoints. Keep an eye on the way in which the relative scale changes the apparent size of things.

As with other kinds of perspective and foreshortening, it can be difficult to arrange a landscape composition within the limited pictorial space of your paper because you know the real space of the landscape is very deep. Notice how changing levels in the landscape, or the divisions of woodland and fields, appear as narrowing bands of texture and color as they recede toward the distance. Relative heights of tall features such as trees or incidental buildings are also important in organizing depth and space.

Use color to control the space in general terms. Colors tend to appear lighter and cooler over distance. Applying strong colors and dark tones to background features can pull them forward; you need to achieve a balance which works in the picture, but also corresponds to naturalistic effects. The direction and pressure of your brushwork can help you to construct the forms and contours. Use contrasts in the actual techniques – flat washes and glazes against busy, active marks; or opaque blocks of color with contrasting underlayers raggedly breaking through to suggest layering of the ground.

Light is also one of the most important aspects of creating a mood in landscape, and you can try to exploit unexpected color effects that indicate heat, mist, dawning light or a setting sun. Watch particularly how atmospherics act upon the physical form of the landscape, making individual objects stand out clearly or dissolving different elements of the view into one another.

Pole deliberately knocked off the vertical to enhance feeling of movement in composition

Dark shape angled to point into end of path; tones echoed in background trees

▲ Fen Landscape

This watercolor by RIMA BRAY *makes use of a classic compositional device in landscape painting – that of using a path, road or river to lead the eye into the picture. Here the path, undulating over uneven ground, also describes the terrain.*

Sea and sky

A clear expanse of sea shows the curve of the earth's sphere at the horizon, with wave patterns formed in what seem to be elliptical patterns receding from you. Puffy cumulus clouds form a low ceiling; above them is a high ceiling of thinly veiled cirrus clouds. Although clouds are vaporous, light models the surface and creates form, and some cloud formations can look very solid.

The appearance of solid form in things which are moving and atmospheric is one of the special problems of painting seascapes. A common error is to reproduce the apparent forms of, say, thick clouds or rolling waves so heavily and precisely that the movement is arrested and the atmosphere lost. Look carefully for the interaction of tones and colors, the effects of light breaking through a form or reflecting unexpectedly above and below a curve. The tonal pattern is a key

Inward movement of boat encourages eye to focal point

Sky color reflected in water; same pale wash used for both, with highlights in opaque paint

▼ **San Giorgio Maggiore, Morning Light**
When dealing with flat expanse of water and sky, care must be taken with placing the horizon. In KEN HOWARD'S *watercolor painting, the water occupies less space than the sky and buildings, and the bright area of reflected light leads the eye in toward the focal point of the church with its tall bell tower.*

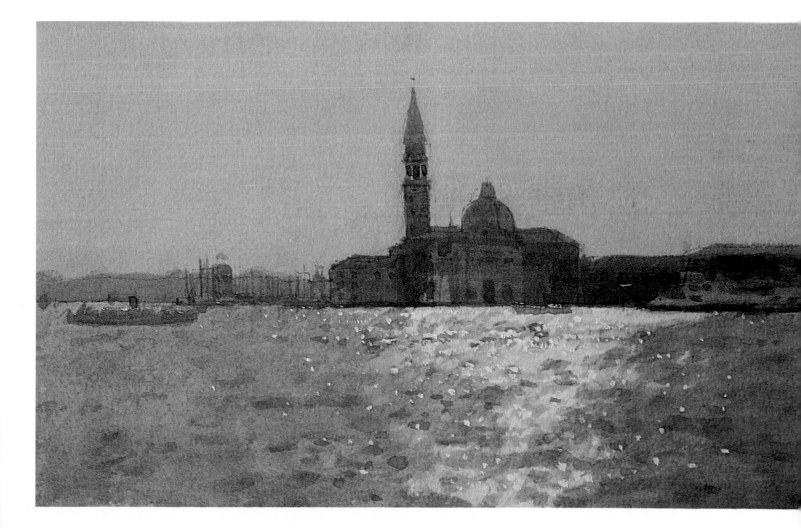

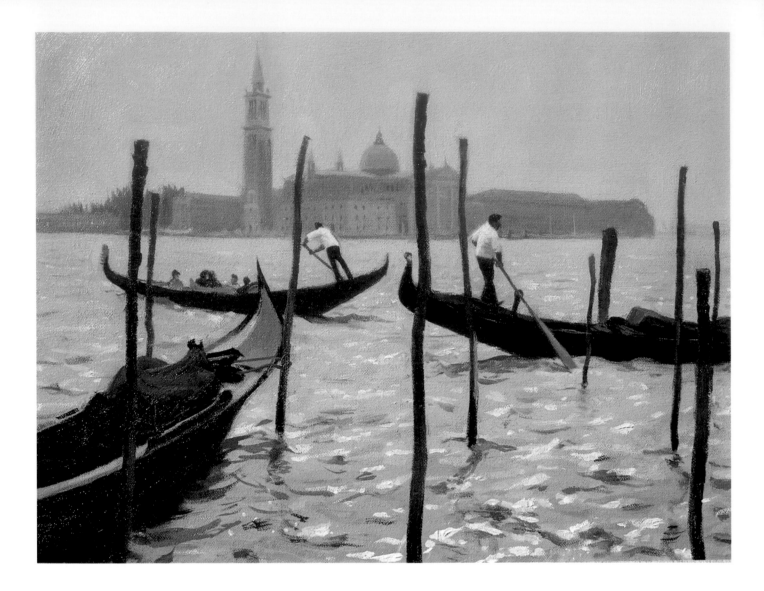

*Cropping of boat places
it in foreground;
overlapping establishes
position of farthest boat*

*Figures and poles
overlap buildings;
minimal tonal contrasts
on buildings*

▲ Venetian Ballet

*This oil painting by
STEPHEN CROWTHER
takes the same
subject and
viewpoint as Ken
Howard's
watercolor on the
previous page, but
here movement is the
essence of the
composition, with
the rhythm of the
gondolas and
boatmen echoed in
the choppy surface
of the water.*

element of the image, but the brushwork has somehow to convey both the solidity of the effect and its transience.

Establishing your viewpoint and the scale of a seascape clearly can be difficult, as the space is so vast and often there are few features that set a human scale. A high viewpoint can help you to identify the wave patterns more clearly, and to see the way the shapes and colors change in relation to general movement, currents in the water, and the influence of the underlying seabed; but a view from above introduces a problem of relating the sea to the land. Can you include part of the land on which you are standing, and how do you convey the steep fall to sea level? On the other hand, if you take a sideways view from the beach, you can see the fall of the land toward the water, but the

depth of the picture space toward the horizon is diminished, and the "telescoping" of distance is exaggerated if the waves are breaking high at the shoreline.

Identifying form in landscape

In both landscape and seascape, forms can appear relatively amorphous, increasingly so as the extent of the view expands. You need to look for the features that will give the interest of clearly recognized and worked imagery. What is the day like, is it having an effect on the colors? What are the types of trees, how do they differ from each other, how do the branches grow from the trunk, is there a definable pattern? Does the light falling on rocks allow you to simplify forms into basic shapes such as cubes or cones that are easier to render? There are generally fewer definable points of scale in seascape than in landscape; can you find a view that means you can include a jetty or rockfall protruding into the sea, or see boats on the water at different distances from the land?

The more challenging your subject, the more rigorous you need to be about identifying basic elements, such as individual shapes, tonal contrasts and gradations, and the interaction of local and reflected colors crossed by variations of light and shadow. These things will sort themselves into patterns as you learn to see them more analytically; it will become more obvious how to create a two-dimensional equivalent.

Landscape is more difficult in this respect than, say, a still life or interior in which the forms and planes are by definition fixed and typically hard-edged, and the atmospherics of light and space can be controlled. But the fundamental elements of form that you have explored both physically and technically on a smaller scale are contained in the logic of the landscape. If you have a recurring problem with a particular subject, try changing your medium, altering your technical approach, or making the scale of your picture dramatically larger or smaller. Reduce the thing to its essentials, then gradually build up the detail and mood.

Perspective lines of flagstones and breakwater lead eye to gull in the distance

Intricate patterns made by receding water and small breaking waves form focal point

Foreground seagulls larger than those on water, explaining degree of recession

▼ Gulls and Surf

A high viewpoint allows you to see farther over the land- or seascape, and was thus ideal for this acrylic painting in which BRIAN YALE *wanted to convey both the sweeping expanse of the sea and the pattern made by the waves.*

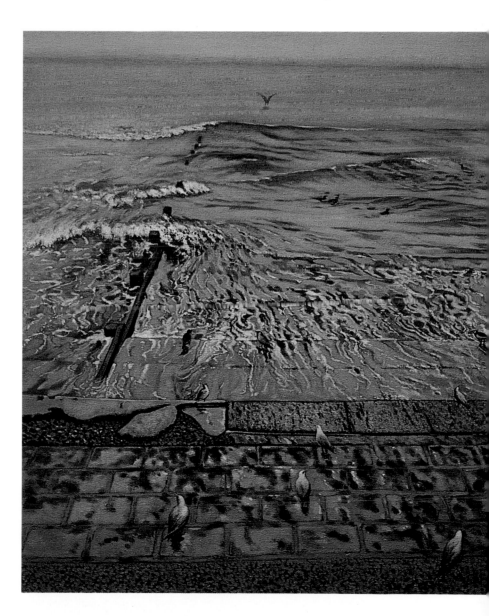

PROBLEM SOLVING

Skies and foregrounds

Both these areas can give trouble for various reasons. Clear skies often look like a painted wall – a vertical plane rather than a wide sweeping curve above your head – while clouds either have a cardboard cut-out appearance or seem too heavy and solid, usually due to over-modeling and too much tonal contrast. Foregrounds, which should lead the eye into the picture, can easily act as a block instead, as well as failing to relate to the more distant areas of the landscape.

▼ **Perspective of skies**

In JAMES MORRISON'S *Guardians of the Eastern Gate, the sky, darker at the top, stretches back to the pale horizon. It is vital to remember that the effects of perspective are seen in skies as well as land; the clouds are largest above your head, often showing pronounced contrasts of tone and color while, on the horizon, the area farthest from you, they become smaller, paler, and more closely bunched together.*

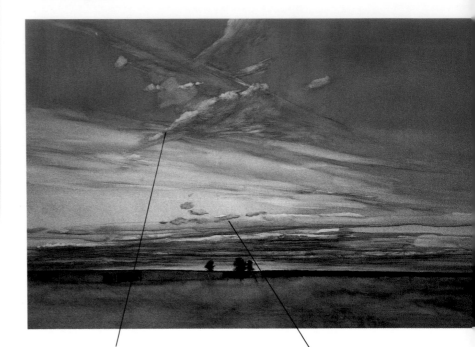

Diagonal lines of windswept clouds increase depth and recession

Small clouds, diminishing in size toward horizon

▼ **Pastel blending**

▶ **Cloud techniques**

When painting clouds, you must find a way of expressing the forms without losing the feeling of soft insubstantiality. Hard edges will seldom look realistic, so, with oil paints or pastels, try blending one tone and color into one another with your finger. In watercolor, the ideal method is lifting out.

1 *Working with soft pastel on smooth paper, the artist lays down strokes of color and rubs them together with her finger.*

2 *It is usually a mistake to overblend, as this can make your work look bland. Energetic strokes give a feeling of movement, and there is enough blending to create realistically soft cloud effects.*

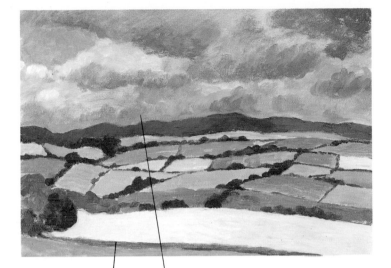

▼ Foreground contours

Too much detail in the foreground of a landscape can prevent the viewer's eye from traveling into the painting, and too little detail, or the kind of unresolved and formless shape seen in the picture (left) has a similar effect, creating an uneasy feeling. In JAMES HORTON'S Landscape, *the curving lines explain the contour of the field as well as leading our eye into the picture. Notice also how he has created pictorial links throughout the painting, repeating touches of pale yellow from foreground to middle distance, and echoing the shape of the foreground field with the light blue area of the sky above.*

Unexplained shape creates jarring effect and fails to lead eye

Central placing of horizon reduces sense of space by weakening relationship of land and sky

Exact shape and size of hedges and trees establish distance and explain forms of land

Diminishing lines of trees beyond foreground field reinforce contour lines

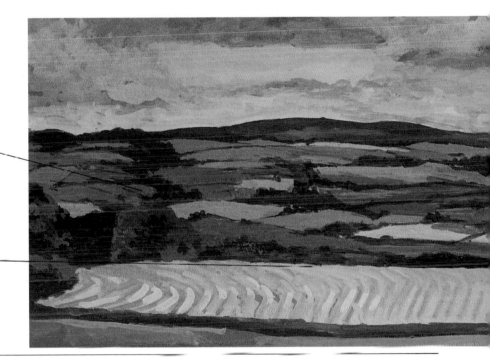

▼ Watercolor lifting out

1 *Having laid several loose washes, working wet into wet to create soft effects, the artist now uses a piece of crumpled paper towel to lift out some of the wet paint.*

2 *The undersides of the clouds have been darkened – the color will dry lighter than it appears here – and the paper is used again to lift out small cloud shapes.*

3 *The effects achieved are extremely realistic, and the method is surprisingly easy. A natural sponge can be used in place of absorbent paper, or for fine lines of highlight paper can be rolled into a point.*

Perspective in landscape

One way of creating the illusion of space in a landscape is through aerial perspective, which causes colors to become paler and cooler as they recede, and tonal contrasts to diminish. But don't ignore linear perspective, such as the sides of a path or river converging in the distance or a row of trees becoming progressively smaller.

Working drawing made from on-the-spot sketches and photographic reference

Materials and technique

Oil paints
●
Turpentine and painting medium
●
Bristle brushes
●
Primed canvas
●

To achieve his delicate, luminous colors, the artist uses white canvas, which reflects light through the thin paint. Here he is working with the canvas taped to a board.

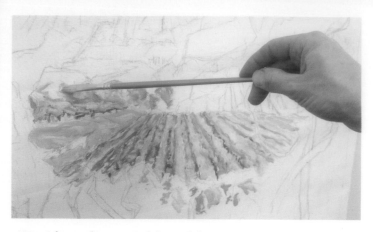

1 *After making a careful pencil drawing on the canvas, the artist begins working from the middle of the picture out. He holds his brush near the end of the handle to avoid tight, fussy brushmarks.*

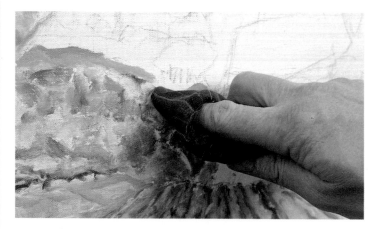

2 *A rag is used to smudge and soften the color. The paint is applied thinly, diluted with turpentine and a synthetic painting medium, which dries faster than traditional linseed oil.*

3 *Because it was important to gauge the exact tone of the sky correctly, the hills have been painted first. The near-white now used provides a base tone, into which other delicate colors will be introduced later (see finished picture).*

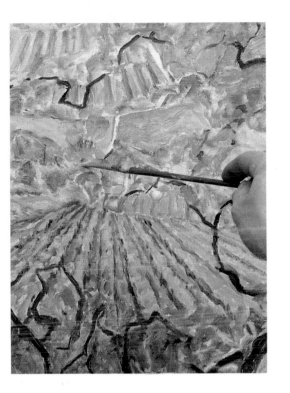

5 The perspective lines of the field in the middleground, which give a feeling of movement as well as emphasizing recession, have now been strengthened, and final touches are given to the trees beyond.

4 The trees and fields are built up with individual brushstrokes of separate but related colors. Foreground and middleground are developed simultaneously, as the artist does not want too obvious a division between these areas of the picture.

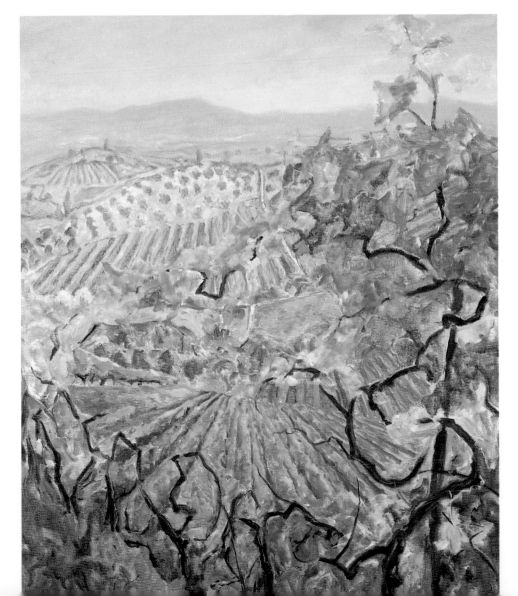

◄ **Gap in the Vines**

The lines of the central field and pattern of tree beyond lead the eye to the similar patterning of fields and hills on the left, receding toward the far hills. PATRICK CULLEN'S painting combines a feeling of space with a strong pattern element, taking its key from the twisting shapes of the vines in the foreground.

Working from a photograph

There is no reason why landscapes should not be painted from photographs, but you will have to exercise all your artistic ingenuity to make sure that your painting does not simply look like a copy. Try to make your brushstrokes or marks express the forms and give a feeling of life and movement.

Dark tree interferes with lines of nearer trees, so is knocked back in painting

Distant trees simplified into broad shapes to give solidity

Garish greens translated as golden browns, with a few touches of green

Materials and technique

Charcoal

●

Watercolors

●

Sable brushes

●

Soft pastels, pastel pencils

●

Tinted pastel paper

●

The (Ingres) paper used here is relatively thin, and as the artist is using wet-brushing pastel techniques, she has stretched it in advance to prevent buckling.

1 *A preliminary drawing has been made in charcoal, and the artist now works in watercolor. This mixes slightly with the charcoal and is modified by the gray paper to give an effect quite different from that of watercolor on white paper.*

2 *Strokes of dark pastel applied over the charcoal drawing are spread with water to create a soft effect. This technique, called wet brushing, turns the pastel pigment into a paint-like substance.*

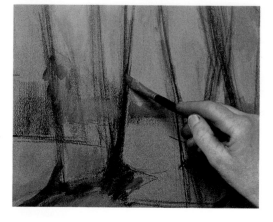

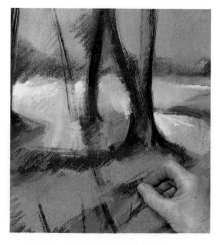

3 *You will often find that certain areas in a photograph are ambiguous or muddled, and thus need to be simplified in the painting. This area of distant water is treated as a broad shape, with varied pressure on the pastel stick creating slight shifts of tone.*

4 *Reflections are always directly below the object itself and lean in the opposite direction. When a reflection is broken by a piece of land, as in this case, it is vital to ensure correct placing and continuity, so the artist has drawn a line from the left-hand tree to the foreground stretch of water.*

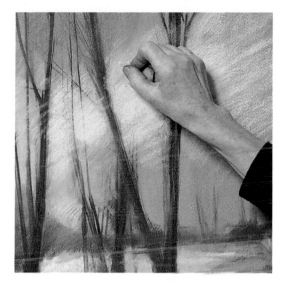

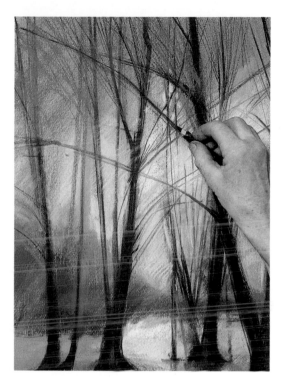

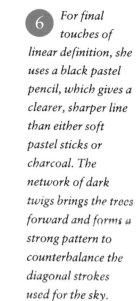

5 In the photograph, the sky was a flat, featureless area, but the artist imparts excitement and movement by using bold diagonal strokes made with the tip of a white pastel stick.

6 For final touches of linear definition, she uses a black pastel pencil, which gives a clearer, sharper line than either soft pastel sticks or charcoal. The network of dark twigs brings the trees forward and forms a strong pattern to counterbalance the diagonal strokes used for the sky.

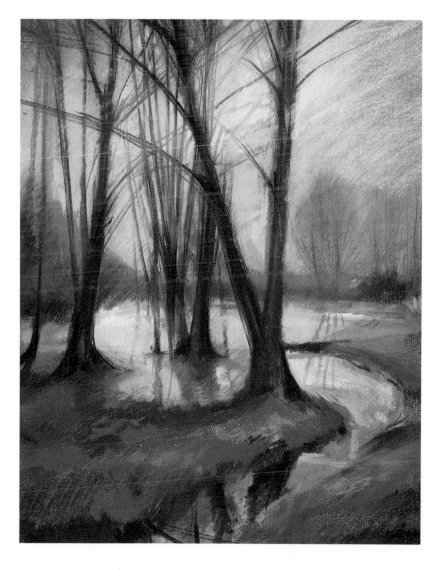

◀ **Winter Floods**
Compare this painting with the photograph and you can immediately see how JULIET RENNY has used her knowledge, experience, and technical skills to produce a work full of atmosphere and excitement. Notice particularly how she has exaggerated the swell of the land in the foreground and the angle of the central tree, which leans over in a diagonal that balances the curve of the stream.

Painting water

Although there are often many different colors and tones visible in still water, it is essential to remember that you are dealing with a flat plane. It is easy to destroy this impression through over-busy brushwork or too much contrast of tone. The high viewpoint here emphasizes the flat expanse as well as allowing individual colors to be distinguished.

Contrasts of tone and color diminished with distance

Boundaries of colors are distinct, but relatively close in tone

Tonal contrasts much stronger in land area

Materials and technique

Acrylics

●

Bristle and soft brushes

●

Heavy watercolor paper

●

Because acrylic dries fast, it allows for a variety of layering techniques. The artist's method is to begin with an underpainting in brilliant colors and modify them as the painting progresses.

2 *A comparison between this stage and the finished painting shows the artist's method very clearly. In the initial stages the picture, with its vivid colors and strong shapes, is almost abstract in concept.*

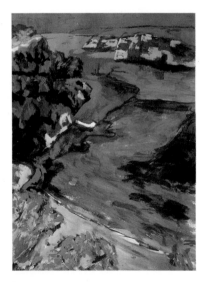

4 *Successive layers of color are laid over the red underpainting, parts of which are deliberately left uncovered to set up exciting contrasts. The predominance of horizontal brushstrokes describes the surface of the water, and in the nearest areas they are varied to suggest the gentle movement of small ripples.*

1 *The main lines of the composition have been sketched in red, and a middle-toned purple, which will later be partially overlaid with lighter colors, is used for the distant areas of sea.*

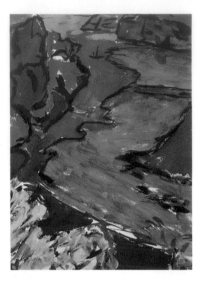

3 *The transformation into a recognizable seascape has begun, with the distant water pushed away by an overlay of lighter color and the left-hand area of cliff and tree built up with bold brushstrokes of black, blue, and green.*

5 The trees in the foreground are now strengthened with black and dark green laid over reds and yellows. It is often helpful to leave the foreground until a relatively late stage, as once the other colors are in place it is easier to decide what this area needs in order to pull it forward in space.

6 The sailing boat plays an important part in the composition, as it forms a focal point, leading the eye in over the sweeping expanse of water. The boat in the photograph is white, but the pale blue used here integrates better with the overall color scheme.

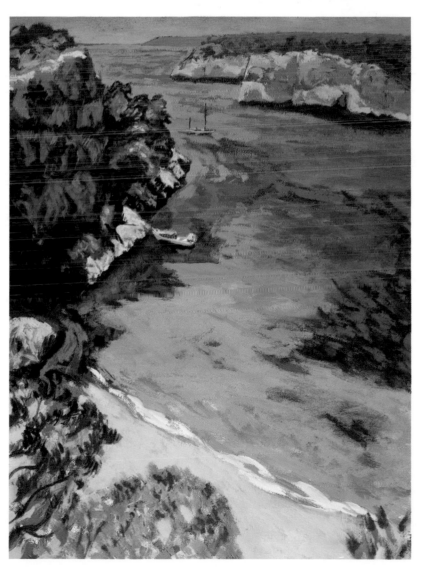

◀ **Rocky Inlet, Minorca**

Some artists dislike working from photographs, but DAVID CUTHBERT finds them a useful jumping-off point for the development of his own pictorial ideas. It is interesting that the sense of space and recession is much greater in the acrylic painting than in the photograph, partly because of the heightened colors in the foreground and partly because of the sweeping brushstrokes leading around the picture and toward the far cliffs.

Still life & interiors

Working on a still-life arrangement or a home interior allows you to study your subject on an intimate scale, with great concentration and, if you wish, over a prolonged period. You can experiment with changes to the direction of the light source, your own viewpoint, the format of the piece, the different painting and drawing media, and your own interpretations of color, tone, and mood.

You can approach both these types of subject matter in one of two ways, either arranging and controlling the set-up or using a natural, "found" group of objects or interior scene. You are free to set the pace and actual scale of the work, reworking the image over time if need be. You can look at the relationships of form and space on a small or large scale, in terms of basic shapes or contrasting detail. It can be useful to make a series of studies on

◀ **Rose**

In a floral still life, simplicity is often the best course, and in this oil painting JAMES MORRISON *has paid homage to the beauty of the single bloom in its unpretentious container by allowing it to stand on its own.*

Directional lighting gives a spotlight effect, creating strong highlights

Near-black background shows up vivid color of flower and shapes of leaves

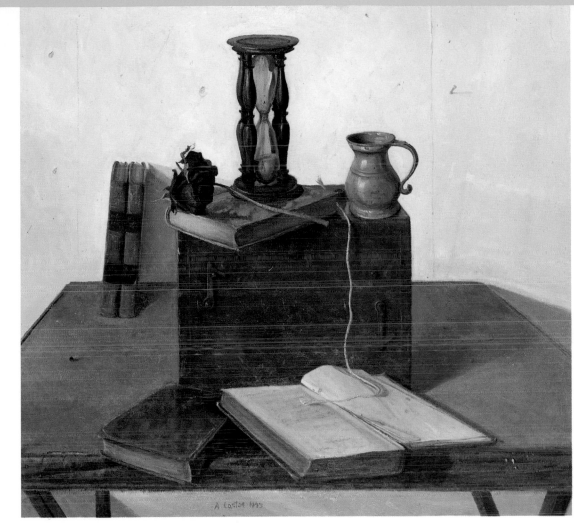

◀ **Still Life With Old Books**

Many still-life painters aim at a natural look, but the arrangement in ARTHUR EASTON's oil painting is formal and deliberate, with colors and textures chosen to exploit the theme of age — even the tabletop is torn and battered. The colors, although muted and low-key, are deep and rich, and the attention to texture imparts a tactile quality to the image.

one particular theme, gradually varying the complexity of your techniques to explore different aspects of form.

Organizing a still life

A good way of concentrating your interest on the forms in a still life is to choose the objects rigorously and set up a highly controlled arrangement. It is easy to make a cardboard "stage set" with a square base flanked by two sides made from a longer piece of cardboard folded at the center. It can be neutral — white, black or gray — or a distinctive color. Even this basic, initial choice introduces particular properties of tone and color which will influence the overall grouping and the interaction of form and background.

In this setting, arrange a few objects that are similar in scale; for example, everything fits into your hand or is roughly equal in

Dull diffused highlights used for pewter surface, a less reflective metal than silver or copper

Layering of paint, with light scumbling and scratching techniques to describe texture of old wood

Writing on book suggested with light brushmarks following plane of paper

height. Try color coordination or a restricted scheme; choose objects that are all blue, say, though the blues may be different in character; or include two things of one color and another that slightly contrasts. Use a limited number of objects — arrange them in different

▶ **Summer Dahlia II**

In any still-life painting, whether the subject is flowers, assorted objects or a combination, it is important to set up visual links between the different elements. Here WILLIAM C. WRIGHT *has used the strong shadow both as a compositional balance for the flower group and as a linking device, which effectively pulls the small objects within its orbit.*

Dark background painted around flowers and stems to reserve them as highlights before lightly modeling the forms

Shadow reinforces painting of flower itself by echoing shape; also provides contrast for shapes of fruit

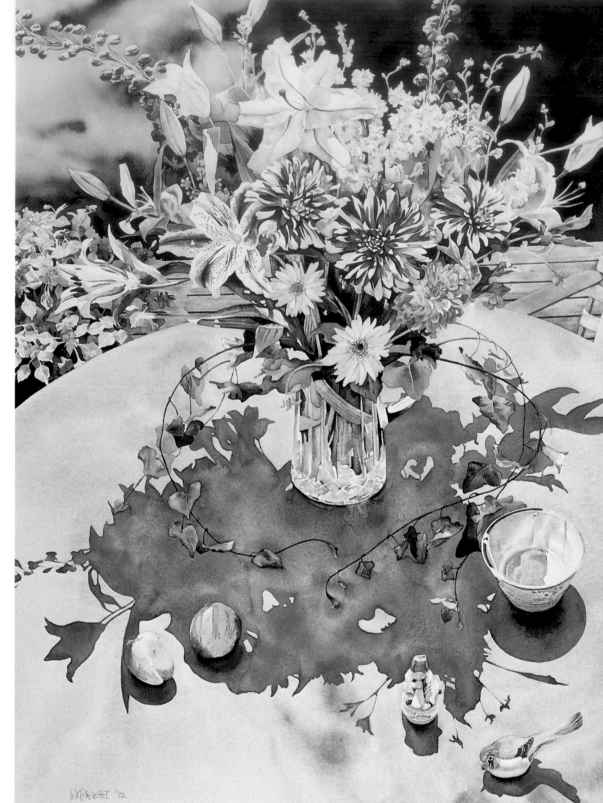

ways, and be prepared to discard some rather than overcrowd the group. You could introduce a sense of narrative by combining natural and man-made objects, such as a couple of matchboxes and a twig; or things that are similar in shape but very different in feel, such as three stones and a hen's egg.

If you put discipline, thought, and understanding into making your selection, it should be possible to create a theme that can be studied over a long period and give back something every time. This will be reflected

in the pictures that you make. You can decide to focus on one aspect of the still life – color or tonality, contour or surface texture – so that the intention of each image is clear, and may even guide you to the most suitable medium and techniques.

When you have experimented with this kind of organization and gained experience of how forms appear in the small world that you have made, you can start to look for more transitory or random motifs that you need to work on quickly. These might be subjects that will deteriorate, such as cake on a plate, fresh fish in a paper wrapping, ripe fruit in a bag, or blossoms ready to drop from their stems. Or they could be chance arrangements, such as an unmade bed, or your brushes, paints, and palette laid out ready for work.

As you start to develop a keen eye for interesting combinations of form, and the confidence to draw or paint them rapidly and decisively, you will increasingly see the potential for impactful images in everyday things. Challenge yourself by working on an arrangement that you really enjoy, then one you really dislike, to find out how both may provide you with a painting that is interesting technically and visually.

Work on similar principles when arranging larger still lifes. Start with a set-up you can organize and control, then move to more complex groupings. Choose similar types of objects, but isolate one by its color; or include an "unreal" thing, such as a postcard, snapshot or drawing, with three-dimensional objects. You can base a still life on an activity or theme; for example, the ingredients of a recipe and the kitchen utensils you need to prepare the dish. Introduce reflective objects to test your ability to identify local and reflected color (if you find it difficult to sort out what you are seeing, try isolating a color by looking through a lightly clenched fist).

On a still larger scale, you could draw or paint a weathered boat and some sailing equipment, contrasting old and new. There is an endless permutation of subjects both inside and outside your home.

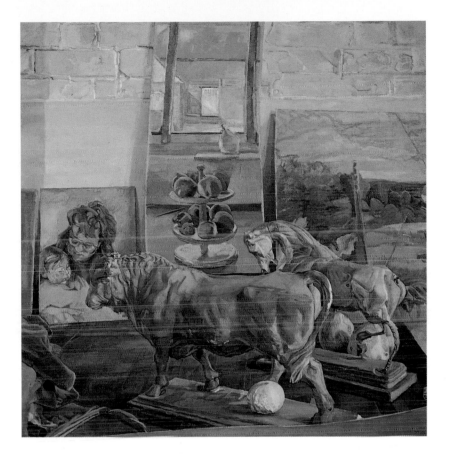

▲ Studio Still Life

A still life can tell a story by making reference to the artist's interests and lifestyle. In this oil painting, DAPHNE TODD's own paintings and objects give a glimpse into her working life.

Circles are natural eye-catchers and thus form a focal point in the composition

Intriguing juxtaposition of sculpture (three dimensions) with painting (two dimensions)

▶ **Studio in Buchgrove**

A still life can be contained on the surface of a table top, but in an interior you are dealing with a larger unit of space, and the composition can be harder to structure. NAOMI ALEXANDER has chosen the mirror, with the suggestion of a reflected face, as the focal point for her oil painting, with the cabinet and wall beams providing diagonals that lead in to it.

Shadow balances shape of mirror top and near side of cabinet

Reflection in mirror treated very broadly; too much detail would detract from rest of picture

Interiors

An interior can seem like a large-scale still life, but because of the size it is important to organize your viewpoint and determine the composition. Try to find an angle that creates a focal point within the setting, but to balance the composition so that the focus is not the center of the picture. You can start by composing the interior view itself – moving furniture, opening a door, rearranging the smaller objects – or you can keep the scene exactly as you find it and draw or paint the chance combination of shapes.

Avoid thinking of interiors only in terms of ordinary rooms. They can include your car, a cupboard, the greenhouse or the garage. It is also possible to draw in public places – a church, café or museum, for example – which provide a greater sense of space and a variety of objects within the space that relate to its function.

Subdivided spaces make attractive, intricate compositions. Try looking up through a hall and stairway, using the stairs and guard rails to break up the composition. Find alcoves and niches that deepen the space with dark shadows, or a concealed window that sends an unexpected shaft of light through a dim interior. Open doors that lead from one

room into another to divide the overall view into a succession of discrete spaces. Position a mirror to reflect the opposite corner of the room at an unexpected angle. A small element of surprise or mystery produces a more striking, imaginative composition than a familiar everyday view, but the ordinary things that help to identify and color the space – furnishings, books, potted plants – are still present.

Interiors are good subjects for suggested mood and narrative. Lighting can have a special role; consider the contrast between a living room or bedroom in soft lamplight and a bathroom with pale, diffused light reflecting off a variety of surfaces. Whatever the shapes, the opportunities to experiment with color and shading are broadly different. If you take a view from the inside out, you can play a game of contrasts; place a chair and cushions outside the door and a vase of garden flowers on a shelf or table inside. This links two kinds of situations by an interchange of shape, color, and texture.

An interior is, almost by definition, a place that people inhabit. Their absence can create an implied narrative, which you can emphasize with small visual clues, such as an opened letter, a television switched on, or discarded gloves and keys. These are the elements of life in motion, grasped in passing. If you want to include a figure, bear in mind that the eye is naturally drawn to people above all other subjects. Position the person near the edge of the frame, partially masked by something.

Curves of body and head counterpoint predominant straight lines

Composition based on interplay of light and shadow giving strong tonal structure

▼ **The Penitent**
This figure in this oil painting by PETER KELLY *has a three-fold role. It provides a focal point, balances the figure of Christ on the wall above, and enhances the mood of quiet contemplation.*

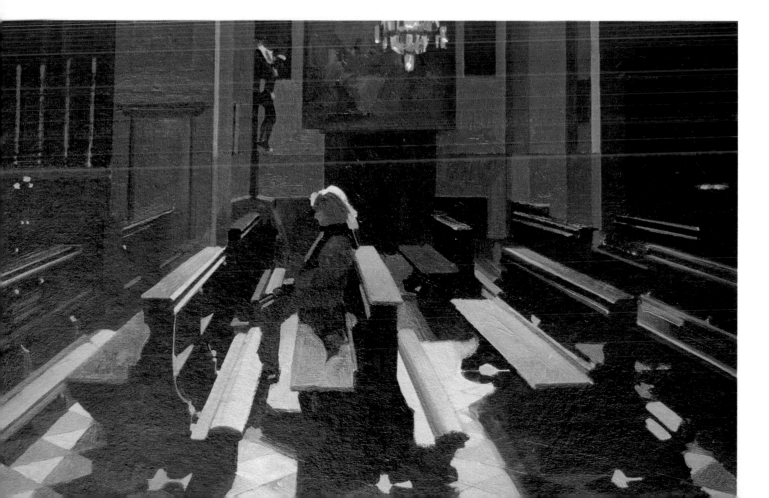

PROBLEM SOLVING

Lighting and perspective

To make the objects in a still life appear solid, it is wise to pay careful attention to lighting before you start painting. If the light from a window is too bright, casting shadows that confuse the forms, put a piece of tracing paper or other diffuser over it. Another common cause of failure is poor observation of perspective effects – if the table top on which objects are placed appears to slope uphill, the objects themselves will lack realism, however carefully the individual forms are treated.

▶ **Dual light source**

Gentle sunlight from a window delicately models the forms and creates a dappled pattern of light and shade in RIMA BRAY'S oil painting Daffodils *(detail). Back-lighting, with the light source directly behind the objects, can create a semi-silhouette effect, but here there is another light source on the left, as can be seen from the cast shadows beneath the pots.*

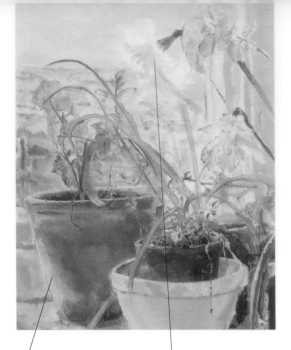

Light from left creates soft highlighting on side of pot and cast shadow beneath

Light from behind silhouettes flower, described mainly by shape

▶ **Single light source**

For his watercolor The Mum, WILLIAM C. WRIGHT *has deliberately chosen hard, bright light which, although it makes the individual forms more difficult to read – notice the surprising transitions of tone on the small jug – it casts strong shadows that play an important part in the composition. Form and depth are created more through linear perspective than by tonal modeling on the objects.*

Construction lines of table closer together at far end, according to law of diminishing size

Clean, straight lines of shadows important in describing table top

Slightly converging sides of book, plus shadow on right, establish flat plane

▼ Perspective

The drawing (right) shows perfectly how even slightly incorrect perspective can destroy the effect of solidity even when the forms are well modeled. In URANIA CHRISTY TARBET's pastel painting, Evening Serenade, the table is explained by the central pattern line and the ribbon draped over the end, while the forms of flowers and vase are modeled by light coming from above and to one side.

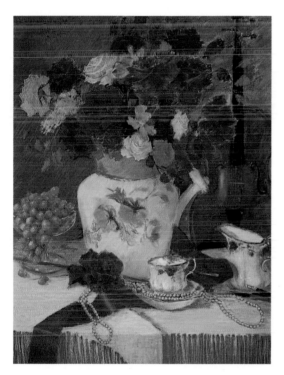

Wrong perspective makes the table appear to slope upward

Ellipse incorrect (too open), contradicting modeling on form

▲ Ellipses

Remember when drawing ellipses that a circle always fits into a square. Practice drawing circles, starting with a square, marking the center lines both ways and then drawing in the circle.

Draw a square in perspective, and repeat the exercise, thus producing an ellipse. The horizontal center line of the square will be nearer the back than the front, resulting in a wider curve at the front of the ellipse.

When drawing a cylindrical object, always mark in the center to help you get both sides of the ellipse equal. Draw the whole ellipse even if you can't see it; you can erase unwanted lines later.

Varying the textures

Texture is a common theme in still-life paintings, many of which exploit contrasts between hard and soft objects, and matte and reflective surfaces, such as fabrics and metals. Vegetables make an attractive still-life subject and can be chosen to make the most of this kind of contrast. Pay particular attention to highlights, as these describe both the forms and the textures and impart solidity.

Clear, near-white highlight

Rough texture creates broken lines in pattern

Softly diffused highlight

Cast shadow helps to decribe shape of object

Materials and technique

Watercolors

●

Sable brushes

●

Heavy medium-surfaced (cold-pressed) watercolor paper

●

Watercolor is often seen as a difficult medium, but in fact it can be controlled very precisely. The classic technique of building up from light to dark is used, allowing the washes to dry between stages except where she wants softer wet into wet effects.

1 *Very pale washes are laid over the eggplant, the red pepper, and areas of the board, with each color kept separate so that one does not run into another. The highlight on the eggplant is reserved as white paper.*

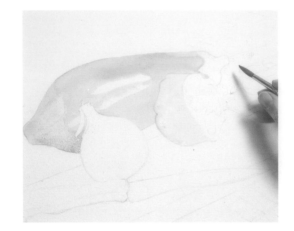

2 *The shadows on the eggplant create subtle variations of color merging gently with no obvious boundaries. The artist works wet into wet, dropping darker colors into a still-wet wash. The top of the highlight is now soft and blurred, with the lower edge remaining crisp.*

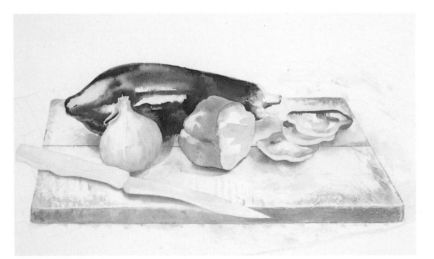

3 *The painting is now at the halfway stage, with the washes still light, but the forms and textures beginning to emerge. The marks on the surface of the old wooden chopping board have been very accurately rendered with small individual strokes made with the point of the brush.*

4 To avoid dirtying or smudging a watercolor painting it is best to work from back to front, so the cloth has been left until the final stages. Tiny brushstrokes are made, again with the point of the brush, to create the effect of the pattern on the rough texture.

5 These touches of reflected color on the surface of the knife need careful handling or they could destroy the impression of the flat plane. Color is touched in very lightly, and the edges softened with a damp brush.

▼ Vegetarian Lunch

The forms and textures of the vegetables and other objects are convincingly portrayed, with the matte surface of the onion contrasting with the shiny pepper and eggplant. Notice how the shapes of the highlights describe the forms, and how the accurate observation of the lines of pattern on the cloth suggests the slight undulations.

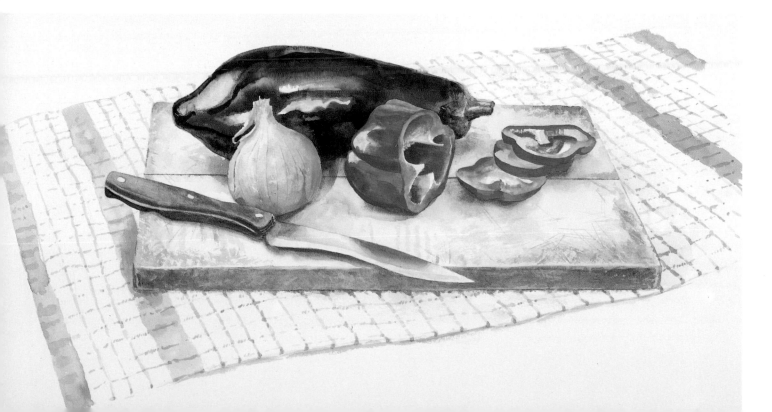

Shadow patterns

Light and shadow can form the main theme in a subject, where cast shadows will help to describe the forms. Here the shadows are clear because they are thrown on the flat plane of the floor, and because of the effects of perspective, they form a series of strong diagonals, increasing the depth.

Light shade omitted in painting, as it weakens the composition

Width of window increased in painting to make squarer shape

Circle of table provides counterbalance for diagonal shapes of sunlight and shadow

Materials and technique

Soft pastels

●

Oil pastels

●

Mi-Teintes paper

●

Because the subject presents a strong contrast of tones, the artist has chosen a dark-colored paper. This means she can begin with the whites and lighter colors, and be sure they are not too light.

1 *The artist begins with the window, which is the focal point of the picture. Using soft pastels, she blocks in separate areas of color, leaving parts of the paper bare for the top window bars.*

2 *She now works on the still-life group, varying both the direction and pressure of the strokes. In places she has used diagonal strokes and pushed the pastel into the paper so that it fills the grain.*

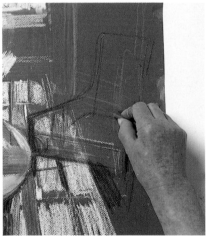

3 *Diagonal strokes of white following the perspective lines have been used for the patches of sunlight, and the chair is drawn on top. The darker color is modified by the white beneath, suggesting the fall of light.*

4 *The edges of the shadows must be straight and true, so a piece of newspaper has been used as a mask. Oil pastel has been used here, as it does not smudge. The paper is now removed, revealing a crisp edge.*

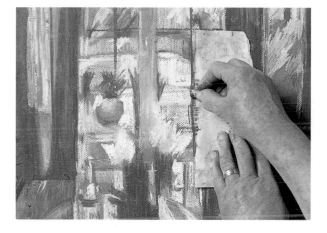

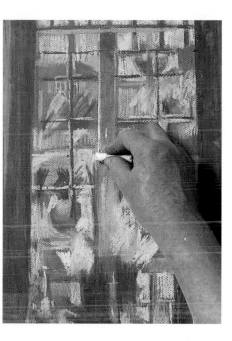

6 When working in pastel, it is usual to leave the small, crisp highlights until last, as they can easily become smudged. Here firm lines are drawn with a white oil pastel stick.

5 The edges have been continually sharpened and reinforced, and the paper-mask method is used again with oil pastel for the window bars. Oil pastel can be laid over soft pastel provided there is not too heavy a build-up of pigment.

◄ **The French Window**

When dealing with a subject that presents two distinct "units of space" – the interior and the landscape view – it is important to create visual links which unify the composition. PIP CARPENTER has done this through color; notice that the pinks seen outdoors find echoes in the vase of flowers on the left, the reflections of the table top, and the highlights on the chair, while the muted purple of the roof outside reappears on the interior walls.

Figures & portraits

Seeking the form when drawing or painting people is probably more difficult to resolve than with other subjects. Making a representation of another person calls on the familiarity you have with the ways people move, behave, and change their appearance. With a portrait, the problem is making a likeness. Supposedly, the camera never lies, but we often see a photograph that does not look like the person. As an artist, you must sharpen your perception to see things that an untrained eye would not. This discrimination is one difference between an average snapshot and a drawing or painting.

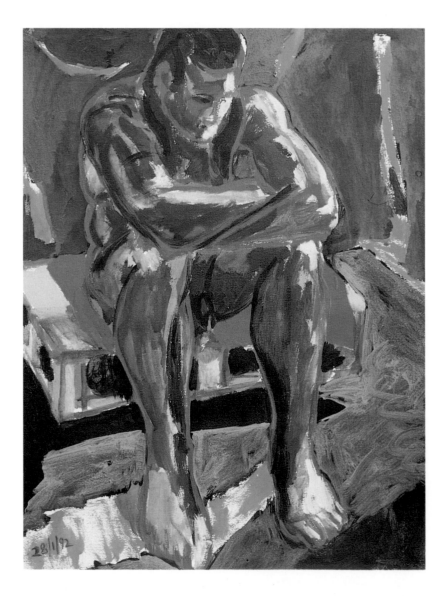

P eople have always been of the utmost importance in art, and examples of symbolic use of figures to express moods and themes are countless. Because of the natural tendency to identify with a figure in an image, there is almost always a narrative involved, real or implied. To make this work, you need to have a clear sense of what you are looking

◄ Arms Folded

It is surprising how far you can depart from strictly naturalistic color and still give a convincing account of a subject. In David Cuthbert's *acrylic painting, all the colors have been heightened, yet the forms have great strength and solidity.*

Strong side-lighting creates shapes describing muscles

Cool greenish brown models form of leg; patch of red suggests reflected color

for in the form and presentation of a single figure or figure group. Are these real people or a type of person; how important is their individuality? Are they directly connected to each other, randomly grouped, or isolated in their setting?

Your task is to use the shapes and forms in a descriptive way and to make your picture expressive. This may not mean constructing a detailed rendering – many very lively figure compositions have an almost abstract sense of shape, tone, and color. But it is essential to select your visual information knowingly and understand what makes it particularly expressive of physical form or mood. This can be difficult to decipher and even more difficult to translate into an image: inexperienced artists often leave faces and hands blank, for example, because it is not easy to draw them convincingly; clumsy detail can destroy a picture that is up to that moment working well. But these particular details tell us most about the character and mood.

Individuals and groups

In a life class or any situation where it is possible to control the light, you will be able to work out how best to position a single figure and light the person so that the subtle forms are revealed. With every subject, seeing and understanding the form is the essence of being able to paint it; the practical techniques can be learned to some extent separately, but ways of handling your materials are also suggested by the exact form, tonality, color, and texture of the thing you are looking at.

Look for the figure's characteristic stance and watch carefully how it is emphasized by the light source. In daylight indoors, a figure is often seen as a partial silhouette, or horizontally lit by a window. Artificial lighting can give dramatic emphasis to the poses and gestures of people reading, watching television, or playing an instrument. Outdoor light can create quite dramatic tonal contrasts – strong sunshine on a beach or in a park, for instance.

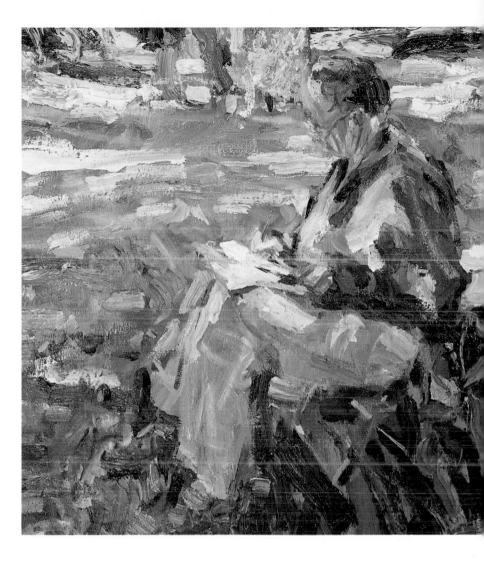

Brushstrokes of thick paint follow direction of forms

Light striking shoulder provides descriptive shape

Warm yellow for highlight area; cool mauves and greens where form turns away from light

▲ **Afternoon Class, Derrimeen**

This figure is cleverly meshed into the landscape setting by the use of separate patches of color that create a lively picture surface. Although there is no detail in this oil painting by ARTHUR MADERSON, *the forms of the figure emerge clearly through the play of light and shade, aided by directional brushwork.*

▶ **Portrait of the Artist's Brother**

In a figure drawing done for study purposes, you need not worry unduly about composition, but it becomes important when a figure is seen in the context of a landscape or interior. A figure will always be the focal point, so you must provide balances and other areas of interest. In this oil painting by PAUL BARTLETT, *the wealth of detail prevents the viewer from focusing on the figure alone; the eye is encouraged to travel from one area to another.*

Strong vertical leads eye from figure to foliage outside window

Careful attention to surface texture creates foreground interest

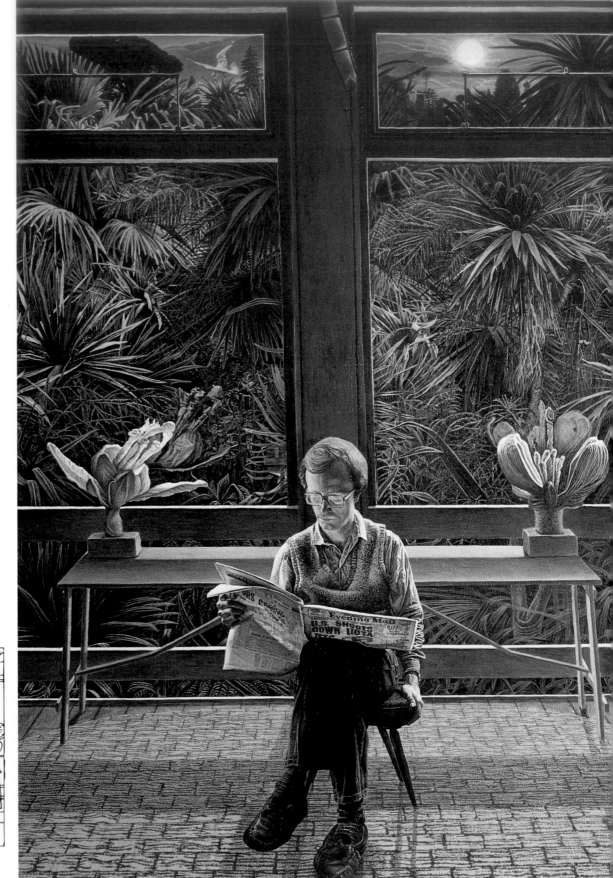

If you are prepared to identify and play up contrasts that show a characteristic sense of form, you can often obtain a livelier representation than one achieved by smooth tonal gradation, which can restrain rather than enhance the impression of form and depth. You can also make use of incidental color and texture – clothing and accessories contribute pattern, color, and other definitive details that help to create an impression of the person's mood and attitude.

Groups of people are less to do with individual expression, but display elements of combined activity that a solitary figure could not convey. Large figure groups are rarely attempted, but you could try a family group portrait, trying to capture something about the relationships of family members. The way in which people who know each other group themselves is revealing of physical likenesses and differences, and their body language constructs a believable composite image which can then be developed by looking at the individual forms of the figures. With random groups outdoors or in public places, you can see who is the center of a group, who is isolated, and the purpose of their being in that location. All these things are part of a narrative that is described by the relationships of figures in a given space.

Movement

Except in a life class, or for artists whose professional work is portraiture, the opportunity to study a posed figure or group over a sustained period is rare. Often you have to deal with relatively transient events, and movement is part of the attractive quality of the subject. If by now you have a basic familiarity with ways of representing form and the capabilities of your medium, it should be possible to work spontaneously and instinctively. A clear understanding of what you want and regular practice enable you to break into a subject that presents practical difficulties.

Anatomical study is by no means essential to successful figure drawing, though some artists still pursue this kind of academic

*Light hatching lines
model forms of breast
and arm*

*Lost edges suggest
rounded form turning
away from light*

▲ **Louise**
*This lovely drawing
in red conté crayon
by* VICTOR AMBRUS
*illustrates the
expressive quality
of line.*

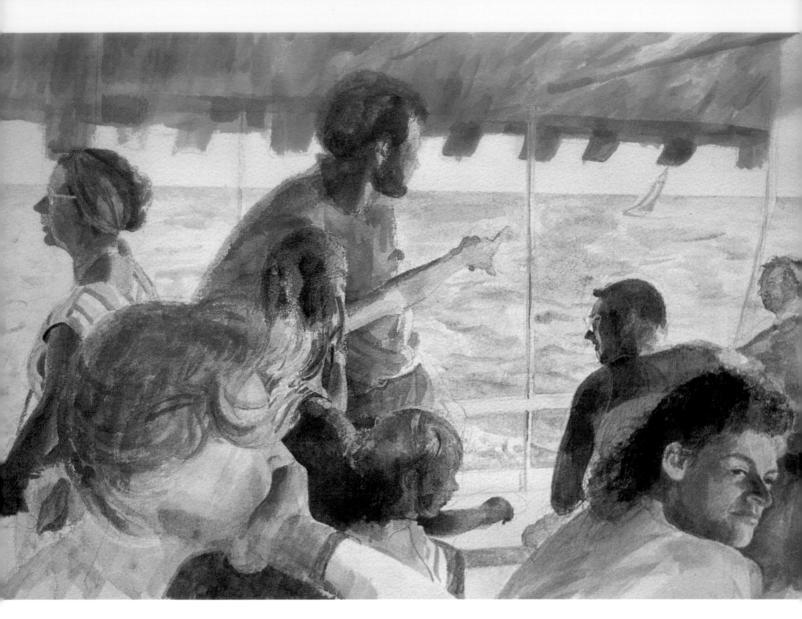

Head of central figure
overlapping awning to
define relative positions
in space

Outstretched arm
draws attention to
expanse of water,
emphasizing space

▲ **Ferry La Rochelle**

In a figure group, it is essential to find a way of expressing the relationship between the people, both pictorially and in a "narrative" sense. In BRIAN DUNCE'S *watercolor, the figures overlap one another and are enclosed in the unit of space defined by the awning.*

approach out of interest in traditional forms. As with most kinds of impersonal study, it is possible to lose contact with the personality of your subject if you are dealing too objectively with form and structure. But there is a basic geometry to the figure which it is important to understand in order to analyze movement quickly. Train yourself to be a "people-watcher," both at home and in outside situations. If people are doing household tasks such as sewing or cleaning, pursuing a hobby such as painting or playing music, you will see both the natural alignment of body parts in particular stances and movements, and repeated actions that give you a chance to study the relationships of particular shapes and forms more extensively.

Constant sketching helps to sharpen the eye, and you can build up a file of reference material that will contribute to more formal compositions. Look at people walking and note how the fabric of their clothing responds to movement. If you can get a high viewpoint, select a group of figures walking toward you and make some rapid line drawings while the figures are still distant; as they move closer, select more and more detail such as sun on limbs, sway of fabrics, shaded faces under hats, tension and balance in the body from walking, carrying bags, pushing a buggy or riding a bicycle. Look for the way people bend over to talk to a child. In continuous sketching, you make bold and essential decisions about your subject in only a few moments. Some of your drawings will be incomplete, but the basic forms will be there, with the added force of movement.

Portraiture

You can achieve a good, even inspiring composition from a landscape or still-life subject, say, which may have traveled some way from being a strictly faithful rendering of what you see. But in a portrait, both the physical features of the sitter and the person's character have to be transcribed. A true likeness is especially difficult because it is not only a matter of getting figurative shapes and details into the correct relationships, but also of getting the living impression of the sitter into the image.

This is something that becomes easier as both your technique and observation improve. In looking for forms in the face, imagine how you explored a landscape. Start with whole shapes and contours – the overall planes and curves of the face – then fit the detail into place. Look for the proportions of brow, nose and chin, the recessing of the eyes, and the way folds and wrinkles relate to the way the face is used; laughter or frown lines and the curve of the mouth say something about how the person presents him- or herself to the world.

Hands are often included in a portrait because they are perhaps the most expressive

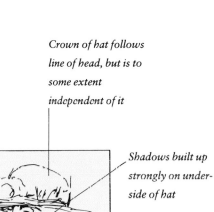

Crown of hat follows line of head, but is to some extent independent of it

Shadows built up strongly on underside of hat

Bony structure of face visible on cheekbones and nose

▼ Sophie

Clothing and headgear can be helpful in portraiture and figure painting, as they will often aid your understanding of forms and angles, so look for clues, such as the way a cuff provided a contour line around the wrist. In this delightful conté crayon drawing by VICTOR AMBRUS, *the line of the hat precisely defines the angle of the head.*

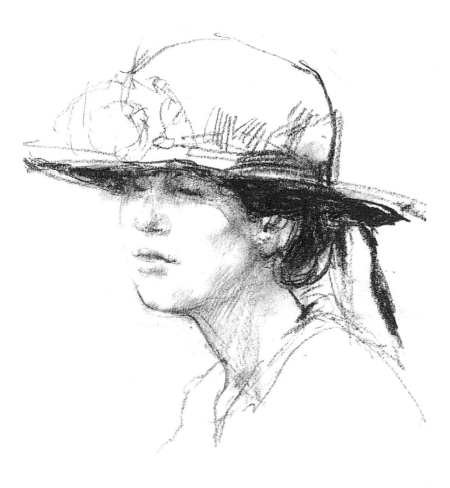

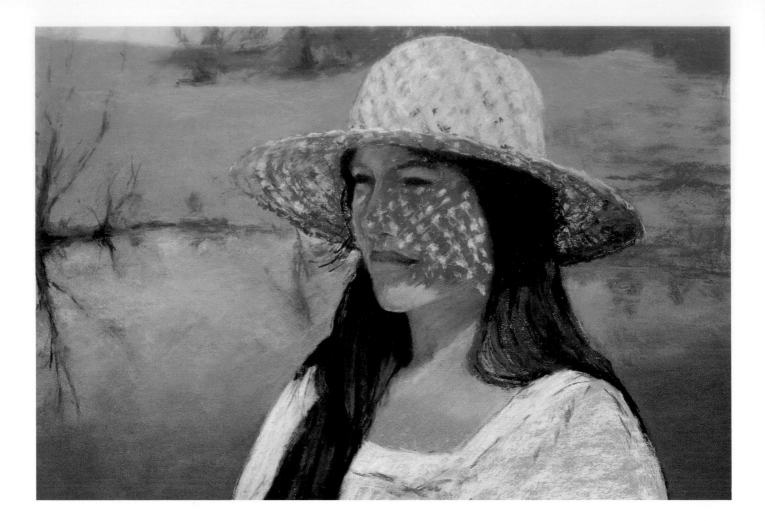

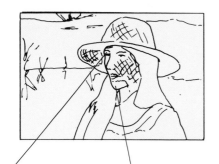

Reflected light creates soft modeling on brows

Direct sunlight strikes chin to create shape that could be ambiguous

▲ Reflections

In this pastel painting, Urania Christy Tarbet *has used natural light from above to model the forms and to create a lovely lace-like pattern over the face.*

part of human anatomy after the face. Try to associate the hands and face within the composition in a way that expresses personality or mood. Hands are not easy to draw, and foreshortening can create some apparently curious shapes, but if you can get them right, they read convincingly as three-dimensional form. Think about the pose and

viewpoint as an expression of mood — upright and formal or relaxed and fluid. Use color to emphasize character, as with dark clothing against pale skin, or colorful, patterned clothing, jewelry and a hat to help convey an outgoing personality.

Lighting is important in revealing the forms of both face and body, or as much of the figure as you include. Check that the light source helps to define rather than disguise the form. Ask the sitter to move if you see that the light flattens the structure of the head, or casts confusing shadows. Look for reflected colors and tones that describe the curves of cheek, jawline, neck, and shoulders. Use the light to model clothing that drapes easily across the body or expresses tension in fabric folds radiating from points of stress.

Consider the background very carefully: how much detail, what kind of tonality? A fussy background can detract attention from

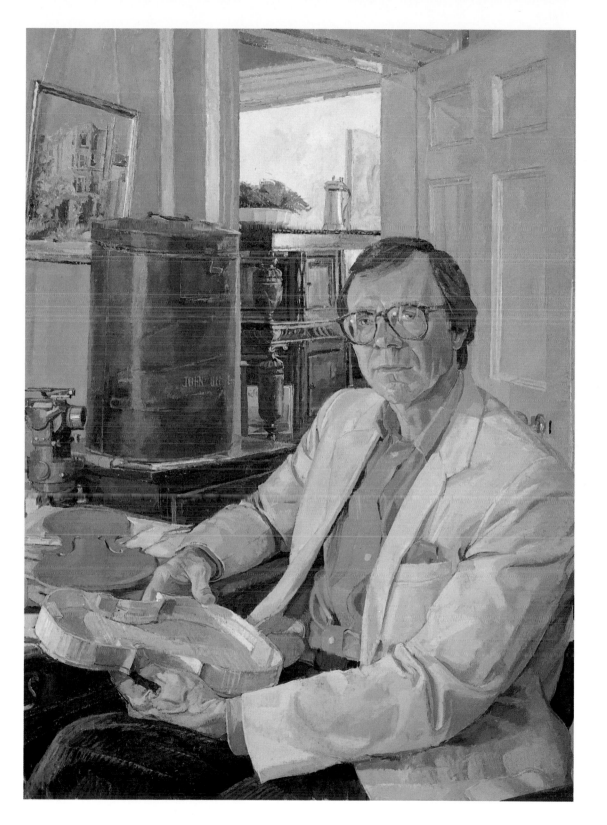

◀ **Professor John Uff**

For this oil painting, DAPHNE TODD has employed what is known as three-quarter lighting, which is much used in portraiture. She has also made use of another device common in portraiture, that of giving clues about her sitter's character and interests by showing him in a home or workplace environment, surrounded by familiar objects or tools of the trade.

Light coming from in front and slightly to one side illuminates three-quarters of the face

Eyes looking out of picture toward viewer emphasize face as focal point

the sitter, but may help you to disguise unresolved elements of form in the composition as a whole. Shadowy surroundings throw the figure into relief dramatically, but a strong, colorful background can give zest to the portrait. Keep in mind that this aspect of the pose – the space around the figure and incidental props, as well as the face and body of the person – also contributes something to the mood or narrative of the picture.

PROBLEM SOLVING

The human face

Because the human face is a complex structure, it can be difficult to see the wood for the trees when drawing and painting. Start by looking for generalizations – when you tackle a portrait, try to identify the basic shape of the face and head, and the predominant color of the skin. If you are painting rather than drawing, avoid using a small brush to outline features such as eyes and mouths, as this will destroy the solidity of the head; instead, build up the main planes of the face first, leaving details until the final stages.

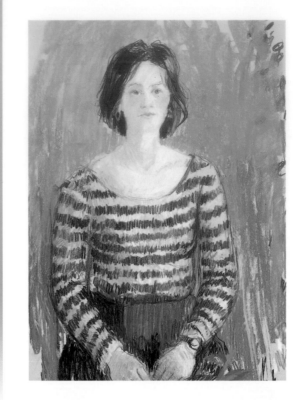

◄ Facial features
As we saw in the first chapter of the book, form can be described by varying the quality of the line. In the painting right, the lines are uniformly hard, and the face looks flat, with the features appearing to have been added as an afterthought. In GLENYS AMBRUS'S *pastel study Alex, left, discrete tonal modeling and sensitive line combine to model the forms with great delicacy.*

► Flesh colors
In analyzing the basic structures and shapes in Rima Bray's The Final Ascent (detail) *and emphasizing them with color, the features are captured well. The yellows, blues, greens, and reds add vitality, but there is an overall yellow glow linking the skin tones; always relate the colors of shadows and highlights to the overall color of the face. In contrast, the colors in the painting below have been muddied through overworking and mixing, resulting in the loss of three-dimensionality.*

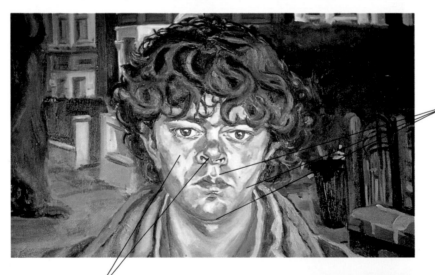

Highlights such as triangles of cheekbone and end of nose painted with cream or muted red

Oval of protruding chin, triangle of moustache area, and slab of shadow on left jaw described with cool receding shadow tones of green and blue

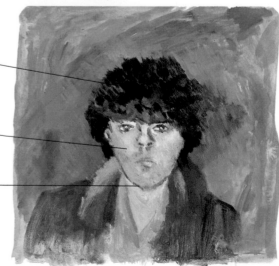

Hair ill-defined

Overworked muddy tones make face look flat and blank

Shadow to chin almost an outline, giving no depth to area under jaw

Facial features appear as though stuck onto flat surface

Hard line around cheek and chin separates head from neck – should be treated as one unit

Stripes suggest form, but should be reinforced by tonal modeling

▶ **Heads seen at an angle**

Drawing the head slightly turned away, or both turned and looking down, as in BRIAN DUNCE'S charcoal self-portrait, is in many ways easier than drawing a head-on view. You can see the way the sphere of the eye sits in the hollows of the socket and, how the nose projects outward from the face. However, because the effects of perspective alter the relationship of the features, it is easy to make mistakes, so you may find it helpful to draw guidelines as below.

Full face

Profile **Three-quarter view looking up**

◀ **Drawing guidelines**

The easiest way to deal with the head and face initially is to treat it as an oval shape, drawing curving lines around it to help position the features. A useful rule to remember is that the midpoint of the face is the bottom of the eye sockets, with the top of the eyes lining up with the top of the ear.

Training your memory

Even with rendering a static sub-ject, there is a degree of memory involved – you must continually transfer your gaze, carrying an impression with you. To render moving subjects sucessfully, you must learn to memorize postures, gestures, and shapes, and the way to do this is through sketching. Even making a few lines will im-print images on your mind in a way that simply looking cannot do.

Rapid drawing made from memory to try out ideas

Scribbled lines suggest movement

Materials and technique

Soft pastels
●
Gouache paints
●
Black chalk, conté crayon
●
Sable brushes
●
Watercolor board
●
Fixative
●

To express movement, you need a medium which has something of the same immediacy.

1 A colored ground is made by laying down strokes of pastel and then brushing over them with clean water. This acts as a fixative, binding the particles and pushing the color into the paper.

2 The artist now draws over the colored ground with black conté crayon, which is harder than pastel and less prone to smudging. The darker color beneath has been spread with a broad brush, so that the marks of the hairs create a striated effect.

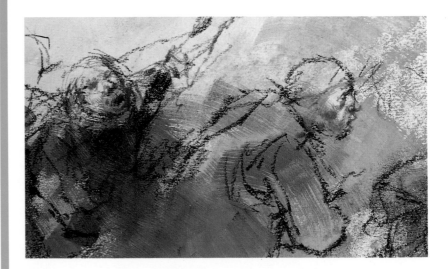

3 Movement is expressed powerfully through the quality of the line, enhanced by the energetic brushstrokes of wet-brushed pastel. Although there is as yet little detail, the faces and bodies are already solid and three-dimensional, with the highlights clearly describing the structures.

4 The forms of the horse are built up in the same manner as the figures, with directional brushstrokes and conté drawing softened in places according to the principle of lost and found edges.

5 The drawing is now sprayed with fixative, and gouache paint is used thickly to provide a vivid accent of color and a slight contrast of texture. Gouache and pastel are often used together, but it is most usual to apply the pastel over the paint.

6 Gouache has again been used for the brilliant red of the scarf and now is applied more lightly for soft highlights and touches of definition on the face of the central figure.

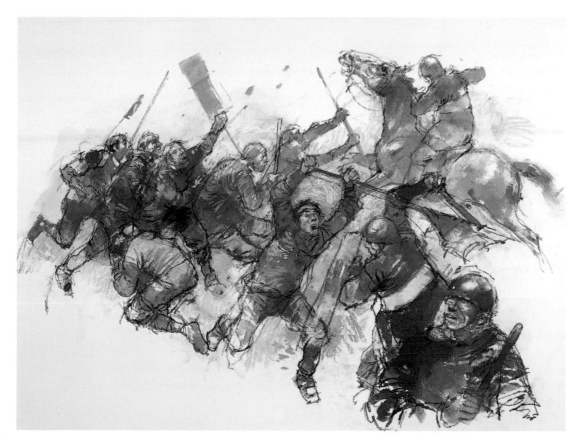

◀ **Riot**

In a drawing whose main theme is movement, the composition needs careful consideration, and VICTOR AMBRUS'S mixed-media work is cleverly contrived. The block made by the figures and horse forms an acute triangle which increases the sense of movement, as well as creating three dimensionality and space, by taking the viewer's eye from the front to the back of the picture.

Lighting

One of the best ways of learning to analyze the forms of the face is by painting yourself in a mirror, but remember the importance of lighting in the context of form, and consider this carefully before you begin. Here the gentle light from a north-facing window falls across the cheekbones and nose on one side of the face, casting the other into slight shadow without obscuring the forms.

Light from window strikes right side of face

Mirror on left enables artist to look at himself with head at three-quarter angle

Materials and technique

Oil paints
●
Stretched canvas
●
Bristle and sable brushes
●

The artist has again started with a monochrome underpainting made in thinned paint. This allows him to establish the forms and composition before beginning to build up color, depth, and character.

1 *A preliminary drawing for an oil painting can be made with pencil, charcoal, or a brush and thinned paint (diluted with turpentine), as in this case. Any incorrect lines can easily be wiped off with a rag dampened in mineral spirits.*

2 *At this stage the artist concentrates on the facial structure and the placing of the features. The warm brown used for the underpainting is the color of the shadowed side of the face.*

3 *Strong brushstrokes of thicker paint have begun the modeling of the nose and cheekbones, and diluted paint is again used for the blue-gray background. Contrasts between thick and thin paint and warm and cool colors will help to bring the head forward in space.*

4 In a portrait, the eyes are the main center of interest, and the pupils must be placed with particular care. All the features must be seen as parts of one unit, however, and the artist only begins work on the eyes when he is satisfied with the modeling of the brows and nose.

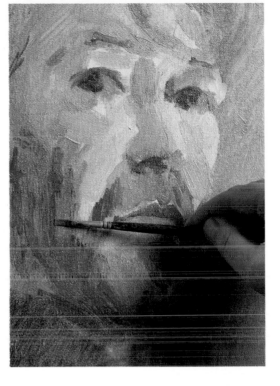

5 He now works into the underpainting on the shadowed side of the face, using a slightly darker and thicker version of the original color, and letting the brush follow the direction of the forms.

6 The shadows on the forehead, cheekbone, and side of the chin have been cooled with a light blue-gray similar to that used for the background, and the same color is now applied on the eyelids with a fine sable brush.

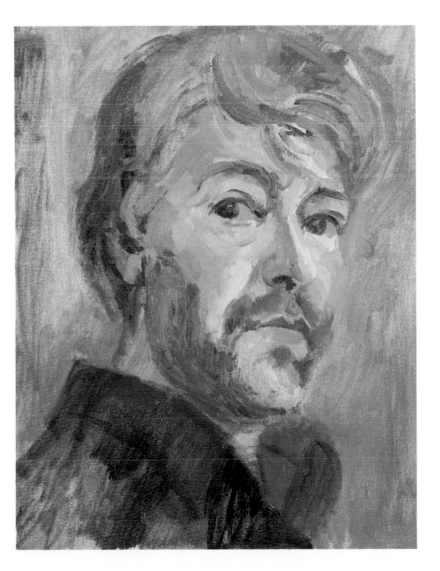

◄ Self Portrait

The angle of the head and the way it is placed on the canvas are of equal importance in a portrait. The three-quarter view BRIAN DUNCE has chosen for his oil painting allows the light to model the features clearly, as well as providing a more dynamic composition than a profile or frontal view. He has taken care to place the face in a dominant position, with the hair and shirt at the extreme edges of the canvas.

Wildlife & animals

If you choose to draw and paint live creatures, it is important to consider how you can arrange opportunities to study and record them. Most wildlife actually in the wild will be seen only for a few moments, and is seldom still. Even domestic animals rarely present a fixed pose for very long, although the day-to-day presence of a pet around the house allows you to draw on memory and your familiarity with its routines. The two subjects are very different, but in either case, you must train your perception to hold onto imagery seen in rapid transit.

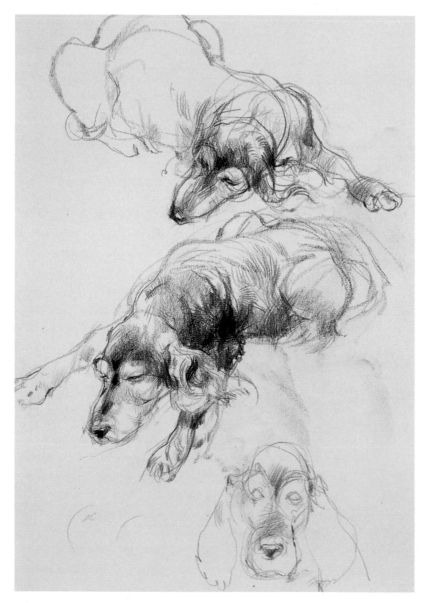

The particular fascination of animals as a visual subject often comes from their continual movement, the fluid and articulate changes to the shape and mass of the body. Freezing the motion naturally makes it difficult to achieve a lifelike effect; you need to make sure that the arrested image displays a truly characteristic pose, or use techniques that enable you to catch the elusive sense of implied movement.

◀ **Sketches of a Spaniel**
Drawing and painting animals requires a high level of observational skills and constant practice, both of which are clearly evident in these eloquent pencil drawings by VICTOR AMBRUS.

Use of expressive and varied pencil outline to describe shapes and posture

Soft pencil shading and contour lines building up solidity of body

Observing the subject

Firsthand knowledge of your subject is the ideal, and the greatest opportunities obviously come from creatures that are close at hand – domestic animals, including family pets or farm stock, or small native creatures such as garden birds or squirrels. Their habits when eating, sleeping, foraging, washing, and so on, usually involve repetitive movements that enable you to observe the specific forms and typical poses over a period of time. Look at them from a distance and determine the main characteristics that make them unique, then build up finer details as you have an opportunity for closer contact. If you are able to hold or stroke the creature, you experience a tactile sense of shape and form that is valuable knowledge you can later bring to image-making.

If your choice of subject is a fully wild or exotic creature, you will probably have little or no opportunity to see it in its habitat. To observe, for example, monkeys, big cats or larger mammals such as elephants or giraffes, which all make most intriguing subjects, you have little option but to go to a zoo or wildlife park, though many people now find these places unsympathetic. From your point of view as an artist, however, the information you can gather on form, color, pattern, and texture by direct observation is much more telling than any detail you can get from photographic reference.

Photographs are good source material if you learn to draw thoughtfully and analytically from them, not simply copy their tonality or coloring. Preferably, you can supplement photographic reference with at least occasional firsthand study, but if you cannot, make an effort to collect as many photographs as possible, showing the creature from different angles and in a variety of situations. You need to acquire a rounded impression which is not available from a single picture, which may itself be incomplete or distorted. If possible, take your own photographs; professional wildlife photography produces extraordinarily sharp, detailed pictures, but everything is pre-

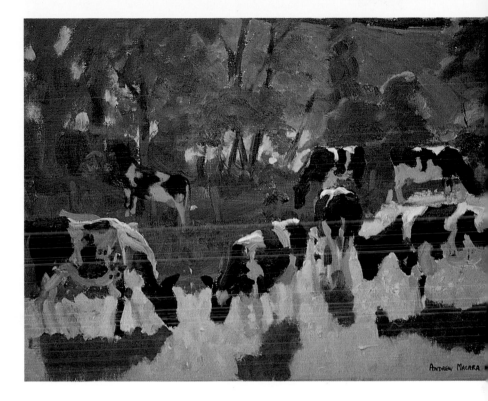

▲ **Friesians**
The black and white cows grazing in a field have been interpreted primarily as pattern in ANDREW MACARA'S *oil painting, though the treatment of both landscape and animals is realistic and convincing in terms of form and recession.*

Cool colors create recession; whites of cow's body slightly blued

Forms of body suggested through brushwork; descriptive shape of head and neck requires no modeling

selected by someone else and may not tell you what you want to know.

Wildlife films on televison and video are an excellent supplement to still photography; the filmed images move too quickly for you to draw from, though it may be worth the attempt, but they show many different angles and incidental impressions that help to build your understanding of the subject.

▶ **Fishes**

As in Andrew Macara's painting on the previous page, pattern is the main theme of this watercolor, in which RACHEL LOCKWOOD has explored the shapes made by the fishes' bodies and the ripples of water.

Calligraphic brushmarks describe rippling water, with paint applied on damp paper to create soft effect

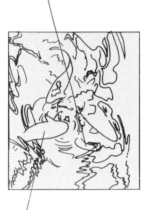

Blurred color fading away at end of tail suggests downward slope of body below surface plane of water

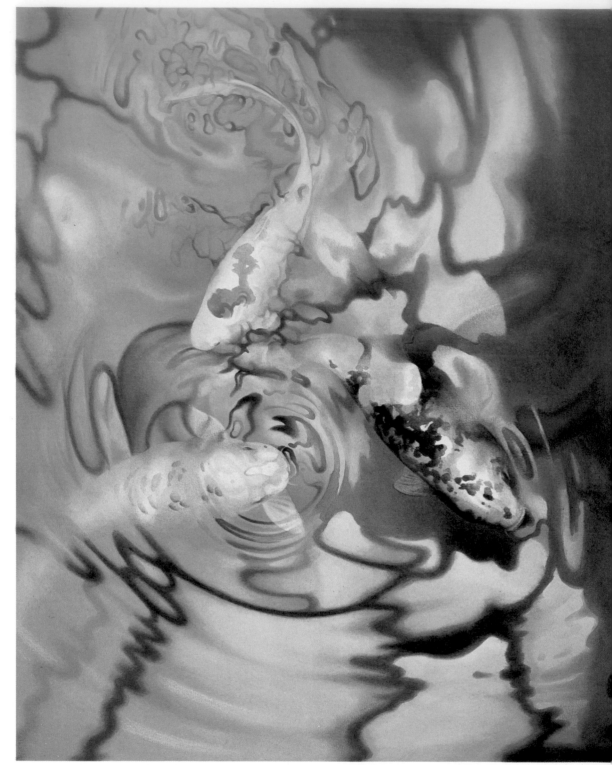

Finding the form

Animals often have striking coloring and patterns that have evolved as display or camouflage features which function precisely to disguise the true form. In large mammals, the animal's bulk and the texture of the fur outweighs the underlying structured essence – the skull and individual bones of, say, a leopard or tiger seem surprisingly fragile compared to the power of the living beast. It can be instructive to study skeleton creatures in a natural history museum. In some animals the skeletal structure is easy to

detect, as in a horse's head, legs, and rib cage. Try to imagine how hard or soft a form is, as this gives you an idea of what is going on under the skin.

Animal coloring is an important recognition factor, but you need to analyze carefully how it acts on the underlying forms. Stripes and spots, although they are effective camouflage, usually vary in size and density relating to the swell and softness of certain parts of the body against the hard, bony shapes of head, shoulders, and haunches. They provide a kind of contouring that re-describes the form through actual surface detail. The texture of the fur similarly may echo the substance of the body, being short and sleek on the head and back, looser and more gently textured on the neck, abdomen, and inside legs where musculature is less taut and bones less close to the surface.

Start by looking at basic shapes, fitting

▼ Donkey

Donkeys are better "models" than most animals, as they usually remain still until goaded into activity. Oil paint has been used skillfully by STEPHEN CROWTHER *to express both the forms and the textures of the creature, and the red of the saddle and harness provide vivid accents in an otherwise muted color scheme.*

Paint flicked outward with brush to mimic the bristly hairs of mane

Small brushstrokes of separate colors curve around sides and girth to describe form and texture

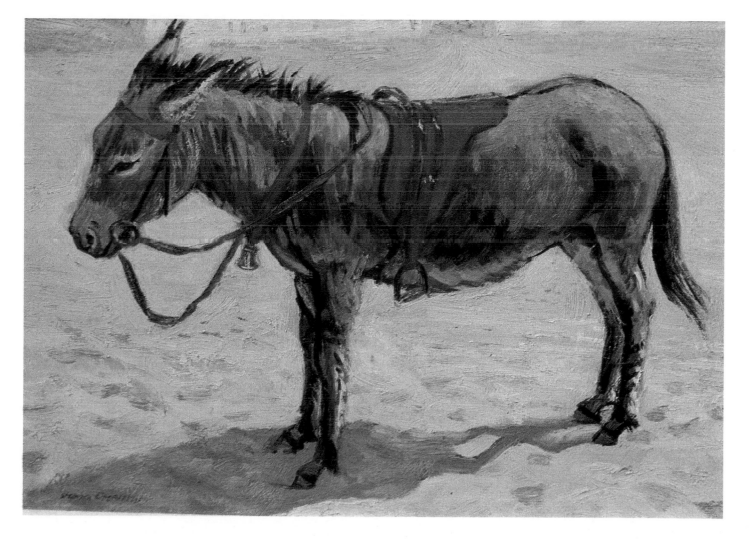

Soft highlights define forms of bodies; markings painted wet into wet to avoid hard edges

Lines of sunlight and shadow curve up to top of ridge, leading eye toward focal point

▲ **Autumn Glade**

In DAVID CRANE'S *beautifully atmospheric oil painting, the animals occupy only a small area but are still the obvious subject. The early-morning light softly haloes their bodies to create a division between the sunlit middleground and the trees beyond.*

as the focus of their own habitat, or as almost incidental details in a broader picture. Sheep, cows, or horses grazing on a hillside or in a field contribute color and scale to landscapes, injecting a note of animation or contrast, and can provide complex issues of grouping and interaction in relation to open spaces and the variety of form in landscape – undulations in ground level, massing of trees and shrubs, linear detail such as fences and plowed rows.

There is the problem of opportunities to sight the subject. You may be able to spend time making sketches of the environment in which the creature lives, without ever seeing it *in situ*. It could be necessary to use a combination of sketches and photographic reference to develop a composite picture of the overall theme, and if you do have a chance to spot your subject, you can take with you a fleeting impression of its exact color or size, a particular movement, or the visual relationship between the creature and the landscape, which will help you to interpret photographs more imaginatively.

them into an imaginary box, triangle, or ellipse. Watch the articulation of the limbs and how this alters the shape. When you work from a live model, it is a good idea to keep up a number of drawings or painted studies at one time, as there will usually be constant movement, even if it is repetitive.

Animals also make interesting paintings

PROBLEM SOLVING

Form and texture

One of the most attractive features of animal and wildlife subjects is texture, whether it is the smooth sheen of a horse, the shaggy hair of a dog, or the soft, downy plumage of a bird. But because these surface qualities are so enticing, they can lead you to ignore the forms beneath, so always look for their main shapes first, and try to identify the way hair or feathers grow from the body.

▲ Contrasts and form

In Peaceful Waters *(acrylic),* MICHAEL KITCHEN-HURLE *has stressed the soft down of the birds by using well-blended shadows and gentle gradations of tone. But the power of contrast is an equally important factor in this painting; the busy effect of the grass, with its restless pinpoints of light against deep shadow, emphasizes the solidity and volume.*

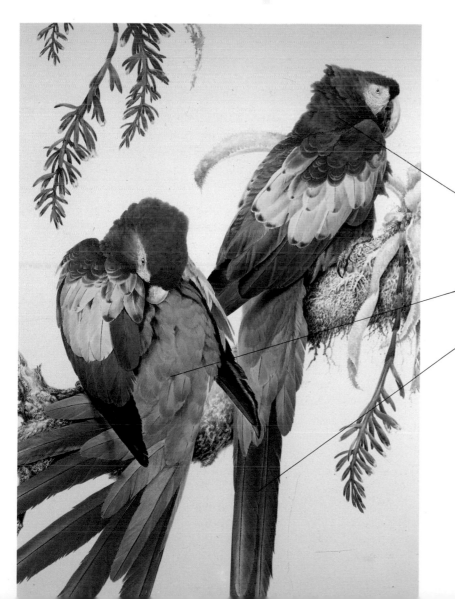

Position of head, slightly sunk into neck, makes small feathers of ruff stand up

Feathers curve gently around forms of body

In this position, tail feathers hang vertically; compare with those of other bird

◀ Scarlet Macaws

Texture has been well observed in this watercolor by DAVID ORD KERR. *Every feather has been painted with precision, but the detail does not obscure the forms, and indeed explains them.*

Composite sketches

Although some animals remain still for periods of time – cows grazing, for example – you will need to anticipate movement and train yourself to record the resulting changes in shapes and forms. A good way of building up a complete picture is to make several small drawings on one sheet of paper, leaving the first one and beginning another if the animal moves, and then returning to the first one when it resumes the original position.

Outstretched head shows line of muscle and tendon linking neck and body

Leg slightly lifted and pulled back, creating distinct bulge at top of joint

Materials and technique

Pencils and colored pencils

●

Large sketchbook

●

The versatile pencil is ideal for sketches, and has allowed the artist both to suggest movement with swift lines and to build up forms by scribbling and shading.

① *These drawings are all sketchbook studies by RICHARD TIBBETTS, made at London Zoo. This page clearly illustrates the value of making several drawings at the same time. Some were done in only a few minutes, yet the page as a whole is a mine of visual information.*

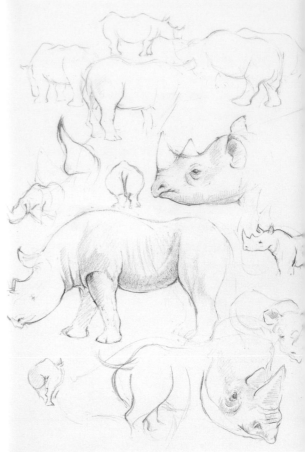

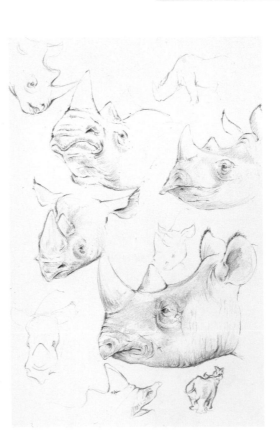

② *Rhinoceroses move relatively slowly, particularly in captivity, and the artist has been able to make a more detailed study of one of the creature's heads as well as adding to this store of information about movement and posture.*

► *Note here the sweeping curve of the bill and the texturing on the chest and above the eye. This sketch imparts well the balanced feel of a perching bird.*

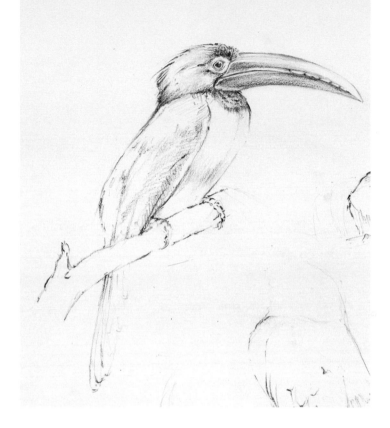

▼► *Some species of bird, like the pelican, will remain still for long periods, or resume the same position after small movements. The artist has been able to achieve a convincingly three-dimensional image.*

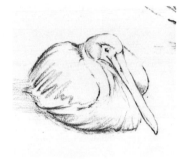

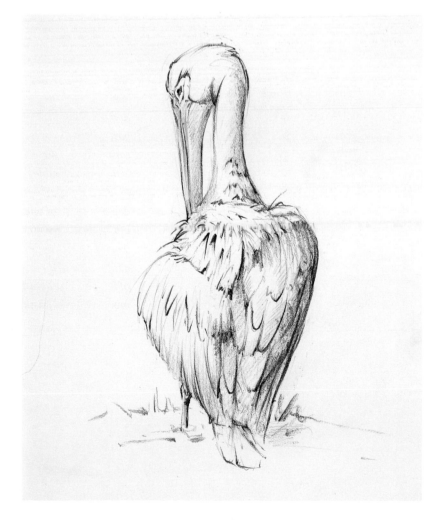

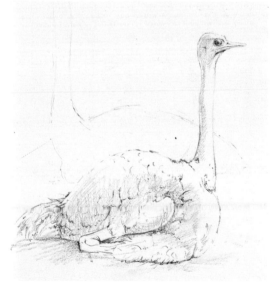

▲ *Intensive periods of observation are necessary in order to draw and paint wildlife well.* RICHARD TIBBETTS *has made a special study of ostriches, and his knowledge and experience have played a major role in the creation of this lovely pencil drawing.*

Index

Credits

Every effort has been made to obtain copyright clearance, and we apologize if any omissions have been made. In addition to those already mentioned in the captions, Quarto and the author would like to thank the following artists for their help with this project:

Elizabeth Ayris p. 74; Sam Cadman p. 75; Veronica Dunce p. 44, bottom; Jeremy Galton p. 8; Peter Kelly pp. 2, 5; Sally Launder p. 86; Giuditta Manno p. 30, bottom; James Morrison p. 1; Paul Osborne p. 76; Camilla Sopwith p. 16, bottom.

The help of the following people is also appreciated:

Anna Compton; Alex Huggins; Lucy and Al; the students and staff of Middlesex University; Caroline Robson; Sheila Smith; Tony Tufon; John Walton.

Thanks also to the following individuals, galleries, and organizations for supplying transparencies and giving permission to reproduce works from their collections:

Vanessa and Brian Cordrey p. 55; Caroline Graham-Brown p. 60, top; Billie Hart p. 29; Mistral Galleries, London p. 56; E. Nash and R. Ronning p. 25; Till Medical p. 45, bottom right.